CONTENTS

CHAPTER 3
FLIGHT SCHOOL 37

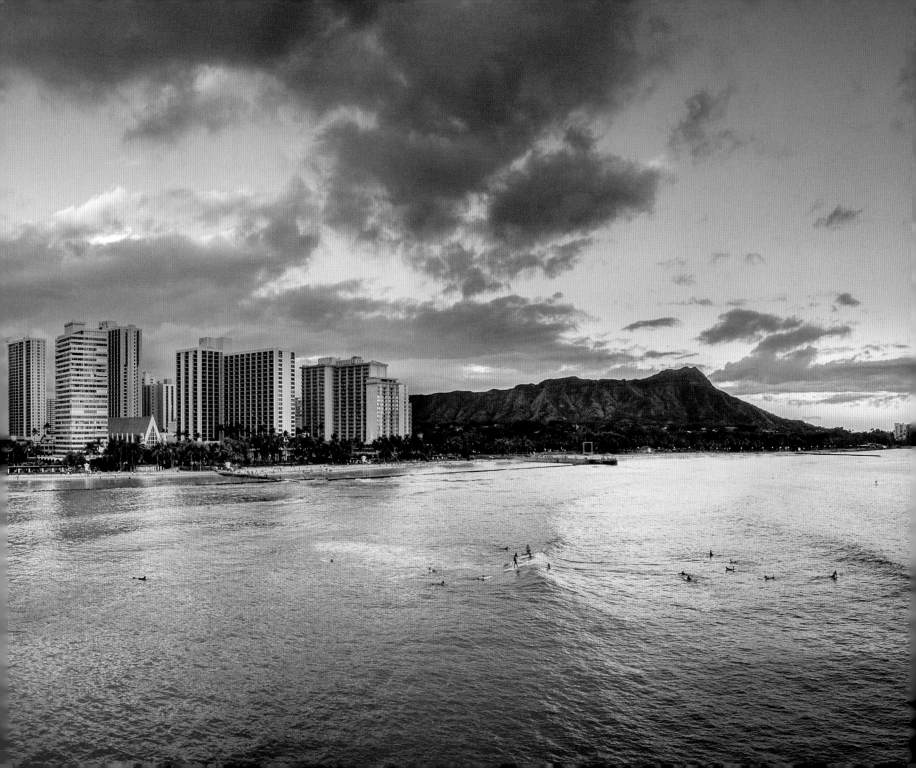

CHAPTER 6
BASIC PHOTO WORKFLOW IN LIGHTROOM OR ACR 125

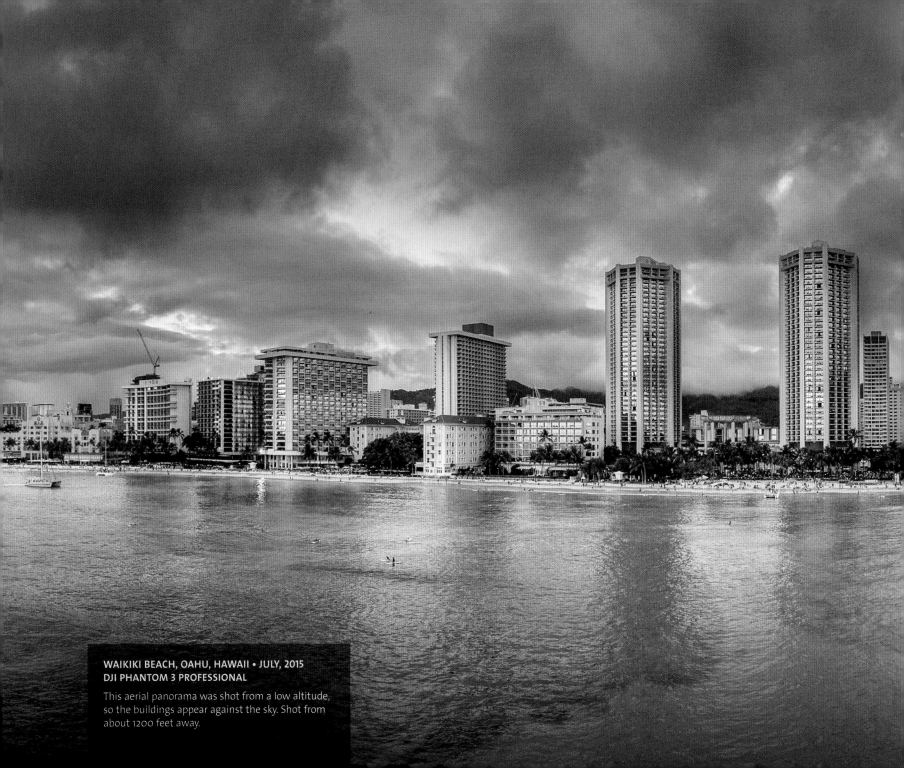

WAIKIKI BEACH, OAHU, HAWAII • JULY, 2015
DJI PHANTOM 3 PROFESSIONAL

This aerial panorama was shot from a low altitude,
so the buildings appear against the sky. Shot from
about 1200 feet away.

CHAPTER 1

SAFETY AND REGULATIONS

SAFETY CERTAINLY ISN'T SEXY, but then again, neither is being sliced by a propeller. Safety is one of those subjects that no one wants to talk about until after an accident. I'm going to keep it short and sweet and give you a crash course on safety and regulations. Safety really is common sense, but I'm sure there are a few things you might not have thought about. Safety goes hand in hand with most current regulations. I'm not going to go into too many details about regulations, because each country has its own rules and regulations, and this information changes too quickly to commit it to a printed page. You need to find out the current rules for your country or region.

SAFETY

YOUR AIRBORNE CAMERA IS NOT A TOY. Spinning propellers and falling objects have the ability to injure people. Depending on the aircraft you have, you could injure or possibly kill someone if you aren't using basic safety and common sense.

Preflight Safety

The first thing you want to do is create some kind of preflight safety check before flying. For instance:

- Are the batteries fully charged in your remote, your aircraft, and your FPV? Don't be fooled by a half-charged battery. If it was subject to a smart discharge, there is less power than you think. A "half-charged" controller can run out of juice in just a few minutes if it's been sitting for a while.

- Have you inspected your propellers for damage and made sure they are tightly secured?

- Are there any cracks or loose parts on your aircraft that could fall off during flight?

- Is your takeoff area open and free from obstructions such as trees and power lines? If there is a return to home failsafe, is there enough open space for an auto landing?

- Are you clear of people and animals for takeoff and landing? While it may be fun to have an audience, if there are too many interested people, unsupervised children, or dogs, it might be a good idea to find a different location to fly.

- Is it too windy or wet for safe flying? How is visibility?

- Are you near an airport? (See the "Regulations" section.)

- Are you near large metal structures? These structures have been known to cause interference with the compass, resulting in erratic flying.

- Have you calibrated your compass?

When starting up your aircraft, always turn on the controller before the aircraft, and always shut off the aircraft before turning off the controller. It's important to never have your aircraft on unless the controller is on. If the aircraft grabs a rogue signal and your controller isn't on, you have no way to control the aircraft to bring it back on course.

Make sure you have the latest firmware running (more about this in the next chapter). Whenever doing a firmware update, leave the propellers off. This is the only time you will turn on your aircraft without the controller being on.

In-Flight Safety

If you take off in a gusty breeze, always stand upwind. That way, if your copter blows over, it will blow away from you and not into you. I have heard people say that you should fly into the wind for lift. This may be true for fixed-wing aircraft (it's why an aircraft carrier turns into the wind for takeoff), but a multi-copter drone, generally has poor aerodynamics and is VTOL (vertical takeoff and landing), so there is no benefit to flying into the wind. Unless you strike an obstacle, crashes and tip-overs are most likely during takeoff and landing. Once airborne, it's extremely unlikely you will lose control and crash.

What's a tip-over? Just before your aircraft lifts, or during landing, its props are spinning fast and it's very light on its feet. Sometimes it can tip over and run along the ground. If you are standing upwind, a tip-over isn't really a safety threat as much as an annoyance, since your props can get scuffed or cracked. I wouldn't call this a crash, because tip-overs happen all the time, even to experienced pilots.

When you are airborne and at a lower altitude, but clear of obstacles and people's heads, quickly run through each control to make sure everything is responding correctly. Ascend and descend slightly, bank forward and backward, roll left and right, yaw left and right. Do small movements just to make sure everything is OK. Don't worry, these terms are explained in the next chapter.

Always be aware of your environment. Take note of potential hazards and obstacles before takeoff, and constantly keep an eye out and know what is happening around you. If you hear a manned aircraft, try to see where it is. If you can't locate the manned aircraft, immediately descend to a low altitude or land the drone. Some drones will show the manned aircraft on your map in the flight app.

If you see any emergency vehicles or helicopters, land immediately and don't fly until you know that you aren't interfering with emergency operations. Resist the urge to "help out"; they don't need your help. It's best to stay out of the way and let the trained professionals do their jobs.

There are simple common sense rules like "don't put your fingers into spinning props." While copters like the Phantom and Mavic are unlikely to sever a limb, they can cause pain and bleeding from deep scratches. Carbon fiber props are another issue altogether. While some pilots say they make for smoother flights, they are essentially turning their plastic props into spinning knives. You can be injured by spinning props even if the motors aren't running. If you get enough of a breeze, it can spin the props like a windmill. It might seem novel, but as I personally found out, propellors spinning with just a breeze can be quite painful if you get your hands near them. If you do see the wind spinning your props, tilt the drone at an angle, so it doesn't happen, or carry it against your body, so that the props can't spin. If you are using a folding drone, such as a Mavic, keep it folded until you are ready for flight check.

Larger crafts such as the Inspire are capable of a lot more damage with their propellers. Just search online for pop singer Enrique Iglesias grabbing an Inspire 1 during one of his concerts. What was he thinking?

Propeller Guards

Propeller guards are another option you can use to increase safety. Prop guards are inexpensive and provide a plastic shield around the propeller area. Usually string is tied between each guard to create an all-around bumper. If you are flying indoors, prop guards aren't a problem. Instead of colliding with obstacles, you can bounce off some of them. But I've seen quite a few quadcopters with prop guards run up a wall and damage it.

Outdoors, prop guards can be helpful. It's possible to bounce off a tree or nudge by it without crashing. Without prop guards, your propellers might stop if they hit an obstacle. When the props stop, your whole craft will fall from the sky. Some hexacopters (six props) and can still fly if an engine quits.

If you're a beginner, it's not a bad idea to use prop guards (think of them as training wheels). They could prevent crashes and give you a little more confidence. Some pros use prop guards because of the extra level of safety. The downside is that the guards can get in your shots, so you need to fly more slowly, or point the camera a little lower than usual.

Attacks by Seagulls

Gulls can be very aggressive and territorial birds, especially during nesting. You will hear them squawking and swooping near your drone. Generally, they won't make contact with your copter, but it's possible. I have personally experienced a seagull purposely knock a small drone (DJI Spark) out of the sky. This small drone went straight into the ocean, never to be seen again.

1.1 Prop guards on an original Phantom

I have found that if you fly away horizontally, they will chase you for a decent distance. The easiest way to shake them is to climb to a higher altitude. They seem to like low altitudes close to their nests and food sources and will leave you alone pretty quickly when you climb higher.

Other Safety Concerns

Some of these are rules, some are proposed rules, and some are common sense.

Are you in restricted airspace or a TNFZ (temporary no-fly zone)? Apps such as Hover or the FAA's B4Ufly can help you know where you are allowed to fly. This could be because of an emergency, presidential visit, or other reasons. The penalties can be quite stiff for violating a TNFZ.

REGULATIONS

I AM NOT A LAWYER, AND NONE OF THIS IS LEGAL ADVICE. The rules and regulations are constantly evolving. Because of this, some of this information may have changed since the time of this writing. Also bear in mind that rules are different in different regions and countries. I suggest becoming familiar with your local laws.

The best place to start is with your civil aviation authority website (USA=FAA, Canada=TC, UK=CCA, New Zealand=CAA, Australia=CAS, China=CAAC, and so on). Some countries have tighter restrictions than others. Some rules are common among most countries. I am going to list the basic rules for the USA, and most of these rules are common throughout the world, with some variances. These rules are for people flying aircraft less than 55 pounds.

- Don't fly over 400 feet.
- Always keep a visual line of sight. You have to be able to see the aircraft at all times with your eyes, not with binoculars or FPV.
- Stay away from all manned flight operations. They have the right of way, and it's your responsibility to get out of their way. Often, you can see them but they can't see you.
- No flying over stadiums or crowds of people.
- If you are planning to fly within five miles of an airport, you need to call the control tower first.
- No flying under the influence of alcohol or drugs. (Although this is technically a safety "guideline" right now.) Either way, no good can come from an intoxicated flyer.
- No dangerous or reckless flying.

Recreational Flyer

In the USA, there are two types of pilots: recreational and commercial.

The definition of a recreational flyer is: "A recreational flyer is someone who operates their drone for fun or personal enjoyment purposes only." This is what we call a hobbyist.

How to Fly a Drone Recreationally

1. Pass TRUST.
2. If your drone weighs more than .55 pounds, register your drone through the FAA's DroneZone.
3. Follow safety guidelines on the FAA website or of an existing aeromodelling organization. For example, AMA.

TRUST Test

In the United States, you need to pass The Recreational UAS Safety Test (TRUST) before you can fly as a recreational pilot. Links to the test are provided on the FAA website: https://www.faa.gov/uas/recreational_fliers/knowledge_test_updates/

You need to take a quick course and pass a simple knowledge test. This is free and should take approximately 30 minutes to an hour. After you complete the test, print out the certificate and carry it with you while flying. You could be asked to show it to FAA or law enforcement. I save a digital copy of the PDF on my phone, so it's always handy.

Registration

Some countries require you to register your UAS/UAV/drone with the government. In the United States, you have to register anything that weighs between 0.55 pounds and 55 pounds before flying. Register at www.registermyuas.faa.gov. This is the official place to register. It's quick and painless. You provide some personal information and pay a $5 fee, and you need to renew every three years. Beware of anyone charging other fees to register and beware of other sites.

You will receive an F-number immediately upon registering, along with a certificate. This number has to be attached to all of your aircraft. If you have multiple drones, you will use the same number on them all, you don't have to register each aircraft separately.

The rules used to say the number has to be accessible without the use of tools. You used to be allowed to keep the number inside the battery compartment. The rules have now changed, and the number needs to be visible on the outside of your drone. Also print out and carry your registration card or keep a digital copy handy.

Commercial Use

Perhaps you plan on using your drone for commercial purposes. The FAA states flying for any purpose other than for enjoyment is commercial.

Part 107

If you desire to fly commercially, you must be a FAA-Certified Remote Pilot. You will need to get a Part 107 certificate.

You will need to complete the knowledge test. There are schools and online courses that can help you with this test. Once you have a Part 107, you are able to fly with certain limitations. Some of these limitations can be bypassed with a special waiver, such as increased range (VLOS waiver), altitude, flying from a moving vehicle, and others. I won't list them all here, because they are always changing, so check out the FAA website for these details.

1.2 Registration card in email

CONCLUSION

ABOVE ALL, FOLLOW THE LOCAL RULES, USE COMMON SENSE, AND PUT SAFETY FIRST. If you are confronted by local authorities and asked to land and stop flying, I suggest you do as they ask, even if they are wrong. You will never win an argument with law enforcement or security, and no good will come from agitating people. Either fly at a different location or come back with written proof that you can fly there.

If you think that something is unsafe, or you are nervous about your ability to perform a maneuver, don't try it. No shot is worth risking your safety or your expensive equipment.

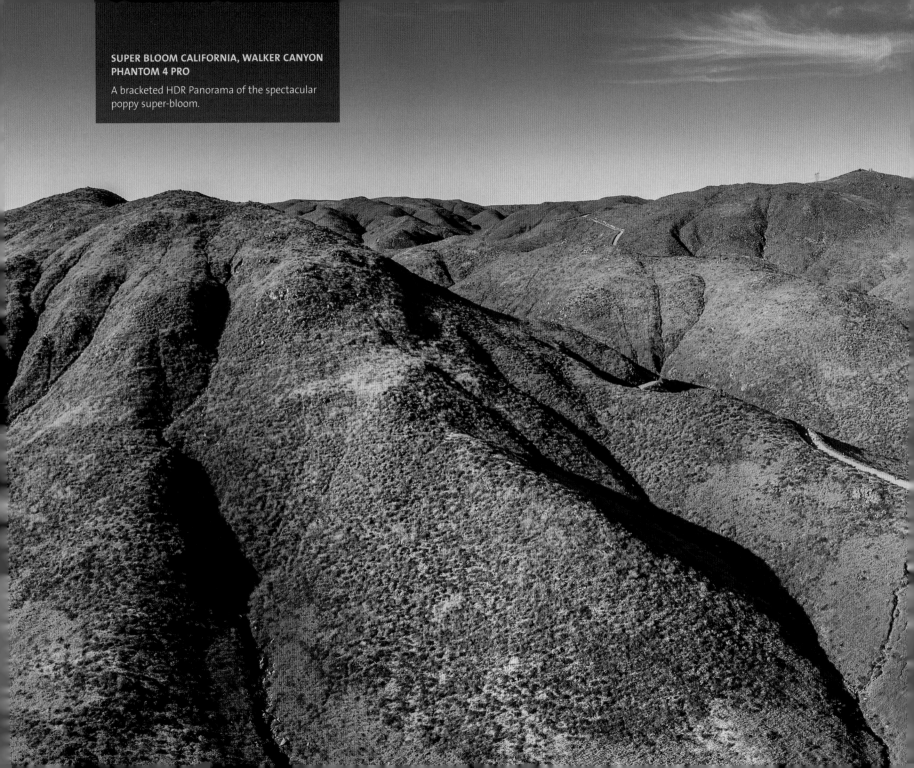

SUPER BLOOM CALIFORNIA, WALKER CANYON
PHANTOM 4 PRO
A bracketed HDR Panorama of the spectacular
poppy super-bloom.

CHAPTER 2
DRONES AND GEAR

THE MOST IMPORTANT PART OF AERIAL PHOTOGRAPHY IS THE GEAR, because without it, you can't fly or shoot. Having said that, you don't need the biggest, best, most expensive gear to get great shots. You just have to make sure that your equipment is able to do what you need it to do. Passion, practice, perseverance, and creativity are the key ingredients to getting winning shots. However, all the talent in the world won't get you great aerial shots if all you are doing is throwing an iPhone up in the air as high as you can. In this chapter, we discuss the stuff gearhounds love! We look at different drones and their features and accessories. As far as what kind of drone you fly, this particular chapter is very DJI-centric, because they are currently the leading platform. It's what I fly and have experience with. But remember that these terms and principles apply to any drone that is available today or in the near future.

DIFFERENT PLATFORMS

EARLY ON, THE RC COMMUNITY WAS MOSTLY A DIY WORLD. People built their own aircraft and flew them. Drones' popularity really exploded with buy-and-fly, out-of-the-box aircraft. A whole generation of photographers and videographers wanted aerial imaging but didn't want to solder wires together. The DJI Phantom changed things by providing a ready-to-go flying camera platform that was easy to fly.

The leaders in aerial imaging platforms today are DJI, Autel, Skydio, and Freefly. Let's briefly examine some of the most popular aircraft.

DJI

DJI are currently the world leaders in aerial imaging platforms, and I don't see that changing any time soon. In fact, it was DJI's Phantom quadcopter that kick-started this revolution in aerial imaging.

PHANTOM

The Phantom is the original consumer drone that kicked-off the whole thing.

The Phantom was a very capable piece of hardware that was able to get a GoPro camera up in the air. Although other small drones existed before the Phantom, its Naza-M flight controller and its use of satellites for stabilization made the Phantom easy to fly. While this was only in 2013, it seems like a quantum leap in technology. There was no FPV or mobile app for flight. The camera was a GoPro attached to the bottom of the aircraft.

DJI then launched the Zenmuse gimbal, with 2-axis stabilization, which allowed for smoother camera movement without the "Jello" effect—video footage that is wobbly like Jello. The 2-axis gimbal removed the vibrations and also kept the camera level while flying. It revolutionized the industry because people could shoot stable, smooth, usable footage.

If you wanted to see through the camera, you had to purchase a video transmitter and use it to send the GoPro signal to a monitor on the ground. There was no control over the camera settings. For video or photos you would have to manually start the camera on the ground and then fly with the video running all the time or with the camera in time-lapse mode, constantly taking pictures. If you wanted to know information like height and speed, then you needed to install an iOSD, which would stream back the flight telemetry. I do not miss those days.

PHANTOM 2

Along came the Phantom 2, with more powerful motors and a battery that didn't require attaching cables and then stuffing them in the door.

One of its options was flying a GoPro with the option of a 3-axis gimbal. The third axis was rotation, which was the missing piece for super-stable footage. If you wanted FPV, you still needed to bust out the soldering iron and do some DIY hacking.

At the same time, DJI introduced the Phantom 2 Vision. I was fortunate to be one of the first to use this craft. I actually owned a pre-production unit. What made this revolutionary was the built-in FPV via the DJI Vision app. This enabled you to see what the camera was seeing through your mobile phone. You could also control camera functions through the app—there was an option to tilt the camera by using the accelerometer on your phone. Because there was no gimbal on this aircraft, you could take photographs, but video wasn't stable enough to be usable.

2.1 Phantom 1 with prop guards attached and a Zenmuse H3-2D gimbal

2.2 Phantom 2 with homemade modifications for FPV

2.3 Phantom 2 Vision

The Phantom 2 Vision+ was the first aircraft that had it all. It had the Vision+ camera with a built-in 3-axis gimbal and an updated app for more control and better FPV. The quality of the camera was just OK, and it took a lot of postproduction work to make things look good. Still, we were able to coax some decent images and video out of it.

PHANTOM 3

The Phantom 3 was a coming-of-age product for DJI. It allowed us to easily create professional-looking photos and video. Flight control was vastly improved, with more power. This product was presented in a very slick and streamlined way. The controller was completely redesigned, with separate controls for camera movement, shutter, and exposure. There were two models: the Phantom

2.4 Phantom 2 Vision+

2.5 Phantom 3 Professional

3 Advanced and the Phantom 3 Professional. The big difference was that the Pro could shoot 4K video, and the Advanced could shoot up to 2.7K (after a firmware update).

A major leap forward was the inclusion of Lightbridge, an HD-quality FPV with a very long range. Lightbridge was originally available as a separate accessory for the larger spreading wings series and was only introduced as an included feature on the Inspire 1. It allows an HD signal to be displayed on your screen with almost no delay and a crystal clear image. Lightbridge works over RF, so there is no need for the additional Wi-Fi unit that powers the older FPV system in the original Vision camera. At this point, DJI migrated everything to the Go app, which connected the DJI product line. The Phantom 3 also sports downward-facing sensors to provide optical flow in the same way as the Inspire 1. See the description of the Inspire 1 for more on optical flow.

After a firmware update, DJI added the intelligent flight modes to the Phantom 3 range. The intelligent flight modes enable the Phantom 3 to fly itself.

PHANTOM 4

Less than a year after the Phantom 3, DJI released the Phantom 4. The main additions to the Phantom 4 were more powerful motors, snap-on propellers, composite-integrated camera, and a more streamlined shell with a higher center of gravity for better balance. Sport mode was first introduced with an official 47mph speed.

Perhaps the biggest addition to the Phantom 4 was the forward-facing sensors. This enables object recognition. By detecting objects and identifying them as a person, a car, etc., the Phantom 4 can follow an object as it moves. This is called Active Track and it's great for people trying to track an object—even themselves. A good practice is to lock onto the target and then fly around it to increase the recognition accuracy. Weaknesses in tracking happen when moving directly into the sun, where contrast is lowered, and when making sharp turns.

Another use for the forward-facing sensors is object avoidance. The sensors can detect an obstacle such as a wall, a tree, or, hopefully, a person. Settings can include stopping, flying over or around an obstacle, and even reversing direction if the obstacle is moving.

More sensors were added to the underneath portion of the aircraft to assist in obstacle avoidance and to increase the optical flow to 30 feet, from the previous 10 feet.

2.6 Phantom 4

INSPIRE 1

On November 12, 2014, I was invited, along with a small group of key influencers, to an event at Treasure Island in San Francisco. All we knew was that DJI was unveiling a new product. During the speeches, the very first Inspire 1 to be seen outside DJI flew into the event space. There were gasps from the attendees, who'd never seen anything like it.

Understand that this was before the Phantom 3, and it was the first streamlined prosumer drone to be unveiled. The first thing that struck everyone was its futuristic appearance and powerful-sounding motors. Also, it was streaming live HD video from its camera onto a large screen. The Inspire 1 was the first small drone to incorporate all of DJI's separate technologies into a single aircraft, and quite frankly, it was years ahead of its time. A larger and heavier aircraft than the Phantoms, this thing is jammed with tech. First of all, the legs were manufactured out of carbon fiber to make them light and strong. From the downward landing position they can be raised upward into flight position, lifting themselves and the propellers out of view of the camera.

The camera itself was a detachable gimbal. The camera could be swapped out with compatible cameras at the turn of a lever. This camera is capable of rotating 360 degrees and can be remotely controlled by the pilot. Additionally, a second controller can be used by a second operator for complete remote control of the camera while the first operator retains control of the aircraft. The camera is capable of 4K video and 12 MP stills in Adobe DNG Raw.

The Inspire 1 uses Lightbridge for long-range HD FPV with almost zero latency (the delay from camera to screen).

2.7 Launch event at Treasure Island

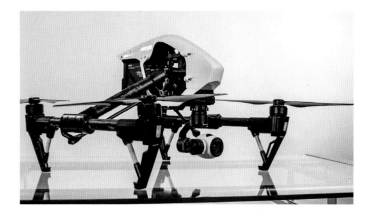

2.8 Inspire 1

Several additional cameras have been released for the Inspire 1. The X5 camera is a micro 4/3 with interchangeable lenses and adjustable aperture and focus (i.e., a "real" camera). The X5R is similar to the X5, but it records images and video on an onboard SSD drive. The X5R also records lossless video as a series of RAW still images.

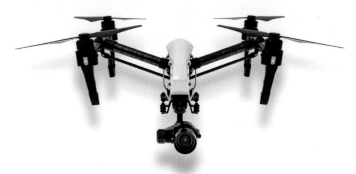

2.9 Zenmuse X5 camera

The Inspire is also available with the X5 camera standard. This is known as the Inspire Pro. Once you have upgraded your Inspire, it's very similar to a Pro and it can run the Pro firmware. The Pro does get a little more battery life than the upgraded Inspire 1 because of slightly more efficient motors.

INSPIRE 2

In 2016, the Inspire 2 saw some significant upgrades, including a magnesium alloy body and a second camera for FPV. This allows the pilot to see where the drone is going while a second operator can control the main camera. Speaking of the main camera, it now has the X7, which features 6K video in Cinema DNG or 5.2K in Apple Pro Res. It's capable of 24MP stills and has 14 stops of dynamic range. Forward, downward, and upward sensors are included for tracking and obstacle avoidance. Upgraded Lightbridge increases video transmission range to 4.3 miles. The speed is increased to 58 mph.

Mavic Foldable Drones

In 2016, there was big jump forward in design. DJI released the first of the Mavic series of drones with the original Mavic Pro. The major move forward was portability with a foldable design. They also redesigned the controller to be much smaller and resemble a controller from an Xbox or Playstation. The range was expanded to 4.3 miles.

As this point in time, 3-axis stabilized gimbals and obstacle-avoiding sensors with the ability to do live tracking are standard equipment.

The video transmission has been upgraded to the Occusyc system, which sends a clearer signal farther and with almost no latency.

Today, the Mavic-style design is the most common type of consumer drone and is broken into three main families of drones. The name Mavic is now used on the flagship pro line. The Mini is the smallest, and in between sits the Air family.

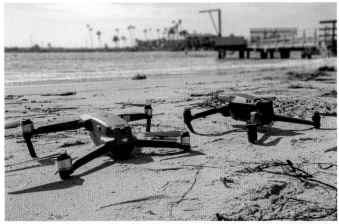

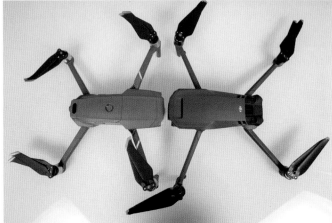

Mavic (Formally Mavic Pro)

The Mavic Pro is the drone that changed it all. If the Phantom introduced drones to the masses, the Mavic introduced the masses to drones. With the smaller, foldable design it's now possible to put a drone into your existing camera bag. At this point, sensors, obstacle avoidance, and autonomous flight and shooting modes have matured to a point where anyone can fly a drone and get half decent shots without any previous experience (**Figure 2.11**).

ORIGINAL MAVIC PRO

At the release of the original Mavic Pro, you made a choice between quality and size. If quality of shots was important from a smaller drone, then the Phantom was the choice. If you were willing to sacrifice a little quality for convenience, then the Mavic was the way to go.

2.11

In 2015, DJI Acquired a portion of legendary Swedish camera maker Hasselblad, and in 2017 it acquired the majority of their shares. The Mavic 2 Pro was released and was the first drone to feature a Hasselblad camera onboard. This was also when the camera quality on the Mavic surpassed that of the Phantom 4 Pro.

The Mavic 2 Pro sported a large 1" sensor at 20MP. What really set this camera apart was the quality of the color. In my opinion, the quality was head and shoulders above any other built-in camera that DJI had produced at that point.

The Mavic 2 shipped in two flavors, the Pro and the Zoom—the former having the Hasselblad camera, while the latter is using a 12 megapixel camera with a 24-48 mm optical zoom.

2.12

The aircraft itself had also undergone major improvements in speed (72 kph), with a range of up to 8 km and a 30-minute battery life. Other features such as downward landing lights and dual IMU's helped with safety.

At the time of this writing, the latest in the Mavic Pro line is the Mavic 3, which features a micro 4/3 sensor in the newest Hasselblad camera. The resolution is still 20MP for stills, but the low-light performance is vastly improved thanks to the larger sensor. Video now supports the holy grail of 120 fps in 4K and 200 Mbps, and goes up to 5.1K at 50 fps. The Mavic 3 shoots in 10-bit Dlog. The Cine model even supports Apple ProRes 422 HQ and writes to its built-in 1 TB SSD drive. The difference between the Mavic 3 and the Mavic 3 Cine is the built-in SSD dive to support the higher transfer rate of ProRes.

MAVIC 3 CAMERAS

With the Mavic 3 (Pro no longer used in the name) you don't have to choose between the Pro and the Zoom camera, you get both. With dual cameras, you get the Hasselblad CMOS sensor as well as a second tele camera (162 mm equivalent) that is mounted right above the main camera (**Figure 2.12**). The tele works in explore mode and is a 28X hybrid zoom 162mm f/4.4 camera. This is designed mostly for scouting shots without having to fly as far, as well as the ability to film subjects like wildlife without startling them. The format of the zoom produces decent images at native resolutions, but fully zoomed in is better for scouting than shooting (**Figures 2.13A-2.13C**).

2.13A Zoomed out **2.13B** **2.13C** Zoomed in

As far as the aircraft, it now supports full 360 degrees of obstacle avoidance with forward, rear, upward, downward, and lateral sensors. The sensors feature omnidirectional, binocular vision system, which is able to see in every direction in 3D, thus giving it a sense of depth. It also has an infrared sensor on the bottom, which is useful flying in low light and indoors. The forward sensors have an impressive 200-meter range for smart return to home. It uses APAS 5.0, which is DJIs latest object detection and avoidance system.

The transmission supports Occusync 3.0, which allows video transmission range at 1080P at 60 fps with very low latency (delay).

The battery life has been extended to a 46-minute flight time (in perfect conditions and no wind).

MINI

The Mini is the smallest of the line and weighs just 249 grams. The reason for the weight is to exempt it from certain regulations in some countries. You don't have to currently register a drone lighter than 250 grams in the United States. But keep an eye on regulations, as they are changing all the time.

IMAGE BY ALDRYN ESTACIO (FLYTPATH.COM)

2.14 The Mini 2 is small

2.15 QuickShots in the DJI app

2.16 Mini 3 Pro

The Mini is a great option when portability is key. While the camera isn't as good as the more expensive models, it's no slouch either. It has the ability to shoot 4K video at 60 fps and the Mini 3 has a 48MP camera.

The Mini 3 Pro brings back the rotating camera. The original Mavic Pro featured a rotating sensor for vertical shooting, but this was dropped in the 2. The Mini 3 has a rotating camera gimble that once again allows the popular vertical shooting. This is an important feature for the target user, who is probably very active on social media (which favors vertical photos and videos on platforms like Instagram and Tik Tok). Another nice feature is the camera is positioned forward and away from the propellers and is able to shoot upward without getting props in the shot. This opens a whole new world of creative possibilities.

The Mini 3 has forward, backward, and downward-facing binocular sensors. As well as safety, this also allows the addition of QuickShots and automatic panorama shooting. QuickShots flies the Mini in a series of pre-programmed maneuvers, making it easy to make a highlight reel. The different shots can also be called up a la carte.

The batteries usually add the most weight to a drone. Because of this DJI offers the standard battery, which keeps the drone under 250 grams so it doesn't need registration. They also offer a larger battery that increases flight time but takes the total weight over 250 grams. For people who already are registered, this is a great option.

AIR

The Mavic Air is the in-between consumer drone. It's designed to be portable, affordable, and support better image quality than the Mini. Currently in its 3ʳᵈ edition, the Air 2S offers the best quality images for the price. Video transmission is 12 km and it can fly for 30 minutes (according to specs).

With the Mavic Air 2S you get a 1" sensor on the camera and some impressive image quality for the size. Four-directional obstacle avoidance—forward, backward, up, and down—allows for great obstacle avoidance as well as tracking. It's easy to track in three ways.

- **Spotlight:** You fly manually, and the camera stays locked on the subject.
- **Point of Interest:** The drone circles an object and keeps it in the center of the frame, even when the object is moving.
- **Active Track:** This is fully autonomous flying and camera control. The drone will follow the subject. It doesn't have to follow from behind either, it can fly beside or in front of the object.

IMAGE BY ALDRYN ESTACIO (FLYTPATH.COM)

2.17 DJI Air 2S

Occusync

The Occusync video transmission system has now displaced the Lightbridge system on DJI aircraft. Occusync offers improved range, clarity, and frame rate while reducing latency (the time it takes the signal to update on the screen from the camera). The video transmission is what you see on your controller, goggles, or mobile device. Another advantage of Occusync is the ability to transmit to multiple devices simultaneously. This is important for multiple controllers and the use of goggles by more than one person at a time.

At this time they are up to Occusync 3, and it is only going to continue improving. The important thing is that clear, HD-quality transmission is now mainstream.

Autel Robotics

Autel are well known in the automotive space. They manufacture intelligent diagnostics and testing products and services. They have been focusing on drone technology and seem to be a viable competitor to DJI. Autel are also based in China, with some manufacturing and operations in the USA. The EVO II drones are made in the USA. This enables use by U.S. government and enterprise.

There are currently three models of quadcopters produced by Autel: Evo Nano, Evo Lite, and Evo II.

EVO NANO

The Evo Nano series is lightweight, weighing 249g (under the weight for FAA licensing requirements). This is a direct competitor to the DJI Mavic Mini series and bears more than a passing resemblance to it.

It has forward, backward, and downward binocular sensors, known as a Perception system. These can be used for object tracking and obstacle avoidance.

The camera is on a 3-axis gimbal and shoots at 48MP on a ½" CMOS sensor and can shoot in RAW and JPEG. Video is up to 4K at 30 fps and HD at 60 fps. The maximum bitrate is 100 Mbps. There is also a Nano+ that boosts the camera to 50MP on a 1/1.28" sensor and offers additional shooting modes. The transmission range is 10 km through Autel Skylink and it has a 28-minute flight time.

EVO LITE

The Evo Lite is larger than the Nano and offers 50MP photos and 4K HDR video on a 4-axis gimbal (allowing for vertical video). The Evo Lite+ has a larger 1" sensor and claims best of class low-light performance from the 20MP camera. (I have not personally tested this.) The Lite+ offers 6K video at 30 fps.

This drone has a 40-minute flight time and a range of 7.4 miles.

EVO II

The Evo II and Evo II Pro are the largest of the consumer drone Evo series.

The Evo II shoots a massive 8K video on a ½" CMOS 48MP Sony sensor. It has 360-degree obstacle avoidance and tracking through 12 visual sensors. The flight time is 40 minutes and it has a 5.5-mile range.

The Evo II Pro is the same aircraft with an upgraded camera to offer Autel's highest image quality. It shoots 20MP stills and 6K video on a Sony 1" sensor. It can also shoot 4K video at 60 fps and HD (and 2.7K) at 120 fps. Bitrate is 120Mbps.

Autel also offers the Evo II Enterprise, which has accessories such as a speaker, lighting system, and thermal camera. Since we are focusing on photography, we won't go into the Enterprise systems, including the Dragonfish series.

2.18 Autel Evo II Pro

Sony Airpeak S1

Sony is the first major camera manufacturer to throw its hat in the ring and produce its own drone. The drone itself is moving into the heavy lifter range, weighing almost 7 pounds without a payload. The S1 is capable of carrying a Sony alpha mirrorless camera on the optional Gremsy T3 gimbal. The obvious advantage of this drone is very high-quality photographs and video. It has a top speed of 56 mph and a 1.2-mile range. The Airpeak offers a two-person mode. One person pilots the drone and uses the small built-in camera to navigate, while the second operator works the gimbal and camera.

The disadvantage at this point is a reduced flight time once a payload is attached—from 22 minutes to about 12 minutes. Personally, I hope Sony will design a camera specifically for a drone. There is a lot of unneeded weight carrying a terrestrial camera, from the battery to redundant components such as display, grip, and controls. An ideal aerial camera is nothing more than a lens, sensor, and electronics. You need to get the weight down to maximize flight time.

I think at this time Sony is concentrating on getting the drone just right, and then I suspect they will release more accessories in the future, perhaps an integrated gimbal and camera. With the modular design of the Airpeak S1, this is very possible.

Sony's ability to quickly innovate and update made them the leader in mirrorless cameras. I will definitely be keeping my eye on Sony to see what they produce in the future. I suspect it could get quite interesting.

IMAGE BY JOHNNY PHAM

2.19

Firmware Updates

No matter what hardware you decide to fly, keep an eye out for firmware updates. These updates fix bugs and add new features to your drone. Usually the app will inform you when new firmware is available. Make sure your batteries are fully charged while running a firmware update, and don't interrupt the update while it's in progress. Another suggestion I have is to join some groups on Facebook or Discord and wait for the thumbs-up from the community before performing the update. I usually wait about a week to decide if I will perform the update or skip it based on feedback from the community. If a number of people are having big problems because of the update, I usually wait until things are fixed.

RETURN TO HOME (FAILSAFE)

Most, if not all, modern drones use satellites for positioning. These satellites mark the position of the aircraft. The satellites help the aircraft stay steady by using positioning information that communicates with the motors to make constant micro adjustments. There are four main satellite networks: GPS (USA), Galileo (EU), BeiDou (China) and GLONASS (Russian).

Most drones use one or a combination of these systems. DJI seem to be discontinuing the use of GLONASS and using GPS, Galileo, and BeiDou. One of the important tasks performed by satellites is to mark the homepoint. This homepoint is saved as a failsafe destination. That means that if the controller loses connection with the aircraft because of a malfunction, battery failure, or an accidental drop into the ocean, the aircraft doesn't just keep on flying away by itself until it crashes into something.

Instead, the aircraft will climb to a safe altitude (this is usually programmable in your app; see the operating instructions for your aircraft) and return to the home position (or homepoint), automatically land, and shut off the motors.

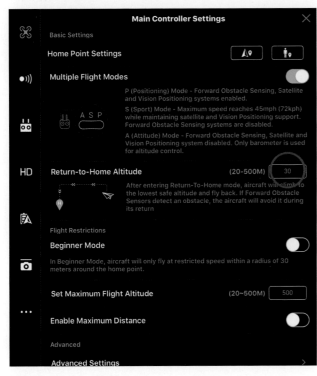

2.20 Homepoint settings

This failsafe is also used in monitoring the onboard batteries on the aircraft. When the batteries get low, the aircraft will return to the homepoint. You have the option to override this if you want to continue flying. However, once the aircraft gets critically low on power, it will go into a self-landing mode. At this point, you still have the option to guide the aircraft to a safe place to land (if you canceled return to home). Once it's in critical mode (usually at 20% battery), you cannot cancel landing, because the software won't allow your aircraft to run out of power in midair and fall from the sky. This is a good safety measure.

You can also force a return to home by pressing the Home button on your controller or app. Once again, refer to the instructions for your particular aircraft to familiarize yourself with this feature before your first flight.

STATUS LIGHTS

Under each aircraft, usually at the ends of the arms, you will see status lights that provide important information. These lights tell you when you have satellite lock, when it's safe for landing, when the batteries are getting low, and if there is an error.

Please refer to the instruction manual to see what the lights mean on your aircraft. Generally speaking, flashing red is never good, amber means that certain features are disabled, and green means all is well. Learn what these lights mean; your aircraft could be trying to tell you something important.

GEAR

Filters

Filters may be some of the most misunderstood accessories for aerial photography and video. Whenever I post an image, I always have people ask if filters were used. This is a fair question, but I have discovered that many people think if you put an ND filter on your camera, suddenly all your photos will be sharper and more vibrant. Many times, these filters produce the opposite result and can make a photo look worse. After you read this section, the purposes and uses of filters will be clearer to you. Then when you do use filters, you will see an improvement in your images.

A filter is a thin piece of glass that screws or snaps onto the front of your lens. Different types of glass have different properties that affect your photographs in different ways. The main thing is that they are distortion free, clean, and, for aerial work, lightweight.

There are several types of filters to discuss: ultraviolet (UV), circular polarizer (CP), neutral density (ND), and graduated neutral density (GND).

ULTRAVIOLET

A UV filter is simply a clear piece of glass that sits on the front of your lens. This filter protects your lens from scratches by taking the beatings for it. Some manufacturers claim that the way the glass is honed gives you sharper images and reduces glare. Some photographers claim that the extra glass on the front creates glare and blur and undermines the benefits. I use them for protection.

2.21 Filters

CIRCULAR POLARIZER

One of the most useful filters for traditional photography is the polarizer. A polarizer creates richer colors while reducing glare and reflections off water and glass. When light bounces off things, it scatters and creates glare. A polarizer filters out all light except the light moving in a certain direction. By rotating the circular polarizer, you can choose which direction of light rays you want to see.

Take two pairs of polarized sunglasses and put them on top of each other. Rotate the top pair to see what I mean—at one point the lens will appear solid black, which is polarization at work.

The advantage of polarizing filters is the ability to rotate the filter to reduce or remove reflections and glare. You will get bluer skies, clearer clouds, and more highly saturated colors in your landscapes. This only works when you are at an angle to the sun, 90 degrees being the most effective. You won't see much of a difference with the polarizer when looking directly into or away from the sun.

Polarizers do have some challenges and side effects. They will darken the exposure; this may or may not be a benefit, depending on the circumstance.

You obviously can't rotate the filter while your drone is in the air. That would require a servo on the filter, which I'm sure someone is in the process of building. The rest of us have to rotate the filter while we hold our aircraft or while it's sitting on a secure base. The added challenge of this is that we have to have a video preview of the effects of the filter as we rotate it to get the benefits of it. This means having the camera on for this process, so we are fighting the active gimbal at the same time. This will get things perfect for a certain shot, but when we rotate for another shot, the filter may not be set up right—we either have to make do or land and adjust the filter.

The other issue with a polarizer on a wide lens is that it can't polarize the entire sensor. This can create a darker area in the middle of the sky, with more white toward the edges (see the sky in **Figure 2.23**). This makes it a bad choice for shooting panoramas unless you want a leopard-skin sky. However, Photoshop sky replacement can be used to fix it; see more on that in chapter 7.

Because of the challenges and side effects, I don't use a polarizing filter that often because it's such a hassle. But for certain shots it's magical.

2.22 Taken on the Phantom 4 without a polarizer

2.23 Now using a polarizer—notice the richer color

NEUTRAL DENSITY

If I could only have one filter, it would be the Neutral Density filter. This filter shouldn't change the quality of light at all; it doesn't sharpen, color, cut through glare, or any of the mystical things people think it does. All it does is reduce the amount of light entering the lens, making everything darker. Because there is less light entering the lens, you have to slow down the shutter speed to get a correct exposure. You could increase the ISO, but all you would be doing is adding unnecessary noise to your images. Let me explain ND for photography and for video (where you will use it all the time).

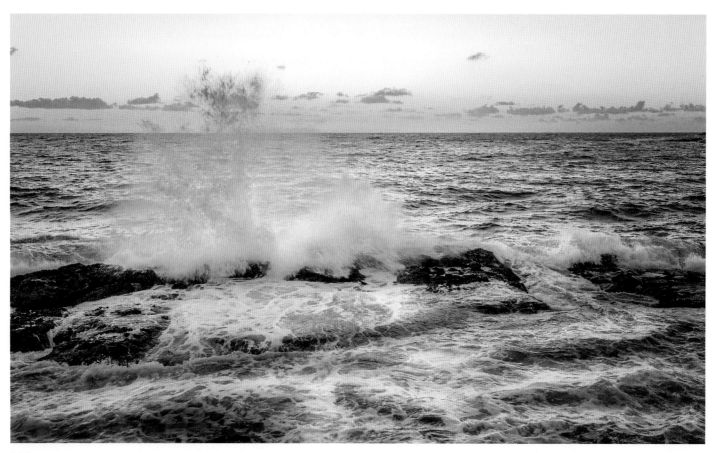

2.24

In photography, the shutter speed is the amount of time that the shutter is open to expose the frame. When it's bright, you want a shorter (faster) shutter speed; otherwise, your image will be overexposed and too bright. When it's darker, the shutter needs to be open longer (slower shutter speed); otherwise, the photo will be too dark.

With a shutter speed of 1/1000 of a second, movement will be frozen, with no blurring at all. You can see that effect with this image of water spray captured in motion (**Figure 2.24**).

This second photograph was shot at the much slower 0.6-second exposure. Because the shutter is open longer, more movement happens in that time, and is captured. This creates a flowing motion effect (**Figure 2.25**).

2.25

The ND filter reduces the amount of light entering the lens, so you can use a slower shutter speed. They come in different densities to allow compensation for different shutter speeds. Higher densities block more light. Unless you want to slow down the motion and create some blur on your photo, you wouldn't use an ND filter. If your copter is moving, the entire photo could likely be blurry when using an ND. Make sure you are hovering, and let the motion happen against a stationary object. If you want tack-sharp photos, the ND filter will actually give you the opposite result.

Different manufacturers use different notations to describe their filters. Here is quick chart that shows the notations and how much light they block.

ND notation	ND notation	f-stop reduction
ND2	.3	1 stop
ND4	.6	2 stops
ND8	.9	3 stops
ND16	1.2	4 stops
ND32	1.5	5 stop
ND64	1.8	6 stops

In video, the ND filter is a necessity.

It's important to use the correct shutter speed for smooth video. While tack-sharp frames are desirable in photography, the opposite is true for video. For fluid movement and motion, a little bit of motion blur makes the video look smoother. If the shutter speed is too fast, the action appears jerky and staccato. Water drops end up looking more like sparks than they do smoothly flowing liquid.

The formula for the best shutter speed for video is 1 over 2x the frame rate. If the frame rate is 30 fps, then 1/60 is ideal. For 60 fps, use 1/120. For 24 fps, use 1/50 (there is no 1/48, so we choose the closest shutter speed available).

To get the correct exposure, often the corresponding shutter speed is much faster than what we want for video, so we need to reduce the amount of light with the ND filter. More quality video is shot with an ND than without. You will use an ND all the time when shooting video outdoors during the day unless it's heavily overcast. It's easy enough to tell—just zero out the meter on your camera in the app and see the shutter speed. If it's too fast, then add an ND.

Typically, you would use an ND16 for most bright-day shooting, or go up to an ND32 when it's very bright, such as over water or snow. If it's a bit cloudy, the ND8 might do the trick.

Here are common shutter speeds in full-stop increments: 1/1000th of a second, 1/500, 1/250, 1/125, 1/60, 1/30, 1/15, 1/8, 1/4, 1/2, 1 second.

GRADUATED ND

The last type of filter that we'll discuss is the GND. This filter is tinted at the top and clear at the bottom. There is a smooth gradient where the darker region blends into clear. This enables us to darken the sky without the foreground being darkened. This is a great option for shooting outdoors and shooting landscapes because the sky is usually brighter than the ground. By adding a GND, we can balance out the difference and show more detail in the sky and the ground simultaneously.

First Person View (FPV)

FPV means seeing what the camera is seeing. Video games like Doom or Call of Duty are called first-person shooter games because they put you in the virtual driver's seat, as if you were actually there. FPV does the same thing. It's easier to see where you are flying when you are looking through FPV, because you can see obstacles and clearings in front of you. When the aircraft is a fair distance away, it's hard to gauge where it is in relation to other objects because of the reduced depth perception.

While FPV is nice to have for flying, it's really important when it comes to framing your shots. When you are making photographs, use the FPV to frame up your shot. When you are shooting video, you will use it to frame the shot, but also to maintain that frame as you move though the shot.

There are two main types of FPV: screen and goggles.

FPV SCREEN

These days, a screen usually means a phone or tablet, but not always. Many drones, such as the Inspire 1, can have a large monitor plugged in through the HDMI jack. This allows a remote feed of what the camera sees. There are also controllers with the display built-in, such as the Phantom 4, Smart Controller, and RC and RC Pro from DJI. These have the app preinstalled on an android system and feature a 5.5" screen. This is a great way to save batteries on your phone. Also convenient, you don't have to plug in a phone, launch the app, and turn on the controller—it's all done with one button.

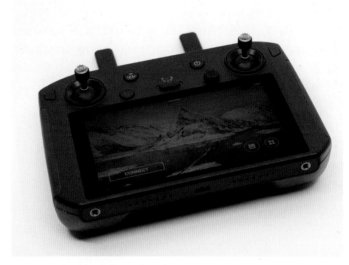

2.26 DJI Smart Controller and RC Pro

Most commonly used is an iOS or Android mobile app that you download on your smartphone or tablet. These all-in-one apps allow you to change equipment, camera, and telemetry (speed and location) settings, and provide a large real-time display of the camera feed. Most of these apps also include a flight recorder that allows you to access your flight logs at a later date.

For most purposes, I like to fly line of sight and keep an eye on the FPV for reference, because I like to be aware of my surroundings. When doing a video shot, I will be looking mostly at the FPV device to make sure the framing is good and that I like the speed and movement. I will be aware of my surroundings and have a spotter with me who watches the aircraft while I'm not. As soon as I've got the shot, I immediately look back at the aircraft and make sure everything is nice and clear.

Sun glare can be an issue, so a sunshield for your screen is important. You can make one yourself out of black foam core. Sunglasses can be worn, but make sure they aren't polarized, because this makes it difficult to see the screen.

GOGGLES

FPV goggles are a fully immersive way of looking through your FPV. When you wear these goggles, all you see is the display through the eyepieces. It provides a very clear view of the FPV and makes it very easy to see and fly as if you were up there in the drone yourself. Because of this superior view, FPV goggles are used for drone racing.

Because I shoot photos and video, I don't exclusively use goggles. I like to be aware of my environment and know where the drone is in space at all times. However, you could fly to position, look around, make sure there are no obstacles, and then put on a pair of goggles and fly. Looking through the goggles can help with composition because it's like seeing your image on a movie screen. Be aware if you are in the USA, law dictates you must have a visual observer standing next to you if you are flying with goggles.

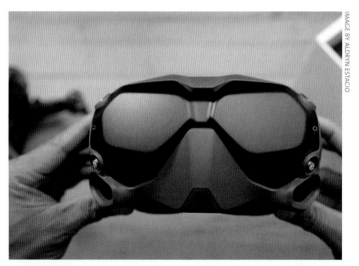

2.27 Remote with iPhone attached

2.28 DJI Googles

My favorite option is to use the Inspire in dual-operator mode. One pilot flies the aircraft using visual line of sight while the second pilot is the camera operator. They don't have to worry about the aircraft, because they aren't flying it. They are operating the camera. It's really nice to be immersed in your own little world as the camera operator and get the best shots possible. The Sony Airpeak also allows this option.

There are goggles that plug into the HDMI slot of your controller, such as the Fat Shark.

DJI also make their own goggles that work wirelessly with their drones through Occusync. These also allow head tracking, which move the camera with your head movements. Check compatibility with your drone before purchasing goggles.

Batteries

Why mention batteries? You charge them; insert them; fly; rinse; and repeat, right? There are actually a few things you should know about batteries for safety and also to make them last longer.

The most common batteries used in UAVs are LiPo batteries. LiPo stands for lithium polymer or lithium ion polymer. The lithium ion isn't that different from what's used in the latest laptop computers. The difference is that they are wrapped in a soft polymer pouch. They are multi-cell batteries. LiPos are popular because they have extremely high power, are lightweight, and can be made in almost any shape or size.

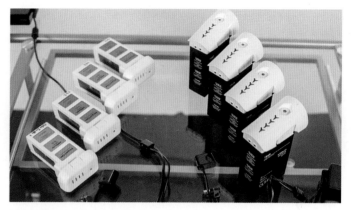

2.29 LiPo batteries

It's recommended to charge these batteries in a well-ventilated, fireproof area, and to not leave them unsupervised while charging. The smart chargers are a lot safer and easier because they shut off once the batteries are charged. Otherwise, the batteries could explode if overcharged, and release gasses and sparks that can catch fire. Just do an online search for exploding LiPo batteries and you will find plenty of results.

If handled properly, these batteries are quite safe and will last a long time. Just don't puncture them, and it's not a good idea to leave them lying out in the sun. If the batteries are looking puffy or swollen, carefully dispose of them. Don't be tempted to grab a sharp object and relieve the swelling, as this will almost certainly lead to them catching on fire.

When you have used a battery, it will feel very warm, even hot, to the touch. Wait until the battery has fully cooled down before charging it; this will make it last much longer. Repeatedly charging a hot battery can ruin it in just a few hours.

When storing a battery for an extended time, don't leave it fully charged or depleted. About half-charged is good. Find a cool place to store it. DJI is now using smart batteries that self discharge if not used for about 10 days. They will slowly release their charge to about half. The days until discharge can be set in the app. Make sure that each battery is programmed individually by inserting it into your aircraft and then choosing the setting in the app. Finally, power down and the battery will be programmed.

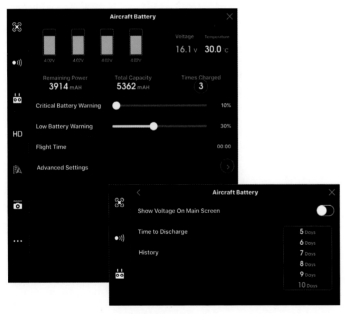

2.30 Go app settings: days till discharge

NOTE *A battery that has smart discharged can appear to have more power than it actually does. Don't be tempted to use it for a quick flight, thinking you have half a battery. Fully charge batteries before use if they been sitting for any period of time.*

When traveling with batteries on an aircraft, make sure you carry them on and don't check them into the cargo hold. They shouldn't be fully charged, and the terminals should be covered. If the batteries are under 100Wh (all the Phantom and Mavic batteries are), there is no legal limit to how many you can bring with you. If you have larger batteries, such as the larger Inspire batteries (TB48) the limit is two on some airlines, but you can get permission to carry more. If you are looking for permission, don't ask the people at the airport or the flight crew, because they probably won't know. I was once thrown off a flight from Las Vegas because I mentioned the batteries to a flight attendant who didn't understand the rules. She talked to the pilot, who also didn't know battery rules, and I was declared a "No Fly" and marched off the aircraft. After missing my flight and waiting for over an hour while the operations supervisor talked on the phone to their head office, I finally received an apology.

If you are going to be carrying batteries over 100Wh and need permission, call the airline office before the day you fly and talk to someone who is trained to handle these situations. This will save you a lot of headaches. I also recommend printing out the rules from the FAA (or the authorities in the country where you are traveling). You will not need these if you are able to put your bag in the overhead storage or carry them in a personal bag. However, if you can't carry your bag on, don't under any circumstances allow your batteries to be checked in the cargo hold. Remove the batteries from the case, but keep the printout handy. Don't

bring attention to it and you will be fine, but make sure to obey the rules and any crew member instructions.

There are a number of reasons to keep your batteries out of the cargo hold. The first reason is that it's illegal. (It's perfectly legal to carry them on your person, though.) A partially charged LiPo battery isn't going to just explode on its own without a reason—which is why batteries are declared safe in a cabin. See all those laptops? They have similar batteries.

There's nothing in the cargo hold that will cause your batteries to catch fire or explode. However, if they do catch fire for some reason, they will be quickly noticed and easily extinguished in the main cabin. However, if they are in the cargo hold, no one will notice them smoldering until they ignite. And from what I have read, the chemicals used to extinguish a cargo hold fire are ineffective against a lithium ion fire. This is also why you aren't allowed to check spare batteries for laptop computers, but you are allowed to carry them.

One last thing about traveling with batteries: When going through airport security, remove all the batteries from your bag and place them in a separate bin for inspection. It's quite common for the inspectors to dust them down to check for explosive materials, because the x-ray machines can't see inside the batteries. If you leave them in the bag, they will ask you to remove them and your bags will have to pass through the x-ray a second time, causing a delay for everyone.

All in all, I have traveled with batteries and drones many times and, with the exception of that one flight, never had a problem. Just remember to put batteries in a separate bin when going through security, keep them in a carry-on bag on the aircraft, and all should go well. At this point, TSA are used to drones and

batteries and it's not a big deal. If you are travelling internationally though, it's a whole different story. Check the drone rules of the country you are going to; some counties don't allow you to bring drones in. Now, these laws could change, so check the rules of the airline before departure so you know what to expect. Also, do everyone a favor and comply with TSA and crew instructions at all times.

SD Cards and Readers

When you are shooting, you are saving your photos and videos to a memory card. The most common type of memory card used in drones is the microSD card. These tiny little cards are popular because they are small and lightweight and allow the camera to be smaller.

It's important to get high-quality cards—not just for reliability, but also for speed. You'll want to use a Class 10 card at the very least. If you want to shoot 4K video, you need a card that is fast enough to write all the data. The other thing to consider is shooting photos. When you shoot a photograph, you want to be able to change settings on your camera and shoot again. On many cameras (all the DJI ones), you cannot change settings, shoot a video, or shoot another photo until the camera has finished processing. You will see a spinning blue circle over the shutter button on the app. The faster the card, the faster the writing process, and the sooner the camera is free again. This is especially noticeable when shooting multiple images in AEB or burst mode.

You really do notice a difference with the faster cards for shooting, as well as for transferring your images to a computer or hard drive after shooting.

To transfer data off the cards, you'll need a good card reader. Many of the Lexar and Sandisk cards come with either a USB adapter or an SD card enclosure so you can transfer files. If you are using UHS-II cards, make sure your reader is also UHS-II (and your drone supports them) or you won't get the full speed out of them.

Just a little tip—when you have finished transferring your media after a shoot, don't just erase the old files off the card. Verify that all the data has successfully transferred. Put them into your camera and format them before use; this will help with reliable writing to the card the next time you use it. Make sure you have a system (such as transferring images immediately after a shoot) so that you don't accidentally erase the only copy of your photos or videos. That really hurts. When shooting I keep the unused cards label-side up and the used card label side down in my card holder, so I know which cards have data on them.

2.31 Lexar microSD cards

Bags and Cases

The first thing I did when I got my first drone was find a travel case for it. It's important to have some way to transport it, and the cardboard or foam box it came in won't cut it for long. There are a few things to look for in a good case. First and foremost, you want it to protect your aircraft, so you want something that fits your aircraft snugly so it can't move around. You also want a soft support so that your aircraft doesn't get scratched. Separate compartments are good too, so you can hold all your accessories. You will be carrying your controller, spare batteries, propellers, FPV device, microSD cards, maybe some tools, and possibly a battery charger. I carry a charger or two when traveling out of town, but when I'm local I don't drag a charger around with me. I usually have four or five batteries, depending on the aircraft, and that's usually sufficient for most things.

The GPC hard cases (goprofessionalcases.com) are the best I have used and are the most popular today. They are watertight molded plastic. The box is very strong and sturdy, and it has a rubber seal around the opening so it won't let moisture or dust and sand in. They have nicely designed interiors of custom waterjet-cut foam that fits your gear perfectly. Each component has its own custom-cut space that holds it safe and secure.

GPC also makes backpacks that are filled with the same custom-cut foam. They hold everything from a Phantom to an Inspire. Thinktank Photo also makes a nice backpack called the Helipack.

Usually when I'm hiking, I prefer the backpack. When I'm local or traveling by car or air, I'll take the hard-shell case. The GPC hard cases also come with optional wheels, of which I'm a big fan, especially for the Inspire, which can get heavy.

2.32 GPC cases

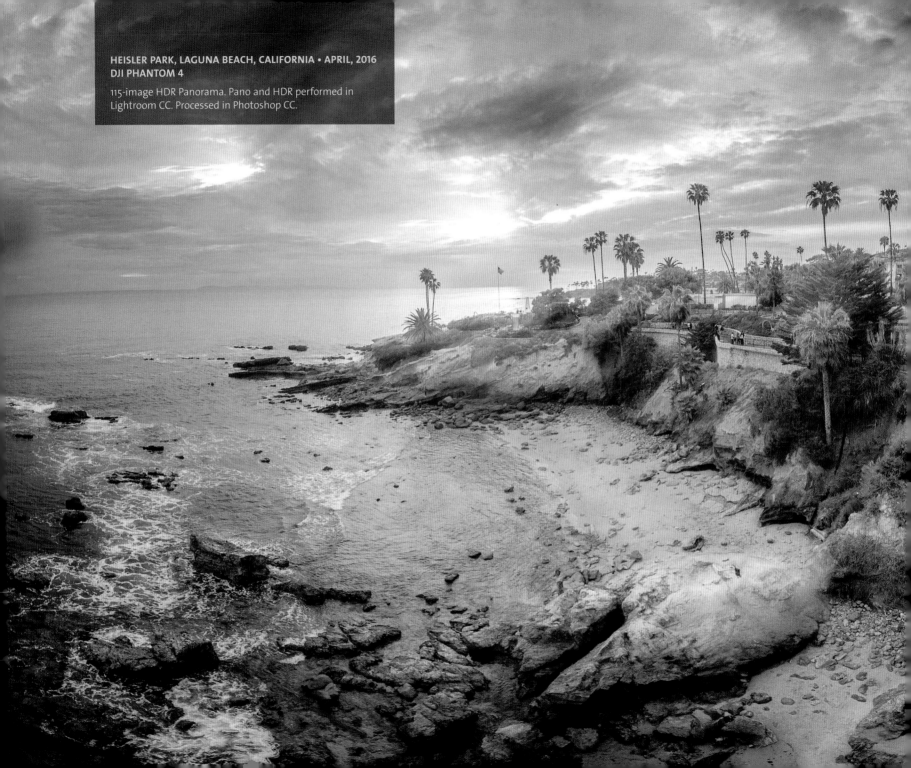

CHAPTER 3
FLIGHT SCHOOL

IF YOU WERE TO FLY A FULL-SCALE AIRCRAFT, you would be expected to attend flight school, where you would learn about the capabilities of an aircraft and how to control it. You would also learn about how things like temperature and altitude affect your aircraft. You would practice some different maneuvers, such as banking and climbing and, most importantly, you'd learn how to land safely. Once you completed these tasks, you would also have the option to become instrument rated, where you could fly based on the instruments. This requires a deep understanding of what all the needles and numbers in the cockpit mean and how to use them.

We are going to take a similar approach with this chapter. Read it carefully and apply what you learn, and you'll become a proficient pilot. We are not going to talk about the camera and how to frame shots; that will come later. I want you to concentrate on becoming a solid pilot first. Before you begin shooting, you need to have full control of your aircraft and be confident that you understand its capabilities. This is a "wax on, wax off" chapter, because you will build solid skills that will make your photography and video better than someone who starts flying without building any solid skills.

PRE-FLIGHT CHECK

BEFORE WE TAKE TO THE SKIES, we need to check some things; otherwise, our flight might be a little shorter than we hoped.

- **Location:** You need a nice clear level area for takeoff. Don't just think about takeoff, but also make sure there is a large enough area for you to safely land—one clear of people, animal, trees, and metal objects that could cause compass interference. Your takeoff point will be the return to home failsafe point. Here's a good rule of thumb: If your controller were to suddenly stop working, would the area be clear enough for an automated return and landing? Or would your drone hit a tree or power lines on the way in?

- **Conditions:** Make sure it's not too windy for safe flying. I advise against flying in rain or heavy fog. Water isn't good for electronics. It's also important that you have good visibility to keep your drone within your line of sight. Check your app to make sure you aren't too close to an airport or restricted airspace.

- **Batteries:** Make sure they are fully charged. This includes the batteries on the controller, your monitor/mobile device, and your aircraft. Also make sure your batteries are in good condition. Check them for any swelling or damage. If the batteries aren't in top condition, don't use them. Batteries are expensive, but not as expensive as replacing your entire aircraft.

- **Damage:** Make sure there is no visible damage to your gear, including chipped propellers and fine cracks on the shell of your aircraft. If your props are chipped or bent, it will affect the balance and possibly cause vibrations that will result in camera shake, blurry photos, and video that has a "Jello" effect (video that visibly wobbles and warps like a wiggling lump of Jello).

- **Make sure everything is nice and tight, especially the props.** Make sure there are no loose parts that could fall off. If they fall, they could hurt someone.

- **Do you have the latest firmware?** The DJI products and 3DR Solo will tell you on your display if there is a newer firmware version available. The firmware is how the internal computer in your drone communicates with the hardware.
- **Are the IMU and compass working correctly?** You will see a warning if they aren't, and you can run a calibration from your software app. Generally, you will see a nice green "Safe to fly" message on your display (**Figure 3.1**).

3.1

You are ready for compass calibration. See the "Compass Calibration Dance" sidebar.

Check the following during each battery change:

- You have a good solid satellite lock if flying in GPS mode, indicated by slow-blinking green lights. If you are flying indoors, then change the settings to Attitude mode.
- Make sure there is a card in your camera and it's fully inserted. It's a little bit embarrassing and annoying to fly to your shooting location to discover there is no card or an improperly inserted card in your camera. As a rule, I keep a number of cards with me. I change the card each time I change the battery, and I format it. This ensures that the card is working and ready to shoot. By changing the card, I also minimize my risk of losing an entire day's shooting should something go wrong.

COMPASS CALIBRATION DANCE

It's important to calibrate the digital compass on your drone. This makes sure that it properly records your location. This is vital, since this sets the "go home" point on your drone in case of emergency. It's also critical for telemetry to have the compass working correctly. Some people speculate that not calibrating your compass causes fly-aways. It's not necessary to calibrate for each flight in-between battery changes, but it is recommended that you calibrate your compass before flying after you've transported your drone to a different location. Because of the way a calibration is performed, it's affectionately called the calibration dance. There have even been calibration dance competitions! The purpose of the calibration dance is to rotate your compass 360 degrees vertically and horizontally and make sure you are in an area free of electrical or radio interference and away from large metal structures. Also make sure you are outdoors; you cannot calibrate indoors. Make sure there are no ferromagnetic items, such as car keys or mobile phones, in your pocket.

1. Enter calibration mode. Press the Calibrate button on the app, or switch the GPS switch back and forth five times rapidly on DJI copters. The indicator lights will turn solid amber to let you know you are successfully in calibration mode.

2. Hold the drone horizontal and rotate it 360 degrees clockwise. The indicator lights will turn a solid green color.

3. Tilt the drone so that it is nose down, battery toward you. Rotate 360 degrees until you see a steadily blinking green light. This means you have a successful calibration.

If you see orange and red lights, calibration failed. Repeat the steps. You may have to find a different area away from interference or obstacles that could be shielding you from satellites. If you see red blinking lights, you may need to perform a software compass calibration. In this case, go to the compass calibration option in your app, perform a full calibration, and then repeat the calibration dance.

3.2 Calibration dance

FPV APP

THERE ARE USUALLY TWO COMPONENTS TO A CAMERA DRONE. The first is the hardware: the drone and the controller. Some have built-in screens such as the smart controller or controller pro, but most are BYOD (bring your own device), and you plug in your phone or tablet. You'll see the app running on the screen. This is the software that enables you to see what the drone is seeing. This is called FPV (first-person view).

You will also see telemetry overlaid on the screen. This is important information, such as your height and airspeed. Some equipment shows interactive maps that help you know where you're flying. Another important piece of telemetry is your fuel gauge, a.k.a. your battery meter. It's vital that you keep your eye on this and come in to land at around 30 percent of battery level.

Different apps have additional information and menus for things like calibration and settings.

Because there are so many different types of drones and the mobile apps are updated so often, I'm not going to go into detail on any specific app. Check out the manufacturer's user manual, onboard tutorials, and website for information on their specific app. Learn the features and how they work. Also check out the videos at PhotoshopCAFE.com for specific tutorials.

CONTROL BASICS

Controllers

While there are many different kinds of controllers available, they all share the same basic controls. Typically, there will be two joysticks. Most controllers are configurable, so you can set them up to work in a way that suits you.

There are some aerial terms that you should know:

- **Yaw:** Rotate or spin
- **Roll:** Side-to-side movement
- **Pitch:** Forward or backward movement

The left stick (from now on, designated LS) controls altitude and yaw. The right stick (from now on, designated RS) controls movement in horizontal space: pitch and roll. Let's examine them now.

The first thing you need to do is ascend to your desired altitude by pushing the LS forward. The more you push, the faster the drone will move. It's usually a good idea to take it nice and slow when you first begin. Some drones have an auto takeoff. Before using this feature make sure the area is clear of obstacles such as trees and powerlines.

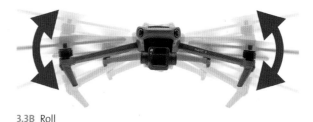

3.3B Roll

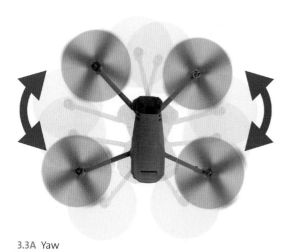

3.3A Yaw

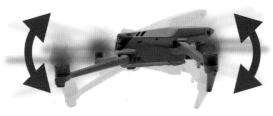

3.3C Pitch

Once you have reached a safe altitude, above people's heads and obstacles but not too high, you can practice moving your drone around. A good suggestion is focusing on the RS first. Use the LS to reach your desired altitude, and then take your hand off it and practice moving forward, backward, left, and right using the RS.

I suggest not yawing just yet. The reason for this is that your direction of movement is based on the nose of the aircraft and not on the position where you are standing. So if you have rotated 180 degrees, the controls will be opposite. Don't be alarmed, though, you will get used to this in time.

Here are some exercises to help you become a solid pilot. Once you're able to perform all these maneuvers with ease with the nose away from you, flip your copter around so that the nose is facing you and practice them again. If you can do all of these with precision both ways, then you are in good control of your aircraft and you're ready for anything. You won't master these in an afternoon. It takes months of practice to become truly proficient, so be patient and take it nice and slow. Even though many of these movements can be automated with different flight and shot modes, it's good idea to master manual flight controls. There are two good reasons for this suggestion. The first is safety. If something goes wrong, you should possess the skill to take over control at any time. The second reason is getting the perfect shot. There is only so much an automated shot can do. If you have the ability to read your subject and make the perfect movements at just the right time and find just the perfect angles, your shots will stand out from the rest.

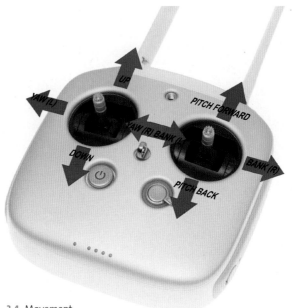

3.4 Movement

A DOZEN EXERCISE PATTERNS TO FLY LIKE A MASTER

THIS IS WHERE WE GET INTO THE GOOD STUFF. These are exercises designed to make you a ninja pilot, in full control of your craft and able to fly anywhere with confidence. Take these slowly, one at a time. Don't move ahead until you are comfortable with the current lesson. The skills build on each other. Find a large, flat open area to perform these exercises.

1. UP, HOVER, LAND

This one lets you get a feel for the joysticks and your aircraft. Make sure you are standing upwind; if a breeze blows over your drone, it will tumble away from you. Start up the motors. Climb slowly to a low height. Let the drone hover for a little bit. Change altitude a few times and then gently land. Congratulations on your first flight (**Figure 3.5**).

2. STRAIGHT LINE

Fly in a straight line away from you by pushing away on the RS. Hover in position, and fly back in as straight a line as you can by bringing the RS toward you. Land (**Figure 3.6**).

3. BOX PATTERN

Fly in a square pattern using just the right stick.

Fly away from yourself in a straight line, just like the previous exercise. Pause and hover. Push the RS to the left and fly a straight line parallel to yourself. Pause, fly back toward yourself in a straight line, and then push the RS to the right to complete a square shape (**Figure 3.7**). This will give you a good feel for moving around in different directions. If your drone starts to rotate little bit, compensate on the RS. Resist the urge to yaw just yet.

4. CIRCLE

Now you are going to get a feel for the RS in a more freeform way. Rather than a box, this time fly in a counterclockwise circle in front of you, using the RS. Take it nice and slow. If you get in trouble, let the stick go back to the neutral position and hover until you are ready to continue (**Figure 3.8**). This will really start to give you a feel for your drone, and it may take some practice to get a nice even circle. Try small circles and larger ones.

5. FIGURE 8

Now this one is going to be a bit of a challenge at first, but if you are this far, you are beginning to gain some basic skills. Fly away from yourself in a nice slow counterclockwise circle; when you have completed half a circle, change direction as if you are creating a letter S. When you have completed the S shape, continue in a full circle and then switch to perform a figure 8 shape (**Figure 3.9**). Keep practicing figure 8s until you are very comfortable and can make them both tight and loose and nice and even. You are developing some real skills now.

3.5 Up, Hover, Land

3.6 Straight Line

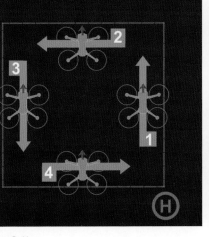

3.7 Box Pattern

3.8 Circle

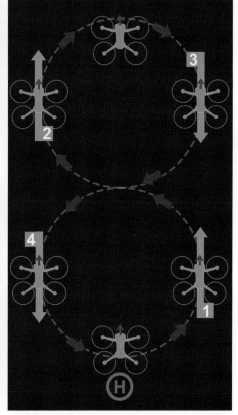

3.9 Figure 8

Time to Yaw

Once you are comfortable moving around and can do it easily, you can start experimenting with the yaw controls of the left joystick (LS). This is a little bit like learning how to play drums; it requires coordination. You first learn how to hit the drums with your sticks (RS), then you add the kick drum (LS).

You can fly your aircraft anywhere you like without yawing, but the yaw will be important for camera orientation. It's easy to stay oriented when looking through an FPV screen or goggles, especially if you have experience playing video games. When you are flying line of sight (which I suggest at this stage), try to imagine looking out the nose of the drone, and always steer from that perspective; it's muscle memory that will come in time.

Hover a few feet in front of you and practice moving the LS to the left and right. As you push it left, the drone will rotate (yaw) to the left (counterclockwise). Move the LS to the right and the drone will rotate to the right (clockwise). Spin it around until you are comfortable with controlling which direction your copter is turning.

6. NOSE FORWARD BOX

We are going to fly in a box again, just like in exercise 3. However, this time we are going to keep the nose (and the camera) forward at all times. Fly away like normal; now when you are hovering away from you, yaw the copter 90 degrees to the left. Fly in a straight line by moving the RS to the left. This is your first time flying in

a different orientation, so it may feel weird at first. Stop, hover, and rotate another 90 degrees until the nose is pointing toward you. Now you are facing the opposite direction and you need to push forward on your RS. You want the copter to go forward and the RS will always move the drone nose forward, no matter what direction the nose is pointing. This may come naturally to you, or it may seem impossible. Don't give up; keep your movements slow and small and you will get the hang of it with practice. Rotate 90 degrees again and move forward to complete your box (**Figure 3.10**).

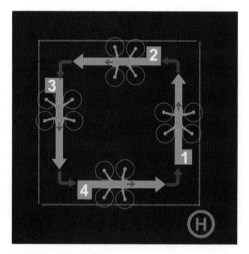

3.10 Nose Forward Box

7. NOSE FORWARD CIRCLE

Time to fly in a circle again. This time, we want to keep the nose pointing forward all the time. You will essentially be pushing forward on the RS for your forward movement and steering by going left and right with your LS. Fly a full counterclockwise circle (**Figure 3.11**). Try to keep a constant speed with the RS and gently hold the LS a bit to the left. Practice a few circles of different sizes at different speeds.

8. NOSE FORWARD FIGURE 8

This is similar to the previous exercise, but you are going to change direction with the LS halfway through and fly a figure 8 with the nose pointing forward continually (**Figure 3.12**). This is really going to build up your yaw skills on your LS. Congratulations for getting this far. You are getting the hang of things. Keep practicing until you are fluent with these exercises.

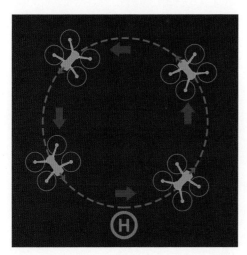

3.11 Nose Forward Circle

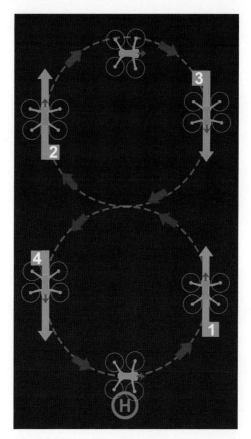

3.12 Nose Forward Figure 8

9. LAND IN THE CIRCLE

This is a great exercise for learning how to judge distance. This is not as easy as you think. You will realize it's really difficult to judge how far away your drone is and exactly where it is in relation to the ground. When it's up against the sky, there is no sense of scale and distance. Here is a fun exercise to help you better judge where your drone is in 3D space. Take a hula-hoop or a piece of rope and make a circle. Walk a distance from the circle, and then fly over to it with your copter and try to land in it. Take off and fly back. If you can, make several circles and see if you can land in each of them in turn (**Figure 3.13**).

3.13 Land in the Circle

Framing Exercise

One of the skills you are going to need is keeping your subjects framed (for still photography) or in the frame (while filming). It's pointless to make a nice smooth sweeping movement with your drone if you can't keep your subject in the shot.

10. ORBIT

This exercise is very much like the circle, with one difference. Place an object in the center of your desired circle. Now, practice flying around the object (orbiting) while keeping the camera pointed at the object at all times. You are going to control your speed and sideways movement with the RS by going left or right. Use the LS to steer. If you keep the subject in the center of the frame, you can fly around it in full circles (**Figure 3.14**). Try to make the movements as smooth as possible by making tiny corrections. The smoother the moves, the better your video will look.

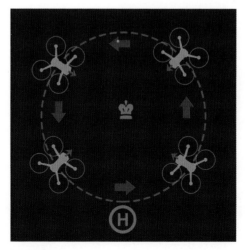

3.14 Orbit

11. MOVING TARGET

Now we are getting into some very advanced flying. Try orbits and flying with a moving target. Maybe use a friend's copter as the target or follow a slow-moving object (with permission) in a large open space. Don't try to learn this with a moving person, as you will hurt them if you crash into them. While following a moving target, make sure that you are quite far away from the object so that you don't collide with it. Remember that the goal here is to keep the subject in frame; it's not to see how close you can get (**Figure 3.15**).

12. RISE AND TILT

This exercise will apply only to drones that have a camera tilt option, which is most of them these days. The goal of this exercise is to lift the drone slowly while tilting the gimbal at the same time to keep the subject in the center of the frame. The goal is to have a smooth, even speed on the copter and a smooth, even speed on the gimbal tilt at the same time.

This isn't as easy as it may sound, and it requires a lot of practice to keep everything smooth enough that you see the subject in the center of the frame the entire time and don't notice the movements. This also requires a bit of coordination. I usually keep my palms firmly flat on the controller while barely nudging up on the LS with my thumb. I then place my ring finger or middle finger of the same hand on the gimbal control lever. At this point, it's a balancing act and an exercise of micro-movements. If you want to add to the challenge, try moving into or away from the subject at the same time with the RS. This exercise will help you to create a bond with your copter and really "feel" its movements (**Figure 3.16**).

3.15 Moving Target

3.16 Rise and Tilt

Master of Movement

Once you have completed all these exercises and you are really comfortable with them, you will have achieved master-of-movement status. Understand that going through this list and doing each exercise once or twice doesn't get you there. You need to do these as drills, over and over again until they become second nature. Once you have accomplished this, and you can fly smoothly without thinking, you are ready to tackle almost any shooting challenge with confidence. Remember to take it nice and slow; you don't need to fly fast—most shots will require slow and smooth flying.

ADVANCED FLIGHT MODES

So far we have been flying in standard flight modes, where the nose of the aircraft is always the front, no matter what direction that nose is facing. Now we are going to look at changing all of that. Some drones have advanced flight modes, which are designed to help you fly more easily and allow you to do different things. Don't even attempt these until you are comfortable with standard flight modes. Let's examine some of the different flight modes now.

GNSS (Global Navigation Satellite Systems) Assist

Sometimes just called GPS (Global Positioning System) mode, this is the mode you will use most often. In GPS mode, you are using satellites to assist in stability and positioning. This is why these little drones are so easy to fly. You start by getting a lock on multiple GPS satellites, operated by the U.S. Other Satellite positioning systems (GNSS constellations) used are Galileo (EU System), BeiDou (China), and GLONASS (Russia). Modern drones have evolved to take advantage of multiple systems at once.

You need to connect to at least four satellites to establish an accurate position.

GNSS satellites help with flying because they help you hover in place and fly while counteracting other forces, such as wind; they also reduce drift. If you let go of your controls, GNSS provides air braking. Without GNSS, you will get a "pool ball" effect, where you slowly come to a rest rather than stopping right away. The GNSS holds your drone nice and steady while you are shooting photos or filming video from a stationary position.

GNSS also establishes a home point. This is useful for return to home (RTH) failsafes. If the connection between the drone and your controller is broken, the aircraft will return to the home point automatically. This might be because your battery ran out, your equipment failed, or you tripped and sent your controller flying into the ocean. There is peace of mind knowing that there is an RTH option.

RTH is also tied to battery usage. Rather than just falling out of the sky when battery power gets low, many aircraft initiate emergency RTH or even assisted landing.

Tripod mode and Sport Mode

Some aircraft have tripod mode and sport mode (and may use other names too). These are essentially the opposite of each other. Tripod mode slows down the movement, reduces top speed, and lowers the sensitivity of the controllers. This enables the user to fly slow and steady. This is great for nice, smooth cinematic shots.

Sport mode unleashes the beast. This enables you to fly much faster than normal. This is great for filming the effects of fast motion and excitement. Another use is to use sport mode to quickly get to your shooting location, and then kick it back to normal or tripod mode for shooting once you are in position. Be aware that your obstacle avoidance and tracking sensors are usually disabled in sport mode, so be careful.

ATTI

Attitude mode, or ATTI mode, relies on the drone's built-in IMU (Inertial Measurement Unit) sensors rather than GNSS. The IMU uses accelerometers (which detect movement) and gyroscopes (which keep you upright). When flying indoors or in extremely sheltered outdoor locations, it's best to use ATTI mode because you can't get clear satellite signals, and picking up a rogue signal could actually cause erratic flight and crashes. Many drones are equipped with sensors, which detect the ground and obstacles, and also help with stability while flying in ATTI mode. If you are flying low over water, disable downward facing sensors, as they cause the aircraft to move with the swell of the water.

Some video shooters prefer to fly in ATTI mode because of the smoothness of the drifting, since GPS corrections can sometimes cause less fluid movements. Some people like to switch to ATTI mode for fast flying when just having fun. Without the satellite braking, it is possible to reach faster speeds in ATTI mode.

These next two flight control modes were common on earlier drones, but are becoming less common on newer systems.

Course Lock

Course Lock is an interesting feature. It treats the direction of travel as a straight line, regardless of the nose orientation. You set the home point and initial direction. As you fly forward, the drone maintains that line as the forward direction. If you rotate your drone, the forward direction is still the straight line. As long as your RS is pointing forward, the drone will continue on that line, no matter what direction the nose is pointed. This is ideal for flyby shots. You fly in a straight line parallel to your target. As you fly by the target, you can yaw and keep the camera pointed at the subject the entire time without arcing around (**Figure 3.17**).

Home Lock

In Home Lock, when you pull the RS toward you, your drone will fly toward you, no matter what direction it's traveling. Push the RS away and it will fly away from you. Home Lock is great because you can yaw the camera around as the drone is flying back toward you, and it has the effect of looking out the window of a moving aircraft. It also has the added advantage of bringing your drone back to you in the event that you don't know where it is. Just pull the stick toward you and wait for the sweet sound of spinning props as your lost child returns home (**Figure 3.18**).

3.17

3.18

SELF-FLYING, ROBOTIC FLYING

MANY OF THE NEWER DRONES have functions that allow you to program them to fly themselves. What makes these really useful is smoothness and consistency of motion. When you program your drone to fly a predetermined course and speed, the speed will be more consistent than a human pilot could manage; humans make quick corrections midcourse, which show up on the video, especially if the video is sped up. I'll list the popular program modes right now, but there will be more coming out all the time.

Almost all of the latest drones including the Mini 3 have forward-facing sensors. Many also have downward facing sensors. Upward and rear sensors are also ubiquitous. The addition of lateral sensors (sides) provides for 360 degrees of sensors. These sensing arrays are becoming very sophisticated and provide functionality beyond obstacle avoidance. These sensors help them avoid crashing into objects, and it enables them to stop or fly over or around objects they see in their flight path.

This makes autonomous flight much safer. The sensors are also used for object tracking. This enables the aircraft to detect and follow a moving object and film it. Action sports fans will find this functionality valuable. The newer object tracking is good enough to predict where an object is heading, even if it is obstructed by a tree or other object.

These sensors are getting very good. Paired with AI, they are used for operations such as Smart Return to Home on the Mavic 3. Smart RTH analyzes the environment (builds a real-time 3D point cloud) and plots the best course to return to home in the most efficient and safest way, even if it's different than the course you initially flew.

Sensors coupled with smart programming allow for all kinds of autonomous flight modes, and I'll list the popular ones. Bear in mind, different brands will use different names for these smart modes.

POI/Orbit

This is the same as the orbit exercise that we practiced in the previous section. You find a point of interest and then set the distance from POI and height. Then you tell the drone what speed to fly in a circle, either clockwise or counterclockwise, with the camera continually pointing at the target. You can often change direction, speed, distance from subject, and altitude by moving the control sticks

Dronie/Selfie

The camera is pointed at you while the drone flies away, keeping you in the center of the frame. This is a great reveal shot, starting on the person and then going out wide to reveal the location. Also try the reverse, where the camera flies toward the person.

Cable Cam/Waypoints

You fly a predetermined path and record each of the points along the way. You can then play this back and the drone will follow this path by itself.

Follow Me/Tracking

As the name implies, the drone and camera will follow the operator or some other moving object. This is useful for sports or chase cam shots. In this mode, on the screen, you draw a rectangle over the object you want to track. You will see a box around the object. When you press go, the drone will follow the object until you cancel or it loses tracking. Here is a tip for better tracking: When you draw the box around the object (painting the target), fly around the object a little bit and let the sensors and AI have a look at the sides before starting. This will make it easier for the tracking to recognize the subject if it turns.

Novelty Modes

There are a number of other modes available, called quickshots by DJI, that I'll group into what we will call novelty modes. This doesn't imply these aren't useful modes, because they are, it just leaves room for lots of new ones. Some of these modes include rocket (the drone flies up with the camera facing down and locked into a target); Helix (the drone orbits with a circle of increasing size); and Asteroid (the drone flies up and away, shoots a panorama, and turns it into a tiny planet).

Autonomous flying is also useful for shooting automatic panoramas. The camera will tilt, and the drone will yaw to automatically capture all kinds of panoramas including a full 360. These are great because they make it very easy to quickly shoot panoramas and they have the ability to separately save out the images. While I'll often use this mode, I usually shoot manual panoramas when I want to make my high-end work. The reason for manual shooting is more control of the area captured, as well as the ability to shoot bracketed. At the time of this writing, autonomous bracketed HDR panorama shooting isn't widely supported. This doesn't mean it won't be soon, because it's just a matter of someone programming this functionality.

TOAL: TAKEOFF AND LANDING

IN ORDER TO GET YOUR DRONE INTO THE AIR, you have to take off; to retrieve it, you have to land it. There are three ways of doing this.

Auto Takeoff and Land

Many controllers and drones allow you to initiate a self-takeoff, where the drone will rise to a predetermined altitude, and hover, waiting for your instructions. They also have an auto land, where you bring the drone to a landing spot and it will land itself and shut off the motors. This is a great method for beginners because it does it all for you and minimizes the risk of a tip-over.

Manual Takeoff and Land

Here, you arm the motors (spin them up) and then press forward on the LS to take off. Upon landing, you will slowly descend using the LS (make sure the landing gear is lowered on the Inspire 1). You will notice a little ground effect when you are low enough that the wind from the props bounces off the ground and tries to push the drone upward. Gently bring it in for a landing and shut the motors off. On the DJI Phantom, hold the LS down until the props stop spinning. This method will avoid a tip-over, which can happen when you pull both sticks into the middle-bottom position because the drone will rev up a little before shutting off.

3.19 Manual takeoff and landing, large flat clean space

Handheld Launch/Catch Landing

Disclaimer: This is an advanced move and not recommended for beginners. Extreme caution must be taken when doing this, because it is dangerous. Do this at your own risk. In situations where it's not possible to find a flat takeoff and landing spot—such as on slippery rocks, up mountains, on sand, on moving boats, and so on—a handheld launch/landing is possible.

This is a method I frequently use while flying at beaches and flying off boats. I do this for small drones only; do not attempt this with an Inspire. Hold the drone firmly on the sides, with your hands well clear of the propellors, or by the side of the skid on Phantoms and above your head. With your hand well clear of the propellers, spin up the motors. Move your hand upward while holding the drone. When you feel it pulling up from your hand, open your grip and it will fly. I do far fewer handheld launches than I do landings, because launches are more difficult—also, it's easier to find large enough areas to launch, which is not always the case for landings. I often launch from the top of my closed GPC hardshell case, which makes a great launch platform. If you have someone with you, have them hold the drone far above their head, and launch that way.

The handheld landing is quite easy to do compared to the launch. Make sure you are well clear of other people, and then come in and hover a few feet in front of you, just above eye level. When the drone is completely stationary, keeping your left hand on the controller and the LS, crouch down a little bit, extend your right arm fully, and slowly step in to securely grab the sides near the bottom or the skid by the side on a phantom drone, being very careful to stay well clear of the props. When you have a firm grip, pull down on the LS and wait until the props have stopped spinning before bringing the drone closer to you. With the

Mavic drones, simply flip the drone over and the motors should stop. After some practice, this maneuver gets quite easy, but don't become overconfident and rush it. I have only ever done this with the DJI Phantom and Mavic drones, so I can't attest to the safety of this maneuver with other types of drones. I recommend practicing gripping the drone with the power off to get the feel of how to firmly grasp it. Turn the propellors by hand to see where they are and how much clearance you will have from your fingers. If there is any risk or doubt, don't attempt a handheld takeoff or landing.

One last thing: If it's windy and the drone is blowing around, DO NOT attempt to catch land or do a handheld takeoff. It's not worth the risk. No shot is worth risking your safety.

Which Landing Style?

I have seen people get into heated arguments over the proper way to take off and land. Should you land on the ground or catch land? It all depends. If you are in a nice open flat area with concrete, there is no reason you shouldn't do a manual launch and landing. If you are concerned about getting sand in the motors, then catch land. If you are in an area where there is no choice other than to catch land, such as on the rocks at the beach, then do a handheld landing (experienced fliers only). There is no right or wrong method. Just don't try to show off; that's how people get hurt.

At this point you have finished flight school. This doesn't mean you have finished learning and improving, but you have some good flying skills under your belt. Now that you can confidently control your drone, it's time to take to the skies and make some beautiful videos and photos.

3.20 A handheld landing, used in cases when you can't find a large, flat clean surface to land on

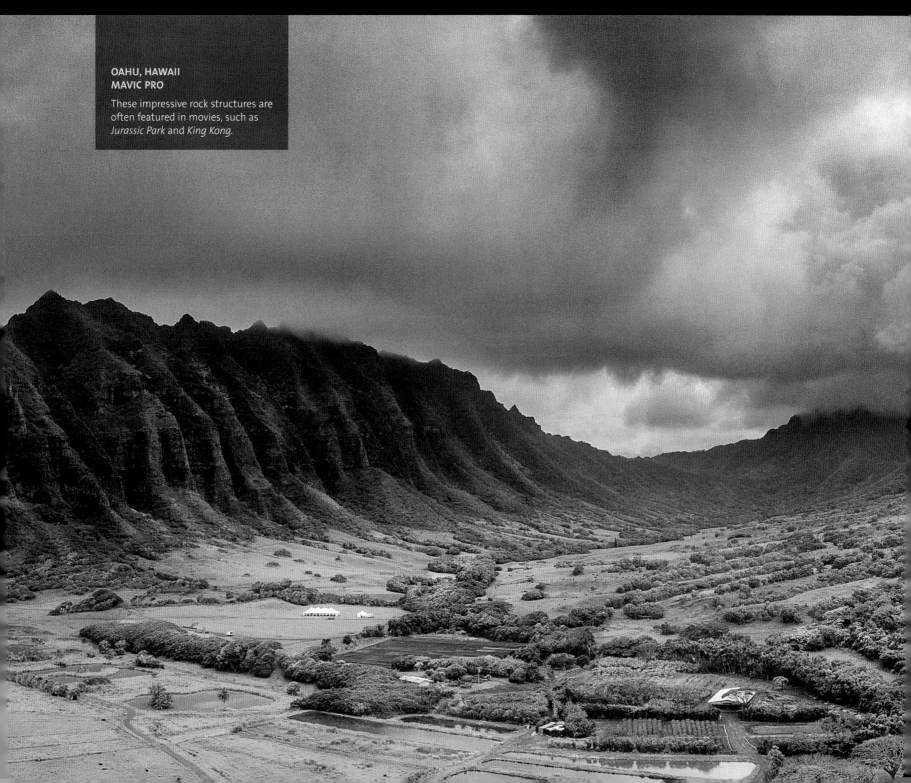

OAHU, HAWAII
MAVIC PRO

These impressive rock structures are often featured in movies, such as *Jurassic Park* and *King Kong*.

CHAPTER 4

SHOOTING PHOTOGRAPHS WITH A DRONE

DRONES HAVE BEEN CALLED FLYING TRIPODS and tripods in the sky. Essentially, you have a flying camera that's capable of hovering in place. With today's drone technology, this can be a very stable shooting platform. One of the things I have noticed about aerial drone photography is that people initially fly as high as they legally can to take a photo. There is nothing wrong with that, and it's really thrilling the first few times you do it. When you look through your FPV and see your copter take off for the first time, it's an incredible feeling. You are vicariously soaring the skies through your flying machine!

Let me tell you a story about my aerial composition style. One of the things that I noticed fairly early on is that shooting at 400 feet all the time is akin to over-processed HDR. It's exciting the first few times, but once the novelty has worn off you start to realize just how bad some of the photos really are. I soon had an epiphany: The rules that apply to regular photography also apply to aerial photography. I wouldn't shoot with my "terrestrial" camera (Mirrorless/DSLR) in bad light, so why am I shooting with my drone in bad light?

Some of the rules that apply to photography have existed for many years, while others are more recent due to changing technologies. When you are flying your drone, you are really just positioning your camera. Instead of the two dimensions that you are used to, forward and backward, you now have a third dimension available: up. You may have learned that standing on a ladder or lying down will change your perspective and add interest to your photo. Imagine what you can do at 100 or 400 feet. Using altitude isn't the only advantage of drone photography. To me, the biggest advantage is being able to position your camera almost anywhere, such as over treacherous rocks, just over a cliff or other places that would traditionally be inaccessible. Although this chapter is focused on photography (pun not intended), the composition rules, for a large part, also apply to framing your videos shots.

You will find that many of the rules of photography, when applied, will make your aerial images look a lot better. Some of these rules need to be modified, and others broken. In some rare cases, the rules haven't been written yet. This is our opportunity to define this new frontier. In the following pages I am going to take the liberty of coining a few phrases. This is a way to label some of these newer things and help us all understand and grow together.

FOUNDATIONAL RULES OF PHOTOGRAPHY

I KNOW THAT MANY PEOPLE WHO FLY DRONES don't have a photographic background. I'm going to mention a few of the traditional rules of photography and then discuss how they can be applied to aerial photography.

Rule of Thirds for Composition

When you place the subject in the center of a frame, there is no tension or implied movement and it tends to be a very boring, static image. The exception is when you are purposely shooting for symmetry, as in **Figure 4.1**.

You can add a lot to a photo by using the rule of thirds. Take the image and divide it up into nine squares by using a grid that divides the image into thirds both horizontally and vertically. This method has been around since before photography and is used by painters on canvas. Place the object of interest on one of the overlapping thirds of your image and it looks more pleasing. This is especially strong with your subject pointing toward the center of the photo, as it leads the viewer's eye into the photo and causes them to be interested in the image for a longer period of time.

4.1

4.2 The rule of thirds grid

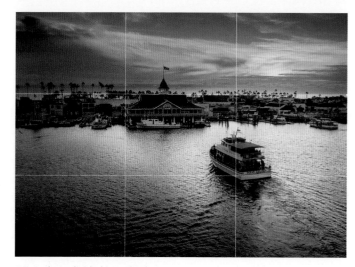

4.3 A photo divided into thirds

HOW IT APPLIES TO AERIAL IMAGING

You will notice that many of the aerial apps will allow you to display a rule of thirds grid to assist in composition. I find the grid lines useful for many things, such as making sure horizons are level. Use the rule of thirds to frame the sky, the ocean, or other elements into thirds. Try to avoid horizons in the center of the image; try to place them in the top third. If the sky is the interesting part of the image, then place the sky in the top two-thirds of the image.

Most current aerial cameras are only capable of shooting horizontally, although some, such as the original Mavic Pro have the ability to rotate the sensor into a portrait orientation. I suspect with all the vertical video and photos on social media, we will see more of this ability in upcoming cameras. If you desire a portrait orientation, and you don't have a camera capable of shooting vertical, there are only two ways to create it. The first is cropping the photo in post-processing software.

The other method is to create a panorama by stitching multiple images together to produce a different orientation.

4.4 The sky is framed in the top two thirds of the image

4.5 A vertically cropped photo

4.6 Vertical panorama

Change Your Viewpoint,
Change the Photo

A lot of people notice something interesting and stop to shoot it. They stay in the place they originally see it and get a good photo. To get a great photo, explore different angles. Move around the subject and explore its many different facets. Notice that its relationship to the background changes as you move around. Notice its angle changes, as does the lighting and the contrast. Don't be lazy; put in the extra effort and you will get a much better composition. Sometimes the original angle is perfect, but more often than not, you can discover a better shooting position.

HOW IT APPLIES TO AERIAL IMAGING

This rule applies more to aerial imaging than anything. You have the ability to explore most subjects from 360 degrees horizontally and 180 degrees vertically. When shooting an aerial photo, look first for the most interesting angle and best lighting by flying around the subject. Then choose the best altitude. For example, when shooting a nice sunset, you can choose the altitude that best shows off the silhouettes. You can add contrast by paying attention to the background—change its relationship with the subject by flying higher, lower, or closer.

4.7 See how the buildings interact with the mountain and the sky at different altitudes

Reflections on water or glass can be planned by flying at the perfect location. Reflections bounce off water and glass at the opposite angle from where they strike the reflective surface. This is the law of reflection (**Figure 4.8**). The incident ray (I) of light strikes a reflective surface and a reflection occurs. Imagine a perpendicular line from the surface. This is the normal (N) angle of the reflection (R), and it will match the angle of the incident (I) ray. Just like shooting billiards and bouncing a ball off the cushion. This is the perfect position to catch (or avoid) a reflection.

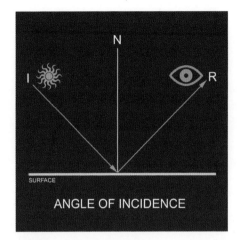

4.8 The law of reflection

4.9 You will notice that I fly low for most of my sunsets. This enables me to get the maximum reflected light from the sun.

Try Flying Lower

Put a person on a drone and they will fly as high as they can; put that same person in a helicopter and they will fly as low as they can.

It's tempting to fly right up to the 400-foot ceiling and photograph from there. There are times when this is the best option. However, when looking at my flight logs, I spend the majority of my time flying below 100 feet, and I rarely go above 150 feet. A lot of the good stuff is down low. There are times when I fly over the water, just a few feet off the surface, and get some fantastic angles. I certainly don't recommend that for an inexperienced pilot, though, since water and drones don't mix.

4.10 Low shot

4.11 Low shot

Fill the Frame with the Subject

Filling the frame with the subject reduces visual clutter and makes it very clear what the subject of the photograph is. Typically, photographers choose a longer lens, zoom in, or move closer to the subject. Cropping is also an option. When you're using prime lenses (fixed focal length; that is, no zoom), the old adage goes "You zoom with your feet."

By coming in close to your subject, it changes the mood. Rather than observing from a distance, the viewer becomes involved with the subject. It's much more intimate and evokes more emotion. Now, remember that this is for a particular type of shot; a sweeping panorama has a different intent, and that is to awe you with expanse. If a panorama is a shout through a megaphone, a closeup is a whisper.

HOW IT APPLIES TO AERIAL IMAGING

Most consumer drones have a wide fixed lens and zooming or using a longer lens often isn't an option. In this case, try flying lower and closer to the subject. If at all possible, stand as close to the subject as you can while flying. The reason for this is that your depth and distance perception (binocular vision) is better when you are up close (you pretty much have no 3D depth perception after about 30 feet). It's OK to use FPV to frame your shot, but if you are getting close to a subject, also have a spotter. A spotter is a person who keeps their eyes fixed on your drone at all times. Remember to be safe and careful when flying close to people. Don't fly too close; no shot is worth injuring someone.

If you are flying a drone that allows you to change lenses, try a longer lens. I have the Zenmuse X5 camera on the Inspire 1 and I use it for shooting things like motor sports. Adding a 45mm lens with a crop sensor is the equivalent of a 90mm lens, and you can get right into the action while staying at a safe distance.

A big challenge of shooting with a longer lens is locating your subject on your FPV. Have you ever used a telescope or binoculars? You see something in the sky and then try to locate it through a magnifying lens—not that easy. I usually fly a little higher or farther away and locate the subject. Then I keep it centered in my screen as I fly into the shooting position. I also recalibrate the gimbal whenever I change lenses. This helps keep things balanced and allows for more stable shooting of photographs and video.

Some drones, such as the Mavic 2 zoom or Mavic 3 allow you to zoom in. In this case, use the optical zoom. Try to avoid using digital zoom because of image quality degradation. Digital Zoom is basically just enlarging digitally and cropping in the sensor, versus optical zoom, which is using the physical lens to zoom. There will come a day when this rule is obsolete because AI powered computational photography is getting better and better.

Another thing to bear in mind is background compression because of your distance to the subject. With a long lens, the background appears more compressed, shows more of the background in the frame, and it looks closer to the subject because you are farther away than if using a wide lens. Use this to your advantage.

4.12 Close shot

4.13 45mm

69

Foreground Elements and Interest

When shooting a photograph, you can add a lot of interest and really make it dynamic by including an interesting foreground element. It's a good idea to walk around and find something to place in the foreground to add interest to the photo. This also adds a sense of depth and dimension to the image. Without this foreground element, a distant photo really lacks a point of focus and can appear flat. Usually a viewer will be drawn in by the foreground object and then notice the features in the distance.

Make sure that the foreground element adds interest to the photo rather than clutter. Look for something that adds context or even contrast to the image. A foreground element can give a sense of location or bring in a bit more of the story.

HOW IT APPLIES TO AERIAL IMAGING

When you are flying, most of what you shoot is going to be in the distance due to the nature of small cameras with wide-angle lenses. Because you have the ability to move around almost anywhere you like, it's pretty easy to reposition a shot and capture some interesting foreground elements. When I'm shooting a sunset over the ocean, I'm always looking for water breaking over a rock or something that will place a feature in the lower part of the photograph.

After shooting thousands of these images, I have realized that the ones with a foreground element have much stronger compositions. If you can't find any features in front of you, try flying back a bit and include a tree or the shore. There is always something for you to include if you look around. Also consider flying lower if you are having trouble with this.

4.14 Example of a photo with foreground

It's easy to see what you are going to shoot in the distance—a mountain, a sunset, the ocean, etc. Try concentrating on how you are going to relate it to the foreground. In aerial imaging, we have a huge advantage over "terrestrial photographers." For example, in regular photography, with careful planning or with luck you can have the sun at the right time of day in a particular location. In aerial photography, you can manipulate this by changing altitude and position. With aerial images, you can have the sun bursting through any object you like.

4.15 The sun running across tiny islands

Leading Lines

Leading lines are objects that naturally draw the viewer's eye into a photograph. They can occur in nature, or they can be manmade. These leading lines are powerful, and they attract the eye and draw it toward the main subject of the photo. Examples are roads, railway lines, rivers, power lines, paths, cracks in rocks, ploughed fields, coastlines, buildings, and trees.

Look for leading lines when making your composition and your photograph will become much more dynamic. Straight leading lines are powerful and fast. Curved leading lines softly lead the eye in a more relaxed and rhythmic pace.

HOW THEY APPLY TO AERIAL IMAGING

In aerial photography, you have the opportunity to see leading lines that aren't visible from the ground. Once you find them, you can move freely and use these lines to your advantage. You also have the opportunity to use leading lines to look down trees, masts, chimneys, and other shapes that are impossible to use from the ground.

4.16 Example of leading lines

4.17 Example of leading lines

4.18 Example of leading lines

Control the Background

When shooting, pay special attention to the background. Eliminate distractions, such as trees that appear to grow out of people's heads. More importantly, look for a non-distracting background that isn't too busy. Change angles so that lines don't intersect and so there is good contrast. If your foreground is a lighter color, look for a darker background to create contrast and make your subject pop. Traditional photography uses depth of field to further separate a subject from a background; shoot with a shallow depth of field to blur the background.

HOW IT APPLIES TO AERIAL IMAGING

In drone photography, using depth of field to blur a background isn't usually an option. You can get a little bit of background blur with some systems. However, in most cases this is minimal because you have to be really close to a subject, or use a powerful zoom to pull this off. Look for alternatives to create background separation. Use fog, mist, and even backlighting to create some separation and depth in a photograph.

So background separation seems to be a bit of a weakness for drones? I would say no. We have an advantage over regular cameras; it just requires a different way of thinking. "Terrestrial photographers" (a phrase I coined to describe ground-based photographers; makes sense, right?) can change positions to create the right balance of foreground to background. They may even be able to change the midground into background by moving. However, they really can't manipulate altitude as a composition tool. Sure, they can climb a tree, mountain, or rooftop, if there is one available. Maybe they can shoot out the window of a hotel. Think about this: You have the ability to get the viewpoint out of every single window in this hotel, and when you run out of hotel, no problem—just keep flying!

One of the greatest strengths of using an aerial shooting platform is altitude. Use it; don't let it go to waste. For example, when shooting a cove, move to the height that best shows the curvature of the cove. Let hills intersect distant hills to create contrast and drama. If you see a tree line, let the trees rise above the hills or set them against a distant area of contrasting tone.

One of the key things I do is purposely find the best altitude. It's no accident when a row of palm trees appears just above or below a horizon. Always think about that when you compose a photo. Think about how foreground and midground elements interact with the background. If it's not clean, don't settle for the shot. Try a different height or a different angle. It's so easy to move your drone around that there really is no excuse for weak composition.

4.19 Laguna Crescent Beach

4.20 Example of palm trees appearing just above the horizon

Take this example of the birds on a rock. The first shot has a decent angle and catches the light nicely, but the silhouette of the birds doesn't really pop. Try flying a little bit lower. Now you can see the edge of the rock and the birds against the sun. Also notice at this lower height we don't see so much of the empty ocean behind the rocks leading to the sunset. Instead, we see more of the foreground water, leading us into the rocks. Often, people fly too high and miss the best composition.

4.21 Making a weak composition...

4.22 ...stronger by changing height

Shoot During Good Light

Choosing the correct time of the day for shooting is vital. All photography is about the art of capturing light. When we are shooting outdoors, the sun is our light source. On a clear day in the middle of the afternoon, the light is very harsh and the shadows are direct. This causes shapes to lose their definition because there is a lack of angled shadows to give them shape. There is also a lot of glare at this time of day. Many outdoor photographers avoid this kind of light because it's not flattering. On the other hand, if there is cloud cover, the clouds diffuse the light by scattering the light rays in all directions. This is nature's soft box. It makes a very soft light and almost eliminates shadows. When it comes to capturing details and natural color, a diffused, overcast day can provide good light for shooting.

HOW IT APPLIES TO AERIAL IMAGING

This is a great time of day for aerial mapping and shooting straight down to capture clear shots that show the detail of a landmark.

Golden Hour

Another type of light, and my favorite for shooting aerial photography, is at sunrise and sunset. These times are called the magic hour or the golden hour. The sun is low in the sky and the light is traveling though particulates or pollution. This causes the golden color that we associate with these times of day. The shadows are also longer, which can be very interesting, especially when shooting from above. The golden hour lasts for about an hour before sundown and an hour after sunrise.

HOW IT APPLIES TO AERIAL IMAGING

I shoot sunsets almost every day. I live quite close to the Southern California coast, so I look out the window a couple of hours before sunset. If I see the right kind of sky—not too clear but not too cloudy, and no wind—I usually grab my gear and head to the coast. If it's too cloudy, such as a solid sheet of gray, then the sun won't break through. On the other hand, if there are no clouds, the sky can be a bit boring. However, there can sometimes be a good marine layer over the ocean, which makes for a great sunset photo. Without clouds, you won't get that amazing afterglow that lights up the sky in an amazing way after the sun dips below the horizon. I'm amazed at the number of photographers that pack up and leave as soon as the sun dips, missing that incredible twilight afterglow.

4.23 The sun setting over Catalina Island in the distance

The big challenge in shooting a sunset is the amount of contrast in the scene. The dynamic range is getting better on most drones, but still not enough to capture the sun in the sky without blowing it out, and not enough to capture enough detail to illuminate the foreground. This is why I often shoot HDR in these situations (check out the section on HDR later in this chapter).

We have just discussed some of the compositional rules of photography and how they apply to aerial photography with drones. If you apply these rules, you will find a marked improvement in your aerial images. Once you know these rules, they can and should be broken. Don't always break them, and don't break them just for the sake of it. You will naturally find opportunities to do something you normally wouldn't. For example, I have been taught to shoot away from the light, with it behind me, so that it illuminates the subject. I break this often because I want to include the sun in my sunsets. If the sun isn't setting, I almost never shoot into the light. So I use sunsets as my exception to the rule. Learn the rules first. Only break the rules when you have a valid reason. Don't be mechanical; stretch the rules often. But learn them first and break them boldly; otherwise, your image will look like a mistake.

4.24 Example of sunset

4.25
Example
of sunset

4.26
Example
of sunset

4.27 Example of sunrise

4.28 Example of sunrise

4.29 Example of sunrise

SPECIAL TYPES OF PHOTOGRAPHY

NOW THAT YOU KNOW HOW TO SHOOT A PHOTOGRAPH, let's look at how to create an image that comprises more than one image. We are still creating a single image, but we might need to shoot multiple frames that we will use to build this image. It's more work, but with practice the results can be stunning and worth the effort.

Panoramas

One of the most stunning landscape shots you can get from a drone is a panorama. A panorama is a series of photographs that are assembled, or "stitched" together, to create a larger photo. The main reason most people shoot panoramas is to capture an entire vista that won't fit in the lens in a single shot. An additional benefit to panoramas is a larger image with more details, which can be printed at large sizes. Some drones have the ability to shoot panoramas automatically and quite often that works just fine. At other times you may want more control over the composition of your panorama, or you wish to shoot bracketed panoramas, which isn't a common option currently for an automatic shot.

4.30 Panorama

4.31 Panorama

4.32 Panorama

4.33 Panorama

Traditionally, the rule for shooting panoramas is to rotate the camera on the point of no parallax, which is called the nodal point. Try holding an object or your finger close to your face and close one eye. Now switch eyes and see how far the background moves in comparison to the object. This is known as parallax and is a key element in our depth perception. Now try holding the object farther away from your face and repeat the eye exercise. Notice that the shift is less marked. Parallax is reduced with distance and almost disappears at about 30 feet. Because you are generally shooting panoramas from a greater distance than a traditional tripod on the ground, parallax is no longer the main issue.

Another traditional rule of panoramas is a 30 percent overlap. For several reasons—wider lenses, more of a fisheye effect on some lenses, drifting position while rotating the drone, and so on—I shoot for more of an overlap. I personally shoot a 50 percent overlap with smaller cameras such as the Phantoms. Overkill? Maybe, but at least I have options, and I find I get a lot less doubling and weird stitches with this method. I also have less stretching of objects in the image. The Phantom 4 has a 94-degree field of view (84 on the Mavic 3), which changes the angle of view between images very quickly while rotating.

When shooting with a longer lens, such as the Zenmuse X5 on the Inspire 1 Pro or the Mavic zoom, the excessive overlap isn't needed.

To capture this kind of shot, I figure out what I call my "shooting rectangle." Corner to corner, how wide an area do I want to capture and how tall? A key part is the distance I choose to shoot from. At 2,000 feet from my subject, I might get the shot in three images; at a lesser distance, it might take six shots to achieve the same width. These images are not the same. The closer shot will have more distortion and bending, whereas the shot from farther away will appear more natural, but with less detail. This is something you will learn with practice.

It's very important when shooting a panorama to make sure that your camera is level with the horizon. If the camera is tilted, you can get a wavy horizon or weird stair-stepping in the panoramic merge, or it could fail altogether. If you are having issues with leveling the camera, try putting your drone on a perfectly level surface that's free from magnetic interference, and run a gimbal calibration. You can also offset the camera tilt in the DJI Fly app or whatever software you are using. If the tilting is caused by a camera balance issue, taping a coin to one side of the camera is a hack that can work.

4.34 Overlay diagram

Bracketing:
HDR, Capturing the Full Range

How often have you looked at a beautiful scene and photographed it, but then been disappointed later when you saw the photograph? Instead of the beautiful sunset, there is a solid white blob, and the light dancing off the sand is just a dark expanse. This is because of a limitation called dynamic range. The human eye can see a wide dynamic range and is able to adjust very quickly. This is why we see an astonishing amount of detail even in very bright light while also seeing a lot of detail in the shadows.

The sensor on a camera isn't capable of capturing the same amount of information. In a high-contrast situation, such as sunset or nighttime, when you expose for the highlights all the darker areas turn solid black. If you expose for those shadows, all the highlights turn pure white with no detail. This situation shows the limits of the dynamic range of the camera. Because it's so early in aerial camera development, many cameras have less dynamic range than their larger siblings, but it's getting better very quickly. Camera quality has increased substantially in the time since the first edition of this book was written. Shooting in RAW definitely helps capture more dynamic range—certainly enough for an overcast day. However, when it comes to capturing a bright sky and dark ground, even the most sophisticated cameras struggle to have enough dynamic range.

The solution is HDR, or high dynamic range. This is accomplished by shooting multiple photographs at different exposures to capture the entire visible spectrum of light. These photos are then combined into an HDR image that contains all the details in both shadow and highlight. Some cameras do auto HDR, but I avoid these because I prefer to have more control. This doesn't mean you can't use these modes, and I'm sure they will improve after the time of this writing; I may use them myself in the future.

My preferred method is to shoot multiple photos at different exposures and then use Lightroom or Photoshop to make the HDR images later, in post. The steps for merging them are included in chapter 7. For now, I'm going to tell you how to shoot these images.

In a perfect world, I would shoot from three to five images that are +/– 2 stops apart (**Figure 4.35**). Let me explain. In photographic terms, an f-stop is how we measure exposure, or more correctly EV (exposure value). Say you shoot an image and want to overexpose it by one stop, or one EV. This means that you double the amount of light that hits the sensor. If you want to underexpose by one stop, or one EV, you halve the amount of light that hits the sensor. You can control how much light hits the sensor in four ways:

- **Change the ISO.** This is the sensor sensitivity.
- **Change the shutter speed.** This is how long the light strikes the sensor to make an image.
- **Change the aperture.** This is how much light can enter the camera at once (the size of the opening of the lens). Many aerial cameras don't have an adjustable aperture.
- **Add an ND (neutral density) filter**, which uses tinted glass to reduce the amount of light that comes into the lens.

Generally speaking, for HDR the best way to vary exposure is by changing the shutter speed. Most cameras have AEB (auto exposure bracketing) so that you don't have to physically change the shutter speed between photographs. At the time of this writing, all the DJI cameras, through the DJI Go app, are capable of shooting AEB. It's under the camera settings (**Figure 4.36**).

The DJI Go app doesn't allow you to change the amount of the bracket; it's set to approximately .7 stops (I have seen it vary from .66 to .7). Because of the small amount of variance, it's best to shoot five images. This will capture a wider dynamic range. In the future, if they allow you to change the bracket amount, set it to two stops +/- and just shoot three exposures.

When AEB is selected, shoot your images like you normally would. You'll hear the camera shoot multiple images. You don't need to do this for all photos, just when there is a lot of contrast, such as a bright sky against a shaded landscape.

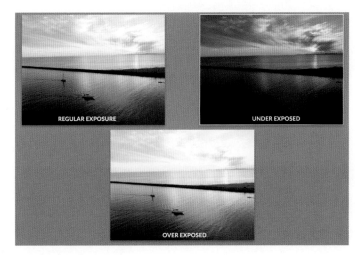

4.35 Bracketed exposures

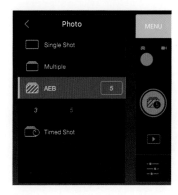

4.36

4.37A Example of an HDR image

4.37B Example of an HDR image

Panoramic HDR

One of the things I'm asked about daily on social media is how I make my HDR panoramas. One image I posted recently was comprised of 115 images. Why 115 images? And how do I shoot that? Because of my background in visual effects, HDR panoramas aren't new to me. I was shooting these kinds of images years ago on a panoramic head with my DSLR and building 360-degree HDR spherical environments that could be mapped to the inside of spheres in Maya. The technical side is much easier with drones, but the execution is more difficult because the precision isn't the same—it's the difference between a nodal-calibrated tripod on the ground with rotation clicks and a satellite-stabilized drone in the sky.

As I have already described, I shoot bracketed photographs so that I can capture more detail simultaneously in the highlights and shadows. This is particularly true with sunsets and sunrises, as visual contrast is much higher at these times. Because of the current limitation on the DJI bracketing options, I often shoot five images for each frame to capture more detail in the sky and ground. If we divide 115 by 5, it comes to 23 frames to make the panorama. I actually attempted to do three levels of eight photographs in this case, but one of them didn't come out right. In many cases it doesn't matter if one or two don't work if you have enough overlap. The goal is to completely cover the area that you want to capture. This really isn't new. When Photoshop came out with auto align, we used to "spray" photos and stitch them together to see what would happen. The truth is that you don't have to have an even number of photos in each stack in order for Photoshop to stitch them together. An even number will get you a better crop though, without losing so much of the image.

TO CAPTURE THIS KIND OF SHOT

1. Set your camera to AEB (five exposures on the current DJI Fly app).
2. Determine your shooting rectangle, corner to corner.
3. Rotate your copter to determine your shooting radius.
4. Tilt the camera to an upward position and rotate to make sure everything is in frame.
5. Tilt the camera to the lowest point and rotate to make sure everything is in frame.
6. Starting with the top row, shoot your brackets right to left (for sunsets on the West Coast; for sunrises, I go the opposite way). I shoot this way because the sun is much brighter and throws off the exposure settings. So I shoot the sun as the last image and sometimes use Exposure Lock for this frame (not always; only if it's radically different than the rest of the shots).
7. Tilt the camera down and shoot the middle row.
8. Tilt the camera down and shoot the bottom row.

TIPS

- *Wait a few seconds for the drone to stabilize between shots, or you could get blurring due to motion caused by rotating the aircraft.*
- *Shoot in an S-shaped pattern, like mowing the lawn.*
- *Use the grid overlay on the app to align the shots and plan your camera tilts.*
- *Use the fastest SD card you can get to minimize waiting time between shots.*

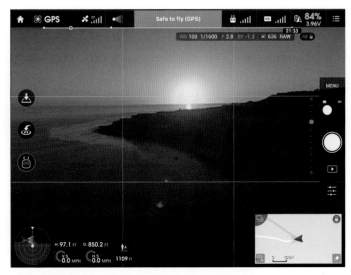

Don't be disappointed if your first few attempts don't work. It takes a lot of practice to nail these HDR panoramas, and you will get better over time. I also like to use Lightroom to at least visualize the shots. Lightroom can quickly assemble a preview so that you can tell if the image is going to work or not. Most of the time, I use Lightroom to assemble my HDR panoramas, because it's quick. Camera Raw in Photoshop works the exact same way. You can also do this in Photoshop or a dedicated program such as PT GUI for more control.

4.38 Grid overlay

4.39 Final HDR panorama

4.40 Final HDR panorama

4.42 Final HDR panorama

4.41 Final HDR panorama

4.43 Final HDR panorama

Burst of Shots to Get the Action

Another type of shot is the burst. This enables you to shoot multiple photographs in a very short succession. On the DJI Fly app, you are able to shoot three, five, or seven images in a burst. The camera fires the photos as quickly as it can and loads them up into a buffer. Then it processes the buffer before you can shoot again. The advantage of this is that it captures the precise moment of the action. If you are shooting an action scene, such as sports or something happening in nature, it can be very difficult to capture the exact moment something happens. If you use burst mode, you are bracketing time and you can choose the best photograph out of the group. It's also common to create a montage of the action over time; this is very common with skateboarders, and it won't take much hunting to find out how to do this online.

Bird's-Eye View

Of course there is always the bird's-eye view, also called the top-down view. This shot is distinctively aerial. It's looking straight down on a subject from above. There is no mistaking this classic, top-down photo. People are looking at things from a view that they've never seen before. This has become the classic drone shot. There really isn't a lot to be said about this shot except that you should look for unique views of shots that people have seen before. This will get their attention and stop them in their tracks. Also bear in mind, scouting a shot from the ground can be deceiving. Because something is interesting from the ground doesn't make it interesting from the air, and vice versa. Over time, you will start to develop a sense of what might look interesting from the air.

4.44 Example of a bird's-eye view shot

4.45 Example of a bird's-eye view shot

4.46 Example of a bird's-eye view shot

4.47 Example of a bird's-eye view shot

4.48 Example of a bird's-eye view shot

4.49 Example of a bird's-eye view shot

4.50 Example of a bird's-eye view shot

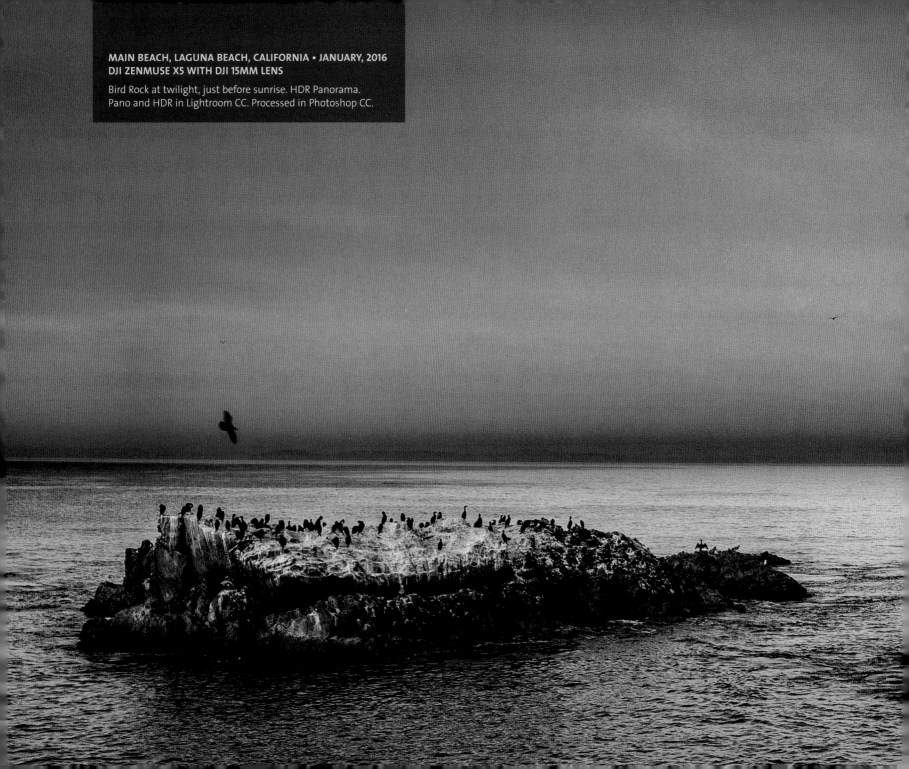

MAIN BEACH, LAGUNA BEACH, CALIFORNIA • JANUARY, 2016
DJI ZENMUSE X5 WITH DJI 15MM LENS

Bird Rock at twilight, just before sunrise. HDR Panorama.
Pano and HDR in Lightroom CC. Processed in Photoshop CC.

CHAPTER 5
SHOOTING VIDEO WITH DRONES

A VERY EXCITING THING ABOUT USING A FLYING CAMERA is the ability to capture amazing video that adds huge production value to any project. Previously, you would have to hire a helicopter and special equipment to stabilize your camera as you captured videos. With a small drone, you have the ability to really get in the action. You can fly lower than a helicopter, and you can fly through obstacles that would be impossible for a full-size helicopter. The other challenge with a full-size helicopter is the strong downforce that blows everything around—that can really ruin a shot.

While some people are creating wonderful reels of all-aerial video, it's more commonly used for specialized shots. For example, watch any big-budget movie or TV show, and you'll see aerials used all the time as establishing shots to anchor the action to a location. You will see these types of shots in smaller productions such as vlogs and event videos because they have now become so accessible. Drones are also great to provide a different viewpoint and add huge visual interest to action scenes, such as cars speeding away. They can also add a sense of beauty and calm, such as slow-panning shots over a boat or shots soaring over a field or a majestic lake.

Aerial video isn't limited to filmmaking; it has many practical uses for vlogs, real estate and construction, inspections and surveying, and search and rescue. In this book, we are concentrating more on the art of photography and video, so our focus is on how to capture visually appealing video footage. There are certain camera moves that are commonly used in Hollywood and film sets everywhere. We are going to examine some of these types of shots, as well as free flying.

FIRST-PERSON VIEW IN VIDEO

WHEN IT COMES TO SHOOTING VIDEO, your FPV (first-person view) is essential. You have to see what you are shooting in order to nail the shot. If you don't have a built-in screen, I recommend using a larger tablet, such as an iPad mini, rather than a phone-size display, to have a clear view of what you are shooting. The other option is to use goggles for a more immersive view.

The most popular goggles are DJI and Fat Shark, but there are many different options available. The advantage of using goggles is a clear, unobstructed immersive display that isn't affected by sunlight reflections. The disadvantage of goggles is that they disconnect you from your environment. You often don't know where you are in the physical world, so sometimes you don't see

dangers and obstacles such as power lines and tree branches until it's too late. They also make it difficult to tell your exact distance from an object. You can be unaware of other flying vehicles, especially full-size aircraft such as helicopters. Features like AirSense will warn you of approaching aircraft if your drone is equipped with this feature.

There are some laws that make the use of goggles a bit of a gray area in some situations, such as flying within a visual line of sight. You'll have to see how these laws affect you in the country or state where you are flying. Stay up on those rules, as they are rapidly changing and evolving. At very least, I would suggest having a visual spotter with you if you are flying with goggles. A spotter is a person who keeps their eyes on your aircraft and the environment and can alert you of dangers and approaching aircraft. In the USA it's a legal requirement to have a visual spotter if you are using goggles.

The ideal scenario is shooting with the equivalent of a DJI Inspire in dual-operator mode. In this situation, you have a pilot who controls the aircraft using visual line of sight and a second operator with their own remote who controls the camera movement but not the aircraft (**Figure 5.1**). The camera operator focuses on getting the shot and doesn't have to worry about flying. In this case, goggles like those in **Figure 5.2** are a great option for the camera operator. The advantage of dual operators is the ability to achieve more difficult and smoother camera moves because the camera operator doesn't have to worry about anything else. A lightweight sunshade is also a good idea, so you can see your screen while flying in bright sunlight.

5.1 FPV screen setup

5.2 Goggles

VIDEO BASICS

WE ARE NOT GOING TO SPEND A LOT OF TIME on the basics of video, because there are whole volumes written on this subject. I do think that there are some basics that you really need to know, and we will cover these here. Don't worry—this isn't going to be a course in broadcast jargon and dry theory. We are going to skim over these as quickly as possible in layman's terms. As they say in the movies, "This won't hurt a bit!"

Frame Size

The frame size, simply put, is how large the video will be. I'm sure you have heard the terms SD, HD, Ultra HD, 4K, and 8K thrown around. Let's decode those terms.

Traditionally, the height of the video was the measure, because it used to be tied to horizontal lines. Remember interlacing (where the *i* comes from in 1080i)? It caused the scan lines you see on old TVs. HD digital has changed all that, and we aren't even dealing with interlacing anymore.

Size used to be measured in vertical resolution. So 720 and 1080 were the height of a rectangle (**Figure 5.3**).

720 = 720 pixels high by 1280 pixels wide, 720x1280.

1080 = 1080 pixels high by 1920 pixels wide, 1080x1920.

Recently, they changed the way we measure screen resolution, from height to width; my guess is that it sounds better for marketing. However, they didn't reclassify any existing resolutions, so 1080 is still 1080 (and not 2K, which is very close in width).

The new numbers start at 4K, 6K, 8K, and beyond. 4K means 4000 and refers to approximately 4000 pixels in width. 4K and UHD (ultra-high definition) are the same thing; it is the most common size used in TVs and consumer electronics.

4K / UHD = 3840x2160.

Then there is Cinema 4K, which is closer to the size they use for theater projectors; this width is 4096. I do all my 4K shooting at UHD resolution because I don't need to scale it for typical 4K viewing. If you have the computing power its OK to shoot larger. Drones like the Mavic 3 allow you to shoot at 5.1K. This gives you some headway for cropping out things like prop shadows. Other drones like the Autel Evo II allow you to shoot 6K and 8K. Maybe by the time you are reading this, 8K will be the standard. Once thing you can be sure of: resolution is going to get larger and camera quality is going to constantly improve.

Frame Rate

A video is a series of pictures. Play the pictures quickly and it looks like motion, just like the old flipbooks. The frame rate is how many pictures are shown per second.

There are common frame rates; these depend on the format standard used. In the USA, Japan, and other countries, the format is NTSC. Most of Europe, Asia, and Africa use PAL.

For NTSC, the most common frame rate is 30 fps (frames per second).

PAL most commonly uses 25 fps.

Cinema (at the movies) is most commonly 24 fps.

Sometimes, higher frame rates are used, such as 120 fps. When this is played back on a 30 fps timeline, it shows highly detailed slow motion at one-quarter speed. 120 / 4 = 30. People like popular YouTuber Peter McKinnon make a lot of good use of 120 fps slow motion. Also worth mentioning is speed. Slow motion shots always look smoother. If you shoot at 60 fps, you can do true 50% speed and 120 fps will give you true ¼ speed slow-motion. When you speed up a shot, all the micro movements will be exaggerated.

Depending on the country you live in, you will most commonly be using that base frame rate or 24 fps for a cinematic look. You will use higher frame rates when you need slow motion.

Best Settings for Video

When shooting video, the desired shutter speed is two times the frame rate. So if you are shooting at 30 fps, you will want a shutter speed of 1/60. If you are shooting at 24 fps, 1/50 will be the best setting. The reason for this is motion blur. When you make a photograph, you generally want it to be as sharp as possible. If you use sharp frames in video, it can give a staccato, or stuttering, feel to the motion. By shooting at a slower shutter speed, each frame will have a little bit of natural motion blur. This motion blur makes motion look smoother and more fluid (**Figure 5.4**).

5.3 Video sizes

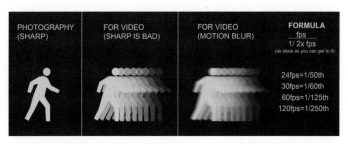

5.4 Video settings for motion blur

ND Filters

ND filters are neutral density filters. An ND filter is like putting sunglasses on your lens. It reduces the amount of light that hits the sensor and allows you to shoot with a slower shutter speed. That's it!

People always ask me if I use an ND filter on my images because they think that an ND filter will naturally make images look better. Many times, the answer is quite the opposite—an ND filter won't give you a sharper image; it will actually give you a softer image. Correct exposure means not too bright and not too dark—the Goldilocks effect. Three things control the exposure of an image or video:

- **Aperture:** The opening of the lens that allows light to strike the sensor. This setting controls how much light can enter. When the aperture is stopped down, the opening is small and needs to be open for a longer period of time to correctly expose the sensor. If you open up the aperture, the hole is larger and needs to be open for a shorter duration.

- **Shutter speed:** The shutter opens and closes the aperture, and the shutter speed determines how long the aperture is open. A fast shutter speed means that the opening is open for a very short duration. A slow shutter speed means that the opening is open for a longer period of time.

- **ISO:** This is the sensitivity of the sensor. A low ISO is low power, and you will need more light to enter from the lens. A high ISO means the sensor is running hotter and will require less light from the lens. Higher ISOs result in more noise in the image.

Exposure is a combination of shutter speed, aperture, and ISO to get the exact amount of light that you need to hit the sensor for a proper exposure. If the shutter speed gets too slow, blurring will occur on the image. To avoid this, either the aperture should be opened larger or the ISO should be turned up. Because many drone cameras don't have an adjustable aperture, this setting often isn't even in the equation.

So to simplify, if it's dark, you need to turn up the ISO to get a sharp shot. The extreme is when the ISO is so high that there is a lot of noise in the image. This is the upper limit of the camera's abilities.

The lower limit is when the aperture (if available) is stopped all the way down and the ISO is at its lowest number. All that is left to set is the shutter speed. If you have to go to 1/1000 of a second to get the correct exposure, you have a problem. You have surpassed the lower limit to get smooth video. If you set the shutter speed to 1/60 of a second, the exposure will be unusably bright.

On a sunny day, it's easy to hit the lower limit of the camera. This is when an ND filter comes in handy. They come in different settings depending on how dark you need it. Put an ND filter on the lens and you can now shoot at 1/60 and have the correct exposure. That's all an ND filter does, but it is an essential piece of equipment for a filmmaker; in fact, you probably need several of them at different densities.

A WORD ON COMPELLING VIDEO

MAKING VIDEOS IS LIKE WRITING A LETTER OR POEM. You don't want to make the whole text one run-on sentence. You are telling a story that consists of groups of sentences arranged into paragraphs. In video, the paragraphs could be your scenes, and the shots your sentences. You really want to think in terms of shots. Don't try to make your whole video in a single shot. You will use creative editing to construct the story.

Don't make your entire flight your video either; it will bore the audience. I remember early drone videos were exactly that. The GoPro starts, takes off, records a few minutes of boredom, a great shot, more boredom, and then a rough landing. Spare your viewers from that kind of video. Actually, you won't have many viewers if you do this too often.

Separate your videos into compelling, planned, and interesting shots that tell a story. You will arrange all these shorter shots together in post-production, to tell your story by editing. Often drone shots are used to supplement footage from other cameras. Maybe it's an establishing shot to show the viewer what location they are in. Maybe it's B-roll of a different viewpoint, or a chase shot—these shots are stunning and add a lot of production value. In the first edition of this book, I talked about how you can get unique shots with a drone. At this point in time, almost everyone has seen drone shots before, so you can't get by on novelty value anymore. It's more important now, than ever, to get compelling shots. There is a common rule in video called the 10-second rule. That is, when getting a shot, let the camera roll for at least 10 seconds; this gives you plenty of room to edit and trim the video. I would even go so far as to say that you need longer than 10 seconds for an aerial shot. **Figure 5.5** shows the three components to an aerial shot:

- **The setup.** Move into position and prepare to make the shot. Line up your aircraft nose with the desired direction of travel, frame the shot, and stand in a position where you can clearly see any obstacles you might be flying near. Start the setup back a few feet from where the actual shot will begin so that you are already moving at the desired speed and direction when you are making the shot. In the middle of a shot is *not* the time to be making a course correction.

- **The shot.** This is the footage you record that you are going to use in your video. It's critical that you make no sudden or jerky moves unless the shot calls for it. Barely breathe on the controls, and make very slow, smooth adjustments on the joysticks. Avoid the temptation to try to get a "better" shot midflight. If you see a new shot, or get an idea for something mid-shot, finish your current shot and then go back to try it on another run.

- **The follow through.** When you have ended your shot, don't just stop; keep flying for a few more seconds and do a nice pullout. Maybe you turn, climb, or just keep flying in a straight line. Just remember that getting a smooth shot is like a golf or tennis swing—it's all in the follow through.

Start smooth, fly into your shot, and then ease out of the shot, giving a few extra seconds on either end. If you do this, you will get better shots and occasionally get some happy surprises on the lead-in and lead-out, which you might end up using as a bonus. There will be times when you break this rule, such as a long flythrough shot that is really compelling. But generally, when you edit, you will be working with shorter clips most of the time. It's also worth doing a few takes of each shot if possible, to give yourself more options in editing.

OK, now you know you need to get smooth shots and you understand the three parts of a great aerial shot. It's time to examine the types of shots that you can capture. This is not an exhaustive list of all the possible movements, but it will definitely get you going with ideas for your next aerial video shoot.

5.5 Making the shot

VIDEO MOVEMENT

IN THE VIDEO WORLD, there are two main types of camera moves: static and dynamic. A static move is when the camera is locked into position, usually on a tripod. A dynamic shot is when the camera actually moves; this includes panning, tilting, zooming, trucking, dollying, and booming. Let's take a closer look at these camera moves and how they apply to you as a drone operator. "Wait a minute," I hear you saying, "I'm flying a drone. Can't I just go anywhere I want?" Sure you can. That's free flying, which most certainly has its place. But you don't want all your shots to be free and erratic. The audience is used to seeing certain types of shots, and these help tell a story, so it's worth being aware of them. You are not limited to these types of shots by any means, but it doesn't hurt for you to learn and practice them.

Also, don't forget to choose your flight path to follow the best direction of light. Generally speaking, you will want to have the sun or light behind you. The exception is when you want to include a sunset or atmospheric haze. Smoke, fog, and mist all look best with a backlight. Bear in mind that when flying with the light in front of your camera, you will often get a fluttering in the top part of the video. This is the shadow from the propellers hitting the lens. Tilt the camera lower, slow down the flight speed, or shoot away from the light to avoid prop shadows.

Static Video

A static shot is when the camera doesn't move. All the movement happens in the scene being shot. This kind of shot is actually very powerful and shouldn't be ignored. Just because you have the ability to freely move around doesn't mean that you have to do it all the time. Because of satellites and optical flow, multirotor drones have the ability to hover in position with very little or no movement. You can get some great shots by framing your shot and rolling video with all the action happening in the frame. In fact, I would recommend getting a few static videos under your belt before shooting dynamic shots if you have never used video from a drone before. Even when you are experienced, ask yourself, "Does this shot need camera movement?" Too much movement can move the stomachs of your viewers rather than their hearts.

Static shots are also a great opportunity to shoot slow motion at high frame rates. You can fly into position and use ever-so-slight adjustments to get the perfect framing, and then shoot at, say, 120 fps.

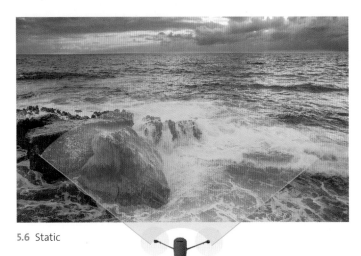

5.6 Static

Dynamic Video

The most common shot you are going to get with your drone is the dynamic shot—that is, the drone is moving. There are lots of ways to move. I'll start with traditional camera moves and then advance to aerial-specific moves. The key to these kinds of shots is to take your time and move slowly and smoothly.

Single-Axis Moves

Let's start with the really basic moves, which don't require too much movement or advanced skill to execute.

PAN

The pan is when you simply rotate in position (**Figure 5.7**). This kind of shot is very common with a camera on a fluid-head tripod. On your aircraft, it's accomplished by yawing slightly on the left joystick. If you have an aircraft like the Inspire, you can keep the aircraft stationary while rotating the camera. You can slowly pan across a scene to show the expanse of the vista or to reveal more of the scene. *Pan* is a term coined in the early 1920s and is an abbreviation of the word *panorama*. You are making a video panorama when you are doing this kind of shot.

A second type of pan is when you are following the action from a static position. Perhaps a car or boat passes by, and you track that object by panning, or rotating, your camera. This creates a different feel than a follow shot. When you are still and the object passes by, it puts you in the spectator's seat, since you are watching something happen rather than being involved in the action. This is a great reaction-type shot.

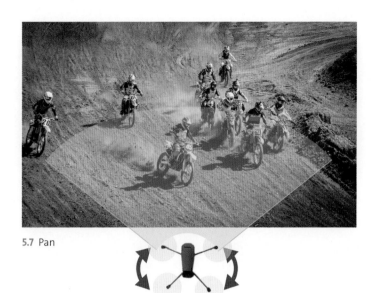

5.7 Pan

5.8 Tilt

TILT

The tilt is very similar to the pan. In fact, the tilt is identical to the pan, except you are panning up and down rather than horizontally. Psychologically, it has a bit more of an insecure, exciting, or dangerous feeling than the calm, horizontal pan. Generally, when things are moving vertically they are falling. The word *tilt* comes from the Middle English word *tylten*, which means to tumble.

A tilt is accomplished by tilting the gimbal. Most drones have a tilt wheel built into the controller that allows you to tilt the camera remotely. Sometimes, you will perform this movement by itself—if you are slowly revealing a tall structure, for example. Most commonly, you will be using the tilt in combination with other moves, such as the elevator shot.

DOLLY

A dolly is when you move the camera either side to side or in and out. On film sets, a set of rails is often constructed for this purpose. The camera is mounted on a set of casters resembling a big train set. When the camera is moved down the rails, you get a very smooth move.

Getting a side-slide type of shot can add visual interest to your videos. These work especially well when you begin behind an obstacle and slide out into the action. You could also slide behind an obstacle and use it as a powerful transition effect, sliding out again to a different shot.

To accomplish this kind of shot, you will need to fly sideways while keeping the camera facing forward. This can seem a bit awkward at first, and it may be difficult for you to fly in a straight line. As simple is it sounds, the challenge is in the orientation and your reflex to pull the stick the wrong way. With a few hours of practice, you can master this move. A dolly shot can also produce nice parallax with the background and add depth as the different planes will appear to be moving at different speeds.

5.9 Dolly

ZOOM

Out of all the movements, most people are familiar with zoom. This is the same effect that you would get from zooming a lens on a camera. Most airborne cameras don't have a dynamic zoom because they have fixed, or prime lenses, although some do have

zooms (such as some of the Mavics). The rule that applies to a fixed, prime lens on the ground also applies in the air. How do you zoom a prime lens? With your feet. You walk forward or backward. In this situation, you would fly closer or farther away. The act of moving the camera is not quite the same as zooming in with a lens. As a lens becomes longer, it compresses the background. A compressed background has the effect of looking like it's closer to the subject. The opposite is true of a wide lens, which expands the background and makes it appear as if there is more distance between the subject and background. This is classic in hotel room photos—they appear huge until you enter the room and can't fit your suitcase in there.

If anyone doubts the difference between zooming and physically moving the camera, just look at the classic Hitchcock camera move in *Vertigo*. As the camera moves back, the lens zooms in at the same rate to keep the subject the same size, but the background seems to grow or shrink. This is known as a dolly zoom. DJI has even built this effect into some of their drones

Let me make a quick mention of digital zoom. Optical zoom is a true zoom, when the glass allows you to change the field of view. On the other hand, digital zoom only magnifies the pixels on the sensor. It doesn't move closer to the subject. This causes the image to become soft and adds noise and artifacts. A digital zoom is the same as cropping the image in post-production and then enlarging it, but it's less than ideal. My suggestion is to avoid digital zoom. As tempting as it might seem, you will gain nothing but a soft, lower-quality image. Computational photography is getting better and I suspect digital zoom will be good enough in the not-too-distant future.

5.10 Zoom

a shot that resembles a first-person video game or what you might see out the cockpit of an airplane. This gives a real sense of motion and speed. It brings attention to the camera and the movement, so it should be used only in appropriate situations.

- **In post-production.** You can roll your footage in software such as Adobe Premiere Pro or Apple Final Cut Pro. In this case, you would be shooting a larger frame than you ideally need. For example, if you are delivering in 1080, you might shoot at 2.7K (see, there is a reason for 2.7K) or 5.1K for 4K videos. Then you have a lot of extra frame that you can play with. You might animate a rotation to create a banking or rolling effect with the video.

5.11 Roll

ROLL (OR BANK)

The roll is when the camera tilts from side to side. You might think that this isn't a shot that you could even do on a drone. It's the kind of shot you will typically get on an FPV drone. It's a rare shot on a stabilized gimbal drone, but it can come in handy from time to time. Without specialized equipment, there are two ways to accomplish a rolling shot:

- **Set your gimbal to FPV.** In the DJI Go app, there are two options for the gimbal: FPV and Follow. Follow provides leveled shots, which are generally preferred. When you change to FPV mode, the camera will tilt with the banking of the aircraft. This provides

Aerial Camera Moves

Let's take a look at some different types of camera moves that you can perform with your drone. These are the kinds of shots that you will shoot while flying your drone, and some suggested ways of moving.

ESTABLISHING

The establishing shot is the classic. This is the shot that establishes a scene. It shows the audience the location and sets the mood for what's to come. Usually these kinds of shots are wide and from a distance. Generally speaking, an establishing shot happens at the beginning of a scene. This is also a way to signify a change of location, if more than one location is used. These types of shots were expensive to create in the past and often needed a crane or helicopter. Because of this restriction, many filmmakers used stock footage for establishing shots. Now, with UAV (unmanned aerial vehicle) drones, anyone can get a really good establishing shot without breaking the bank. This kind of shot could be stationary, panning, a reveal, or a flythrough.

5.12 Establishing shot

REVEAL

Quite often, a reveal can be used as an establishing shot, but not always. I love a reveal shot; it's so powerful. A reveal starts on an area, and as the camera moves it unfolds a larger location or something unexpected. It's kind of like opening a gift for your viewers. These is a reason this is used so much in opening scenes of movies.

One famous reveal appears in the movie *Independence Day*. Will Smith's character is at the mailbox getting his newspaper, and he sees his neighbors packing up their cars. A helicopter flies overhead. The camera slowly tilts up as it follows the movement of the helicopter until it reveals a giant spaceship hovering over Los Angeles.

A reveal can start with a view of an obstruction, such as a tree or hill. When the camera flies up slowly or slides sideways, it reveals the scene. You could start close on a subject and then pull out and up to reveal the location. Another type of reveal that is quite common is the dolly-and-tilt move: You fly forward with the camera tilted slightly down. Then, slowly tilt the camera up as you move forward to reveal the environment in a dynamic way while moving into the scene. Another variation is tracking a person from above, starting almost as a bird's eye view; as the person walks away, the drone slowly descends while tracking, so the drone is very low by the time the location is revealed.

There are a number of ways you can film a reveal; the important thing is to take your time and do it smoothly. Also, have a good look around before you begin shooting. Plan your shot. Where are you going to start and end? When are you going to tilt your camera, if at all? Are there any obstacles in the way? Are there any leading lines you can use to fly with to make the shot stronger?

5.13 Reveal shot

ORBIT

The orbit is when you fly around the target in a circle while keeping the camera on the target at all times. The orbit, or POI (point of interest), is one of my favorite shots. This is easy to accomplish with intelligent flight modes and smart shots in the latest drones. It can still be accomplished manually, which I do often because of the added flexibility.

To fly an orbit:

- Point the camera at the target and choose your desired distance and altitude. (Don't forget to start recording.)
- Move your aircraft either to the left or right.
- Use the yaw (left stick) to steer around in a circle.

The right stick controls the speed, and the left stick controls rotation and direction. This can take a little practice to get the coordination right, but it will be easy once you get it. Also, be aware that you can do this automatically on many drones. Check your operations manual for particular instructions for your aircraft.

5.14 Orbit

Here are some things to be aware of while flying orbits:

- Always be safety minded—don't get too close to the target you are flying around. If you don't feel confident that you have the required skills just yet, don't try to make a difficult orbit around a subject or person. Practice flying around a ball, first. No shot is worth injury or the risk of crashing your expensive drone.

- If you are orbiting a large structure, make sure you are flying high enough to see your aircraft at all times. If you fly completely behind a structure, you can lose radio signal and control!

- Not all orbits have to complete a full circle. It's very common to fly a semicircle and get exactly the shot you need. You will probably use a semicircle rather than a full circle if you are cutting together a segment that combines a number of shots.

FLYTHROUGH

I think the name of this move says it all. This is a fun and some-times-tricky shot to execute. This is where you are going to fly right through the middle of your scene. Slow and steady is the best way to accomplish this move. If you need speed, many times you can speed it up a little bit in post-production. If you fly too fast, you will get propellers in your shot. Most of the time, the camera will be pointing directly forward; occasionally, it will point backward.

Before a flythrough, plan your flight path. Where will you lead in, where will you fly the shot, and how will you pull out? Try to find an interesting flight path that follows something on the ground. Maybe you can pass over a moving prop, such as a car or bicycle. Even better if the prop is moving in the same direction as the camera. Look for things like roads and paths as leading lines.

When you are more experienced, find some interesting objects you can fly through that can make the shot even better, such as between trees, close to a roofline, or through a large opening. These kinds of surroundings add a lot to a shot, and you really don't have to get that close to them.

The flythrough involves the audience and gives them a sense of being present at the location, as if it's the viewer who is traveling. You will often use FPV for navigating a flythrough. If you are looking through FPV goggles, make sure you have a visual spotter with you at all times.

5.15 Flythrough

FLYBY

A flyby is very similar to a flythrough, with one major difference. On a flythrough, the camera is usually pointing in the direction of travel and you are immersed in the scene. On a flyby, the camera will constantly rotate to stay on an object as the aircraft flies by in a straight line. The flyby is quite a tricky shot to get perfect and smooth, because it involves rotating your aircraft as you fly in a straight line. The exception to this is the Inspire, where you can rotate the camera independently from the aircraft. Using tracking and autonomous flight modes, it's getting easier to perform great flyby shots.

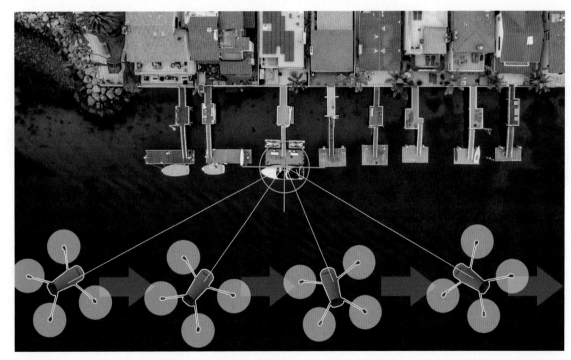

5.16 Flyby

ELEVATOR (OR PEDESTAL MOVE)

The elevator shot is when the camera moves straight up or down. There are two types of elevator shots. The first is when the camera is stationary and follows the movement of the drone up or down. It could be pointing straight ahead and scanning something like a building. This a little bit like a vertical dolly move and would otherwise need a crane or a jib to accomplish.

The other type of elevator shot is where the aircraft is changing altitude and the camera stays locked onto the target and tilts. The challenging part of executing a good elevator shot like this is tilting the camera smoothly as the altitude changes. When it's executed correctly, you won't even notice the camera tilting; you will just notice the change in the altitude, the angle, and relationship between the background and the subject. The subject should remain more or less in place.

To make this kind of shot, you need to practice your gimbal wheel movement. Practice tilting the gimbal slowly and smoothly while changing altitude and keeping the target in the center of the screen. There are settings in most flight apps that can help.

5.17 Elevator tilt

Choose the Gimbal settings and set the gimbal wheel speed to a sensitivity that works for you.

Another setting is in the DJI app is Smooth Track (it could also go by other names, as these names change often). Smooth Track will ease the gimbal movement. What is easing? Imagine if you closed a door at a constant speed—you would end up slamming every door. Take notice the next time you close a door: you slow down the movement just before it's closed to smoothly close it without slamming. Likewise, a train doesn't come to a complete stop instantly. This is easing—something slows down and speeds up to offer a smoother movement. Smooth Track does exactly that. It can feel as if the gimbal is on a big elastic band rather than a steel rod. Choose the settings that work best for you to make smooth gimbal moves.

Active Track on the Phantom 4 or APAS (Advanced Pilot Assistance System) on the Mavic, air and mini helps with these elevator shots.

CHASE

The chase cam is a shot utilized a lot in James Bond films and car commercials. These types of shots were accomplished by attaching stabilized cameras to large jibs on moving vehicles, sometimes trucks. The vehicle follows the action, which could be another car, a horse, a skateboarder, or even a person running down the road. Chase cams follow the action wherever it might go. These are very exciting shots to watch and also used to be some of the most difficult to execute. The use of sensors and tracking on drones has made it quite easy to do an autonomous or tracking-assisted chase shot.

5.18 Chase

Using your aircraft, you will follow your target and film it from above, behind, the side or, the front. When flying manually, it's quite difficult to match the exact speed of a moving object, especially when you get in tight. It's a bit easier if everything is choreographed beforehand. This isn't always the case, such as filming a surfer or a sports event. The added challenge is anticipating sudden changes of direction.

Filming a good chase shot requires fast reflexes and a smooth hand. The temptation is to tightly track the target and constantly adjust to keep it in the center of the frame. A better approach is to anticipate the line of travel and smoothly match speed and direction without having to make too many adjustments. When you do make adjustments, try to avoid sudden, jerky movements.

There are times when the action happens so fast that you can't avoid sudden movements. Here is my suggestion for this kind of shot: If possible, shoot a little larger than you need, in the highest resolution supported, and hang back a little bit. That way, you can keep more of the action in frame without having to constantly adjust the camera framing. Then in post, when you are cropping to a smaller window, use your software to smoothly animate some of the camera moves to keep the subject in frame.

BIRD'S-EYE (TOP DOWN)

The bird's-eye, top down, or God's-eye view is when the camera is pointing directly down in a Google Earth kind of way. This is a very distinctive drone shot. The bird's-eye is a unique shot that has a lot of impact; it's the classic eye in the sky. Rather than looking down at objects from an angle, you are looking directly down on them. You could fly around at the same altitude and do a scanning type of shot. This is good for showing a neighborhood or following a car in a surveillance-style shot. The bird's-eye is especially great when you are pulling away from your target—in effect, creating a type of reveal as a bonus.

When it's late in the day and shadows are long, you can get some really interesting bird's-eye shots by playing with shadows.

5.19 Bird's-eye

STEADICAM-STYLE FREE-FLYING

Since the 1970s, the Steadicam has complemented a lot of other equipment on set, such as dollies. The Steadicam is a counter-weight-balanced camera platform that is attached to the wearer with a harness. A skilled Steadicam operator can move around a set and create handheld camera moves that are very smooth. It takes a lot of training and skill to operate a Steadicam successfully.

Lately, a lot of Steadicams are being replaced by gimbal systems such as the DJI Ronin, Zyjung Crane, and the Freefly Movi. These gimbal systems came directly from the gimbals that we fly on our drones.

When you are flying your aircraft, you have the ability to fly anywhere you like, even as erratically as a bumblebee, and still get smooth shots thanks to the onboard gimbal. You really need to have a gimbal to capture smooth and stable video. It's fun to try some free flying, where you just fly around a scene and film. Don't follow any rules or be constrained by tradition—just fly, shoot, and enjoy. Don't make all your shots free flying, or you will disorient your viewers. A good mix of smooth, planned camera moves with some free-flying shots mixed in will produce stunning results.

Oh, by the way, there is one more camera move. Don't forget you can hand carry your drone. Turn it on and start the camera, but don't turn on the motors. Use your drone as a handheld gimbal and move the camera through some really tight spots by hand. People will wonder how you have such amazing flying skills. It will be our little secret.

5.20 Freestyle

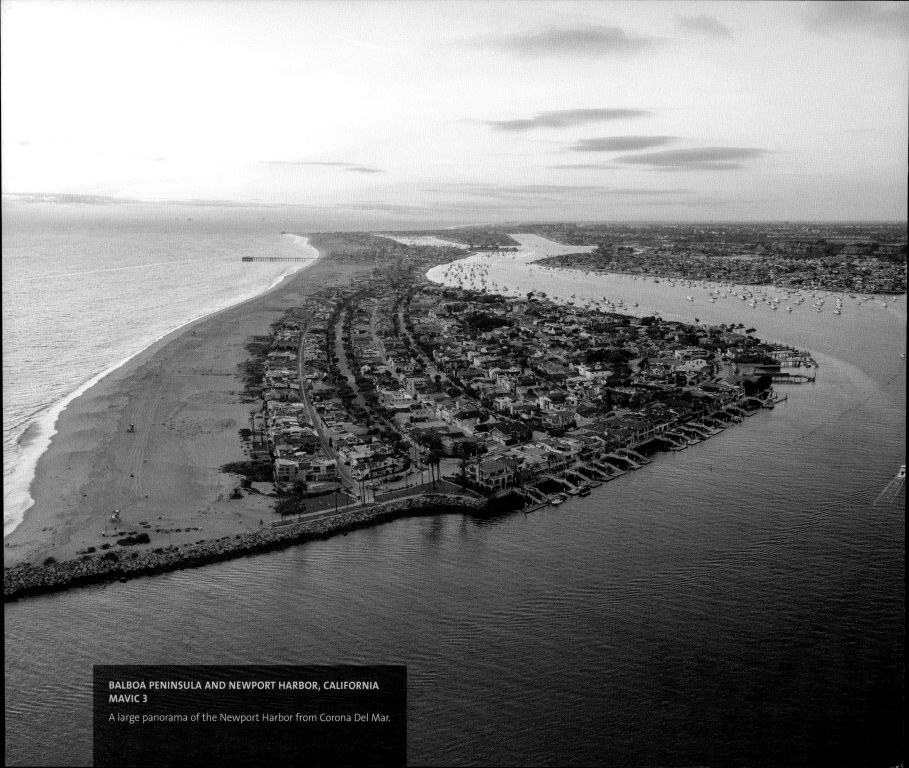

BALBOA PENINSULA AND NEWPORT HARBOR, CALIFORNIA
MAVIC 3

A large panorama of the Newport Harbor from Corona Del Mar.

CHAPTER 6
BASIC PHOTO WORKFLOW IN LIGHTROOM OR ACR

WHEN WORKING WITH PHOTOGRAPHS, post-processing is half the procedure. I know there is a school of thought that says you should get it all in camera. I stand across that aisle. I am not a purist. I believe in using whatever tools are available to create the best possible image.

To a certain degree, "get it all in camera" is not a bad philosophy. This might be true for journalism, but what does "all in camera" really mean? When you are shooting in RAW, you have made a digital negative. It still requires processing. In a traditional darkroom, decisions are made that affect the final appearance of a photograph; this is the same with the digital darkroom (e.g., your post-processing software).

I have an alternative mantra: Get it all on the sensor and then bring out what you need in post-processing. Why limit yourself to capture, the first part of the process? The second part is where you really get to put your personal fingerprint, your signature, on the image. You will learn that there are ways of capturing images that lend themselves really well to your style of post-processing. Most of the small cameras we fly lack the dynamic range and sharpness of their ground-based siblings. Generally, there is more distortion because we are shooting wide angle, and noise can quickly become a problem with the tiny sensors, although with a wider adoption of larger sensors, this is becoming less of an issue.

There are two programs I mainly use to process my aerial images, and we will examine the best ways to apply their tools to aerial imaging. We are going to look at Adobe Lightroom and Adobe Photoshop. These applications have been my trusted friends for a long time. I have been using Photoshop since 1993, when it first came out on the PC as version 2.5. I have used Lightroom since it was in beta, and I've had the privilege of being an Adobe Alpha and Beta tester on both applications. There are two variations of Lightroom, Lightroom and Lightroom Classic. I will be using Lightroom Classic for these examples, but almost everything is transferable to Lightroom.

It's impossible to cover Photoshop and Lightroom in depth without writing a 1,000-page book. I have made a career by creating many in-depth resources on these programs at PhotoshopCAFE.com.

The point I'm making is that these Adobe tools have been a part of my workflow since I started working with imaging, before digital cameras were any good. In some ways, the quality of the earlier aerial images took me back to those early post-production days of film scans. This helped me because those images took a lot of massaging. There was a good image in there somewhere, but you had to be heavy-handed to coax it out—but not too heavy-handed, because the images were flimsy and would fall apart quickly. What was needed was an iron fist in a velvet glove. Nothing proved this more than working with the DJI Vision and Vision+ cameras. I was able to evolve this processing with the Phantom, Inspire, and Mavic cameras. I'm now going to share what I have learned over the past 20+ years but filtered into the context of the newer workflow I have developed over the past several years.

Every time I post an aerial image online, I get questions about how I process my images. I hope to answer all these questions and more in the following pages. You can find me on both Facebook and Instagram, where I post daily aerial images, as PhotoshopCAFE. Disclaimer: I haven't perfected my workflow. I'm still experimenting and learning and growing, so this is what I am doing currently. Some of these techniques will evolve and some won't. I encourage you to learn from my efforts, but then use that as a jumping-off point to develop your own unique style and workflow. I know I will! I'm not ready to bake my clay just yet.

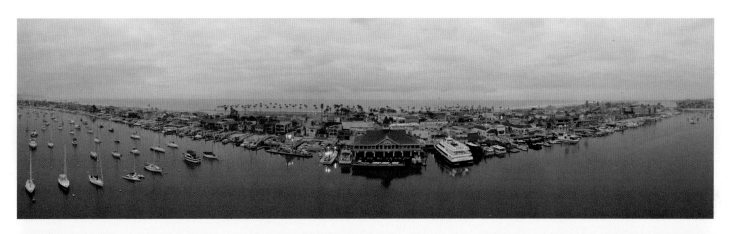

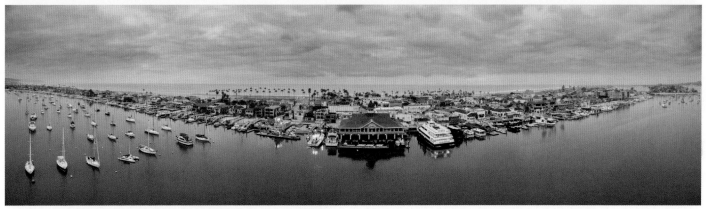

6.1 Before and after post-production

MEDIA DOWNLOADING AND TIPS

BEFORE YOU CAN DO ANYTHING, you need to get your photos off your aircraft and onto your computer. This means that you need to come up with a system. There are three main things to take into account.

1. How will you get the files off your cards?
2. Where are you going to put them?
3. How are you going to find them when you need them later?

Dumping Your Data

The first question is easily answered. There are three methods available to remove the files from your memory card. The first is to transfer the files wirelessly through your app. The second option is to connect your camera through a cable, such as USB. The third and recommended way is to transfer the files directly off the card using a card reader. This is the fastest way to "dump" your data, and it doesn't require you to use up your drone batteries while you are doing it.

Most aerial cameras use microSD cards. These tiny cards can be placed into an SD adapter and treated like an SD card. Many devices, such as the MacBook Pro, come with SD card slots that you can plug the card into directly. Alternatively, an external Micro SD or SD card reader works just fine.

If you are shooting on multiple cards, then investing in a good card reader is a great idea. I use the Lexar UR2, which supports UHS2 and can transfer from three microSD cards simultaneously. Always use Class 10 or faster cards. I talk about cards in chapter 2.

6.2 MicroSD card reader

Where Are You Putting It?

The second part of the equation is where you are putting the images. You are transferring your images to a hard drive. This could be a spinning platter or an SSD (solid state drive). It could be an internal or external drive. All of this really depends on your workflow. Personally, I move my photos and videos onto an external hard drive. I shoot a lot of footage and need flexible storage, so I use an array of external drives. I am a big fan of using external RAID drives because of their size and redundancy. I also look for speed, so a Thunderbolt connection is great. USB 3 is OK, but it's 4.8 Gbit/s. Avoid USB 2—it's a lot slower. USB 4 is the same speed as Thunderbolt 3 and 4. Thunderbolt 3 and 4 are up to 40Gps and on it will go. Get the fastest drive that fits your budget. For photos, this doesn't matter as much as it does for video.

Where Is It?

This is where digital asset management comes into play. There are many management systems you can use. The important thing is to be consistent. Whatever management system you use, make sure you stick to it so that you don't accidentally delete important files. Have a system for cataloging your downloaded files. You can sort the main folders and subfolders by camera, by date, by location, or some other way. Beware with multiple MicroSD cards, because of the file naming on DJI drones. They restart numbering on each card after formatting. You can use continuous file naming, but after 999 it restarts. It's not uncommon to have multiple images with the same filename.

Personally, I sort by camera and location. I have a main folder, called Drone. I then sort by location: country, state, city, and finally, specific location. If I shoot the same location multiple times, I create a numbered folder for each shoot; this prevents me from accidentally overwriting other files with the same name. This is where I dump all the files when I come home from a shoot.

The second and most important part of organization is metadata. File-based management has its limitations, but metadata is far more powerful because of how quickly it makes finding files; it also leads to better version control. I use Lightroom to catalog all my footage and images. I have a catalog for all my aerial photos and videos. I then create collections and subcollections. These collections are based on locations. I also add keywords to the photos as I import them. Keywords and collections make it really easy to find images later on for processing. A lot of the information, such as dates, times, and GPS coordinates, can be useful and are written into the files.

You can also use smart collections in Lightroom to automatically create collections for things like HDR images and your processed images. For example, I made a smart collection that automatically includes all TIFF and PSD files for this book. All the images I have processed in Lightroom and Photoshop appear in this collection, which saves me the time of digging around trying to find things.

ASSET MANAGEMENT IN LIGHTROOM

I don't want to spend too much time on asset management, because you may be using a different system than I am, but it's worth looking at some quick basics. Lightroom is a great program that lends itself well to aerial imaging. It's a good place to bring all your photos and videos together so you can manage and locate them later. For more features and a larger workflow, I have a 15-minute Lightroom crash-course video here: http://photoshopcafe.com/Learn-Lightroom

6.3

Catalog

The catalog is where you save all your photo information. Lightroom doesn't actually store your photos. It knows where they are and creates a reference to them. It keeps a little text file for each image in its database (known as an XMP). Lightroom is just a database that lets you change settings. This text file contains the EXIF information that the camera writes, such as shutter speed, time of capture, and so on. It also stores the metadata that you add, such as keywords, and it contains the Develop settings—the things you change in Lightroom, such as the brightness, contrast, gradients, etc. When you look at a photo in Lightroom, what you are seeing is the program reading the text information and displaying the photograph accordingly. You change this information by moving sliders.

The database is called the catalog. You can have multiple catalogs in Lightroom, but you can open only one at a time. I created a catalog where I keep all my aerial photos separate from my other photos.

When you want to view all the photos in your catalog, make sure to click All Photographs at the top of the Catalog panel in the Library module. If you don't choose All Photographs, you won't see all your photos and you may think some are missing. This is our home base (**Figure 6.3**).

Scroll down a little bit and you will see the Folders panel. This shows the actual location of the physical images on your computer's hard drive or external drives. If you want to change the location of photos, don't change them on the drive, because Lightroom won't know where you've moved them. If you drag the images from within the Folders panel, you can relocate them and they will also change physical location on the drive. To summarize, move the indexed files inside Lightroom, not on the drives themselves (**Figure 6.4**).

6.4 Folders view is where the actual photographs live

Collections

There are many times when you don't want to sift through all your photos. Maybe you want to look at photos from a particular shoot or from a specific location. This is what collections are. Collections are sets of photographs from the entire library. It's a great idea to make collections, because you can quickly group photos together. When you click a collection, only the photos in that collection will show (**Figure 6.5**).

To make a collection, click the little + button on the collection and type in a name. If you have photos selected while creating the collection, you will have the option to include these photos in the new collection. If you don't have any selected or choose not to add selected photos, you will have a blank collection (**Figure 6.6**).

Photos can easily be added to collections by dragging them into a collection from Grid view or from their folders. You can add a single image or multiple images.

6.5 6.6

When you add images to collections, they do not move from their original location; you are just grouping them together in Lightroom.

TIP *You can drag a folder from the Folders panel into the Collections panel and a new collection will be created with the photos from the folder.*

Keywords

Keywords will help you find your photos. You add keywords through the Keywording panel on the right side of the Library module (**Figure 6.7**).

Finding Images in Lightroom

All this fancy metadata doesn't mean much if we don't have a way to use it later.

Keywords and other metadata can be searched by using the filter bar in Lightroom. Choose View > Show Filter Bar, or press the / key (**Figure 6.8**).

Choose a criterion from across the top: Text, Attribute, Metadata, or None (to turn off filtering). If you want to search the entire library, select All Photographs from the Library panel or select a collection to restrict searching to the photos in the collection.

ATTRIBUTE

A useful option on the filter bar is Attribute. I use this all the time to quickly display all the video files. There are a number of different ways you can filter attributes (**Figure 6.9**).

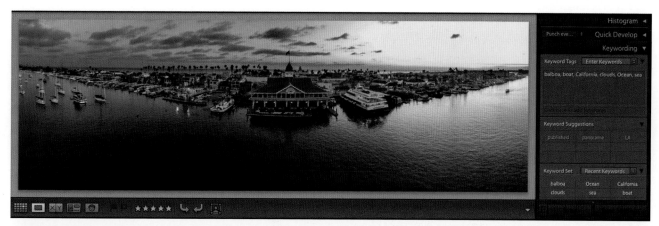

6.7 The Keywording panel

6.8

6.9

At the far right of the Attribute panel in **Figure 6.10** are three buttons labeled Kind. Click the last one, which is a little filmstrip icon. Now all the photos will be hidden and all that remain are the video files—that's a huge time-saver!

6.10

Basic Edits in Lightroom

Lightroom is a great place to start making adjustments to your images. The adjustments in Lightroom and Adobe Camera Raw (ACR) are identical. This means you can start in Lightroom and if you choose to open a photo in Photoshop as a Smart Object, you have direct access to your Lightroom adjustments from within ACR. This also means that the following tutorials will work in either Lightroom or ACR. Also, ACR and Lightroom aren't restricted to the RAW format. They also work with the JPEG, TIFF, and PNG formats. RAW is the preferred format to shoot because there is more information and dynamic range in a RAW file. Also a RAW file supports a 16-bit color depth, whereas jpg is limited to 8-bit color.

A QUICK NOTE ON LIGHTROOM AND CAMERA RAW COMPATIBILITY

If you are on Adobe Creative Cloud, then the latest versions of Lightroom and ACR have exactly the same feature set. If you have an earlier version of ACR, you can still open the file from any version of Lightroom, but only the features in that version of ACR will be re-editable.

- Lightroom 4 was fully compatible with Photoshop CS6.
- Lightroom 5 was fully compatible with early Photoshop CC.
- Lightroom 6 was fully compatible with Photoshop CC 2015.
- Lightroom CC and Lightroom Classic are always up to date with the latest version of Photoshop CC.

This is worth mentioning because Adobe renamed Lightroom and caused considerable confusion. Here is an easy way to think of it. When you hear Lightroom Classic, it means the Lightroom that has always been around, the Desktop version. The "other" Lightroom was called Lightroom Mobile, and consisted of a desktop app, a mobile app, and a web app that all synch together in the cloud. This cloud synced ecosystem is now just known as Lightroom. Lightroom now has most of the features from Lightroom Classic, so the tutorials I present here will work on both.

BASIC LIGHTROOM WORKFLOW

I'M NOW GOING TO WALK YOU THROUGH the basic sequence and steps to editing your photos in Lightroom. Most of the time, these are the steps that I apply to every photograph.

Note that ACR in Photoshop works exactly the same way, with the same settings. You can open a RAW file into Photoshop or Bridge. In versions of Photoshop newer than CS6, you can access ACR as a filter.

Fix the Lens

The first thing we need to do is remove the distortion from the lens. GoPro cameras usually have more distortion than many of the others, but all wide-angle cameras have some distortion. Lightroom has built-in profiles for most of the cameras you'll be using. If it doesn't, try something similar and see how it looks (**Figures 6.11A–6.11C**). The newer DJI Drones have built-in profiles, so there is no need to apply a lens profile to them; in fact, no profile will show if its built-in.

1. Switch to the Develop module at the top of Lightroom. (I have collapsed the left panel by clicking the arrow in the margin to provide more working space.)

2. In the right column, scroll down to the Lens Corrections panel.

3. Click on Profile. Choose Enable Profile Corrections.

4. Choose the make of the camera. In this case, it's DJI. Many other manufacturers are supported, including GoPro.

5. Choose the model of the camera. Once you do this, the profile will be applied and you should see a reduction in lens distortion (the fisheye effect) and vignetting (darkening of the edges). Under Model, you may not see your exact model, so try using something close. Currently, the Phantom 3 FC300X seems to work well for all Phantom 3 and Phantom 4 cameras.

6.11A The original image as shot

6.11B The lens profile applied

6.11C Before and after image taken with the Phantom 2. No adjustments other than lens profile.

Crop and Straighten

The next step is to straighten the image. Sometimes your gimbal isn't correctly leveled, or perhaps the wind blew it off a little. If this is the case, the best place to straighten is the Crop & Straighten panel (**Figure 6.12**).

1. Click the Crop icon at the top left of the Develop module.

2. Click the Level icon in Angle.

3. Drag the tool along the horizon line. This straightens the horizon.

You can also manually drag the corners to change the rotation of the image.

This is also the place that you can crop the photograph to remove distractions or to change the composition if you so choose.

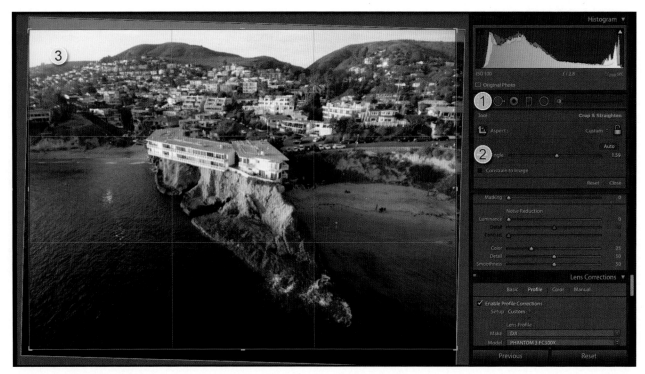

6.12 Straightening the horizon

Color Correction

Because the color of ambient light changes based on the time of day and on whether it's sunny or overcast, we often need to correct the overall color of the photo. Sometimes the color can be spot on, but we might want to warm it up a little or adjust it creatively.

Here is how to correct the color in a photograph (**Figure 6.13**).

1. Under the Basic panel in the Develop module, click the Eyedropper tool.

2. Move it over an area that should normally display as a neutral gray or white. Usually gray works best because often the white is blown out. You will see a grid that identifies the exact color under the eyedropper.

3. Click the gray to apply the color correction. If you don't like it, try clicking a different area.

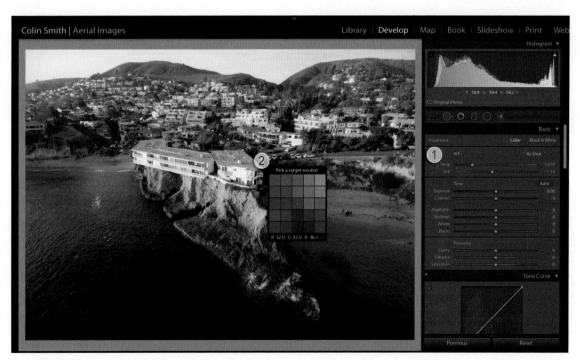

6.13 Applying the color correction

6.14 The result of the color correction

COLOR CORRECTION TIP *Near the end of the day, such as at sunset, try looking for a gray area that is in shade. This often produces the most natural results.*

You can also slide the Temp slider to make a manual color correction.

Tonal Corrections

We are now going to move on to the tonal corrections. This is where many people begin their editing. To see what they are missing by not starting with a corrected image, look at the before and after images as they look thus far.

Tonal corrections are achieved by adjusting the brightness of the image. The brightness can be broken into three main areas: shadows, midtones, and highlights. These tonal corrections can

be made to make the photograph look natural, or they can be pushed to extremes for image enhancement and exaggeration. Feel free to choose the style that you prefer. All of this is going to happen in the Basic panel in Lightroom (or ACR).

HIGHLIGHTS

If you look at the photograph we are working with (**Figure 6.14**), you will notice that the highlights are blown out. The sky is bright, it's hard to make out much color, and the building is lacking detail in its brighter areas, such as the balconies.

We recover highlight details by moving the Highlights slider. Slide it to the left to recover highlight details. There is rarely a reason to move it to the right. In this case, we had to move it all the way left to recover the highlight information we desire. It's very common to be a bit heavy-handed with this, since highlight detail gets lost easily in digital photography (**Figure 6.15**).

Note that when something is overexposed and completely blown out, moving the Highlights slider will only turn the white areas gray and will not recover details, because they don't exist on the sensor. Be watchful of this, as gray, milky whites are not attractive.

SHADOWS

The Shadows slider enables us to recover detail in the very dark areas of a photograph. Be careful not to overdo this, as you can easily end up with a faux HDR look. Not all photos will need shadow recovery. Move the slider to the right to open up the shadows and reveal details (**Figure 6.16**).

6.15

6.16

Adjusting the Shadows and Highlights sliders will reveal more of the dynamic range that was captured but hidden in the RAW file (or, to a lesser extent, in the JPEG file). Use of these sliders will reduce the contrast of the photo and make it look a little washed out. That's OK. Don't worry about contrast yet; we will get to it soon. Also keep an eye out for noise. If you open up shadow areas too much, you will see speckled noise appear in your photograph. While a little bit is acceptable, too much will ruin the image.

EXPOSURE

The Exposure slider adjusts the overall brightness of an image. Even though it affects the entire image, it's where you can tune your midtones (the grays). Sometimes I begin with the Exposure slider if the image overall is too dark or too bright. Whether I begin with Exposure or wait until after Shadows and Highlights, I always check it at this stage of the adjustment. It's a balancing act. To adjust exposure, move the Exposure slider to the left to darken or to the right to brighten. In this case, I barely moved the Exposure slider, because not much adjustment was required (**Figure 6.17**).

6.17

WHITES

At this point we are looking at setting the contrast of the image. What is contrast? High contrast is having clean, bright whites and deep blacks in the shadows—more of a punchy image. Low contrast is akin to looking out a dirty window. The picture can look faded.

You could move the Contrast slider to the right to add more contrast, or to the left to reduce it and increase dynamic range. I rarely move the Contrast slider because I prefer separate control of the highlights and shadows. By using the Blacks and Whites

sliders, I can choose high contrast in the shadows but low contrast in the highlights.

There are two ways to use the Whites slider. If there are highlights or areas of white that have turned milky or gray, moving the Whites slider slightly to the right can clean these up and produce clean, crisp highlights. This is its main use. A secondary use is in a situation in which we need to recover more highlights than the Highlights slider was able to; moving the Whites slider slightly to the left will bring out more detail. Since there are very few pure whites in this image, this works well (**Figure 6.18**).

6.18

BLACKS

The Blacks slider is where you push the darkest shadows, without detail, into pure black. This gives the most contrast punch. An image without true blacks can look washed out and lacking body. Move the Blacks slider to the left to darken the shadows (**Figure 6.19**).

When an area of shadow is solid black with no details, or when highlights are solid white with no details, it's called clipping. Usually the goal is to show as much detail as possible, (while keeping it tasteful). You usually want to set the Blacks and Whites sliders to add contrast but avoid clipping your image. Here is a tip to help you do that: Hold down the Alt key (Option key on Mac) and move the Blacks or Whites slider. The image will initially appear blank white. As you move the slider, areas of the image will start to appear. These are the areas that will be clipped if you apply the slider. Use this technique to quickly identify when clipping will begin to help you choose how far to move the sliders (**Figure 6.20**).

6.19

6.20

This little trick also works with the Exposure, Shadows, and Highlights sliders. **Figure 6.21** shows an image that is adjusted right to the clipping point using the basic adjustments. It produces a very natural result, which is preferable to some people. In our example, we have slightly exaggerated the details, which is something I personally like with the small cameras on the Phantoms and GoPros. With the Inspire Pro (X5), I go for a more natural result because the sensor detail is better. How far you move these sliders is entirely up to you, of course, and we all have different preferences.

6.21 A natural, non-stylized adjustment. You can see that there is less movement on the Shadows and Highlights sliders.

PRESENCE

You'll find additional adjustments in a section called Presence at the bottom of the Basic panel. These adjustments allow a little creative boost. There are three tools that add some pop to your images, but they do it differently. If you really want to make your images pop use the presence tools. These aren't sharpening tools, although they will make the image look sharper.

TEXTURE

The texture slider is the newest of the three sliders. This is really great for revealing surface textures. A little bit of this adjustment can add dimension and make an image feel like it has touchable depth. It's also worth noting that using a negative number can smoothen textures. In the past, people have used negative clarity to smoothen textures, but it's a practice I never cared for, because of the artificial appearance. With texture it now works quite nicely. Notice the subtle textures on the tile roof and water in this image.

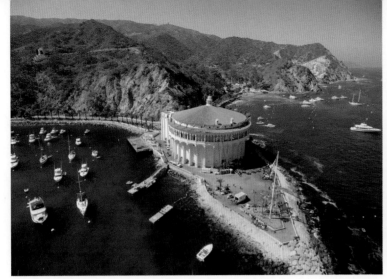

6.22A The image before Presence adjustments

6.22B

6.23

CLARITY

Clarity was the first of the presence tools introduced to Lightroom and Camera Raw. It was introduced at a time when the grungy Faux HDR look was all the rage. This tool increases midtone contrast. It adds fine halos in the midtone region, thus making the image pop and appear to have more definition. Be careful with this tool because it can make a photo pop, but it can also make it look over-processed very easily. Most of the time, I opt for texture over clarity, but it certainly has its place if used subtly. Overuse and your images will have that 2010s grungy faux HDR effect. If that's what you are aiming for, go for it. Otherwise just be gentle.

6.24A

DEHAZE

Dehaze was released with the most fanfare of the three tools. It was first revealed as a "sneak" at Adobe Max. It has been marketed as a miracle tool to reduce glare and haze in an image. While it does a remarkable job of doing what it was intended to do, I have found it has an even better use. Adding some Dehaze can bring out texture in clouds in a way no other tool does. I love to pop clouds with this tool. When you use Dehaze, note that it crushes the blacks. Usually you can compensate by moving the Blacks slider to the right.

6.24B

6.25

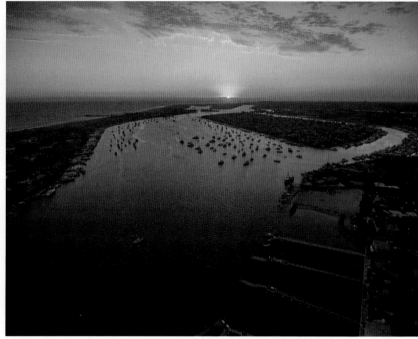

6.26 See the image to show before and after adding Dehaze.
See how it makes the sky come alive.

6.28

6.27

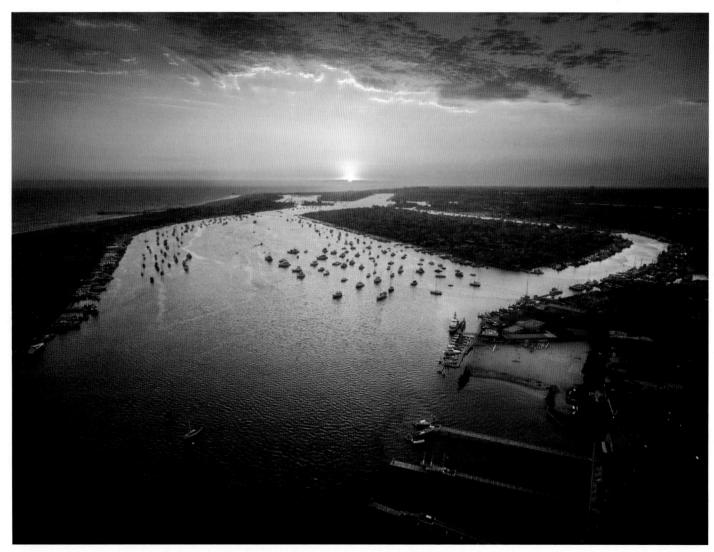

6.29 And here is the final image after further adjustments that you will learn in this next chapter when we look at Dodge and Burn and a final color correction to top it off.

VIBRANCE AND SATURATION

The Saturation and Vibrance sliders increase or reduce the amount of color. The difference is that Vibrance looks for areas with a low amount of color and boosts those more than areas that already have a lot of color. This allows you to add color without clipping the existing color in the image. A little vibrance in skies, water, and sunsets can go a long way (**Figure 6.30**).

6.30

LOCAL CORRECTIONS

SO FAR WE HAVE EXAMINED GLOBAL ADJUSTMENTS, or adjustments that affect the entire image. But sometimes an image looks great, but there is one part that is too bright or too dark and you can't fix it without messing up the rest of the photo. This is where local corrections come in handy. The one that you will use the most is the Gradient tool. The Gradient tool is most useful for skies. Because the sky is usually your light source, it's often brighter than the rest of the image. The Gradient tool is a great way to darken the sky to allow color, clouds, and sunsets to show without over-darkening the rest of the photo.

Gradient

When shooting outdoors with lots of sky, you will find it's very common to get a very bright sky against a dark foreground. This is understandable as the sky is basically one large light source. The challenge is to darken the sky down enough to see the clouds and sometimes the sun (sunset, sunrise) whilst keeping the foreground legible. Later on, we will look at the more advanced techniques of HDR and Exposure blending. For now, let's look at the simplest of solutions. We will create a gradient to make the sky darker.

6.31 Make your basic overall adjustments in the develop module. Notice the sky is too bright.

1. Click on the masks icon (1). Choose the Linear Gradient from the menu that appears (2).

2. You will see a mask panel appear—this shows the gradient mask.

TIP *You can drag the Masks panel to the side panel and dock it if you like (***Figure 6.33***).*

3. **Figure 6.34** shows the panel docked

4. To apply the gradient, click and drag on your image. A rubylith color will appear. Because everything in Lightroom is non-destructive, you can reposition the gradient at will.

5. In the Gradient adjustment panel, darken the sky area. Notice just the rubylith area of the mask is adjusted.

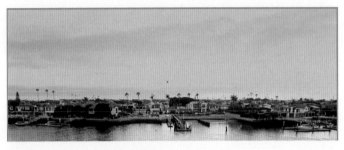

6.35

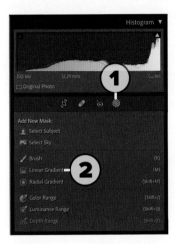

6.32

6.33

6.34

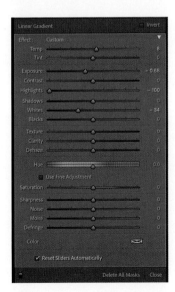

6.36

For skies, I always start by reducing the Highlights slider to reveal cloud detail and sky color. At this point, change the exposure to a pleasing level. On brighter skies such as this one, you can slightly reduce the whites. Be careful not to overdo the whites or your skies can look unnaturally gray.

6.37 Here we have a nice balance of detail in the sky and foreground, without the image looking overly processed.

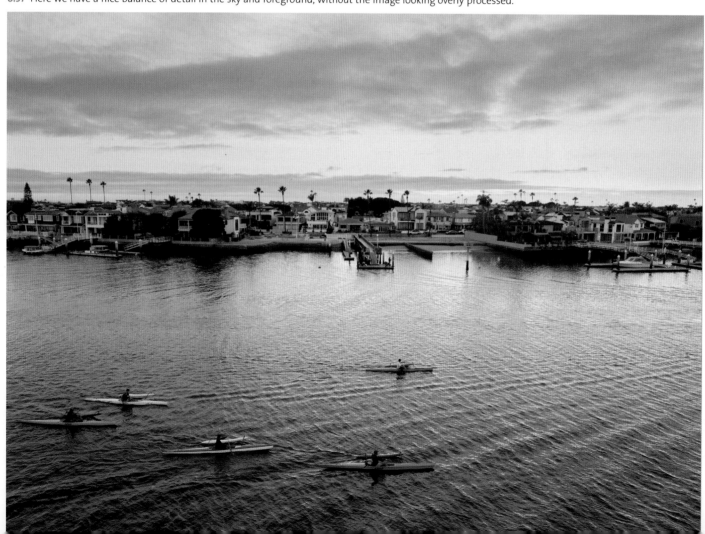

Using AI Tools to Darken the Sky

In Lightroom 2022, there was a huge update to the masking tools in Lightroom and Camera Raw to include some AI (Artificial Intelligence). These tools are called Adobe Sensei. This tool can automatically detect subjects and skies in images. They are perfect for selecting key areas of photos and selectively adjusting them.

The most common one you will encounter is the sky selection.

Let's use this photograph of a yacht returning to Newport Harbor at sunset. We can see some nice reflection in the water, but this image could be enhanced by making the color in the sky really pop.

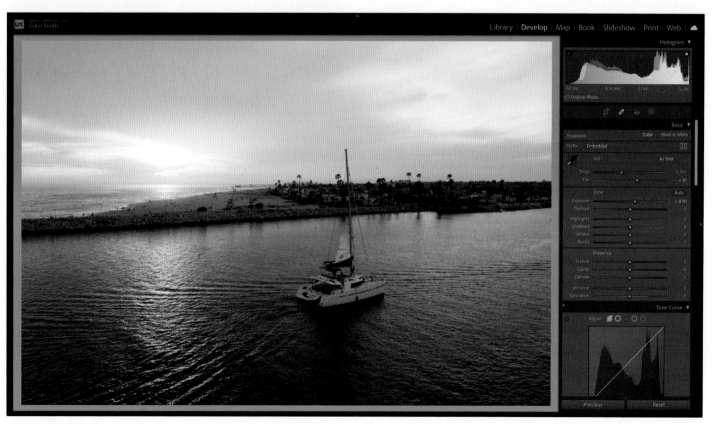

6.38

1. Choose the Mask.

2. From the dropdown, choose Select Sky.

 You will see Sky under the Mask tool and the sky will be selected in your image.

3. Make the appropriate adjustments to make the sky pop more.

 The main two adjustments are the same as we used in the gradient. Lower Highlights and exposure.

TIP *Sometimes reducing dehaze slightly can really bring out the details in clouds. This particular image didn't need it.*

You can see here, the sky is darkened.

However, part of the water was also selected.

You can refine the AI selection to fix it because it isn't always perfect.

6.39

6.40

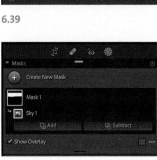

6.41

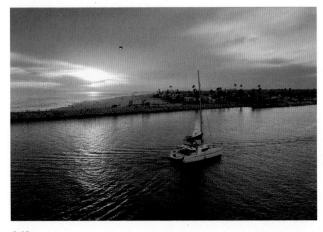

6.42

6.43

Here is how to refine a selection.

1. Click on the Mask in the Masks panel. You will now see two buttons, Add and Subtract.

2. Choose the Subtract button—this will make a new mask that will undo portions of the existing mask.

 You can choose any of the tools from the Subtract mask (or the Add mask, if you want to add to an existing selection).

3. Choose the brush option.

4. With the brush, choose the size and density. To simply paint away the existing selection, turn the density to 100.

 As you paint on the mask, you can paint away the areas that you want to remove.

5. When you have finished making the edit, choose the close button to close the Masks panel.

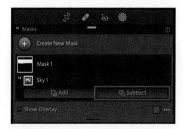

6.44

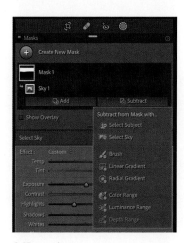

6.45

6.46

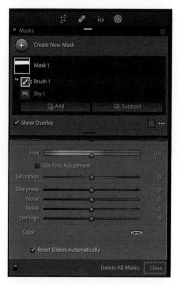

6.48

6.47

A nice final touch that can look nice for sunset shots is to slightly warm up the Temperature.

This brings back the color I saw at the time of shooting.

6.49

6.50

Making the Subject Pop

Another AI tool is Select Subject. This is one you won't use as often for drone photography, but for those low shots it can be a really powerful way to pop your subjects.

Here is a photo I shot at Eaves Movie Ranch in Santa Fe, New Mexico, with a phantom 4 pro. I just love the incoming storm in the background. It would be really nice to brighten up this old western church just a little bit without affecting the wonderful sky, or the grass in the foreground.

Click on Masks and choose Select Subject.

Lightroom will now select the church. I know it's like magic. The AI actually analyzes the photo and knows it's a building.

6.52

6.51

6.53

Increase the exposure very slightly. It's worth noting, that a small adjustment can go a long way.

The result is a brighter, cleaner-looking building, while the rest of the image is unchanged.

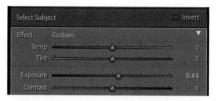

6.54

6.55

Adjustment Brush

The most powerful tool for local adjustments is the Adjustment Brush. This tool allows you to brush on the adjustments wherever you like. You can apply the basic adjustments to any portion of the photo. Here is a good way to use it.

Make your global adjustments to the image in **Figure 6.56**. We want to add some details to the shipwreck but not to the rest of the image.

1. Click on the Masks button and then the Adjustment Brush to make it active (**Figure 6.57**).

2. Adjust the Size, Feather (softness), Flow (painting opacity), and Density (overall opacity) settings (**Figure 6.58**).

3. Turn on Auto Mask if you want to detect edges and paint inside the lines; otherwise, turn it off.

6.56

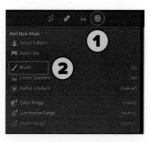

6.57

6.58

4. Paint over the object you want to adjust. (**Figure 6.59**).

5. Make your desired adjustments to the masked area. Note, I added a little bit of texture (**Figure 6.60**).

6. The result is shown in **Figure 6.61**.

6.59

6.60

6.61

FIXING THE BAD STUFF

A COUPLE OF BAD THINGS CAN HAPPEN TO A PHOTOGRAPH. When posting images on social media, they may be too small for these deformities to be noticeable. But if you are going to print any of your photos, then you definitely need to know how to resolve these issues.

Noise

You could think of noise as film grain; the difference is that some people find film grain pleasing because it's a natural by-product of the way we used to make images. Noise is just bad, and it's not an attractive type of grain. Noise is a by-product of the sensor working hard and trying to capture details. There are three main causes of noise:

- Shooting in a low-light situation. Noise will especially manifest in the shadows.

- Shooting with the ISO turned up high. Many quadcopter cameras will show noise at any ISO higher than 100. Try taking a few test shots to find out at what ISO the noise becomes unacceptable on your camera, and then avoid going above that number. When the ISO is turned up, it boosts the sensitivity of the sensor, which produces noise.

- The sensor getting hot. If you are shooting a lot of video without any cool-down time in between shots, you might start to see noise.

Figure 6.62 displays noise. It's not always easy to see the noise until you zoom in close.

6.62 This image displays noise

In **Figure 6.63** you can clearly see the noise. It's widely recommended to view images at 100% for noise reduction and sharpening. There are two types of noise: color noise and luminosity noise. Color noise is when the grain on the images contains colors that don't belong. This is the easiest type of noise to reduce, and usually a very small amount of color noise reduction will do the trick.

In the Detail panel, look for Noise Reduction. Slide the Color slider to the right until the grain color looks even and the colored speckles are gone (**Figure 6.64**).

6.63

6.64

The second type of noise is luminosity noise. This is the grain structure that appears—the tiny dots everywhere. I chose this particular image because it's easy to see the side effects of noise reduction in the tire tracks in the sand. Move the Luminance slider to the right until the noise is reduced or gone. Play around with the Detail and Contrast sliders to restore as much detail to the image as you can. It's really a compromise between the level of acceptable noise and the loss of fine detail in your photo. In this case, I got quite heavy at 100%, maybe too heavy, but I wanted you to clearly see the difference (**Figure 6.65**).

6.65

Zoom back out and you can see the effect the noise reduction had on the entire image. This should look pretty decent for a social media post or online viewing, but for print, you may want to reduce the Luminance slider a little bit. Don't forget that we haven't applied any sharpening yet, and that will bring back some detail; sharpening is covered at the end of this chapter (**Figure 6.66**).

6.66

Chromatic Aberration

Chromatic Aberration, otherwise known as color fringing, is a result of the different colors of light at different wavelengths hitting the lens and sensor. An easier way of explaining it is to look at a photograph at 200% magnification. **Figure 6.67** displays color fringing as a purple halo around the white bows of the catamaran.

In the Lens Corrections panel, click the Color tab to reveal the Defringe tools. Select the Remove Chromatic Aberration check-box, and adjust the Amount slider to reduce or remove this problem (**Figures 6.68–6.69**).

6.67

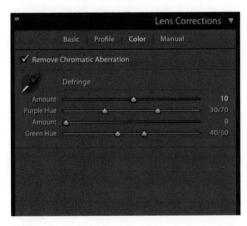

6.68

6.69

FINISHING TECHNIQUES

THESE TECHNIQUES aren't going to be used on every photo that you process, but I think you will find them very useful when you do need them.

Radial

The Radial adjustment is immensely useful when it comes to focusing the viewer's eye on a portion of a photo. This works a lot like the Gradient tool, but it works as an oval or circular shape that can be any size, angle, or location. Adjustments can be applied to the inside or outside of the elliptical selection.

In **Figure 6.70**, the island looks interesting, but the bright background competes for attention. We want to darken the surroundings without the rest of the image being affected, like shining a spotlight on it (**Figure 6.71**).

6.70

6.71

1. Apply a mask and choose Radial adjustment. Drag the radial shape.

2. Select Invert Mask so that the outside of the radial is affected.

3. Darken up the exposure.

4. Adjust the feather so it's nice and soft.

Figure 6.72 shows the result.

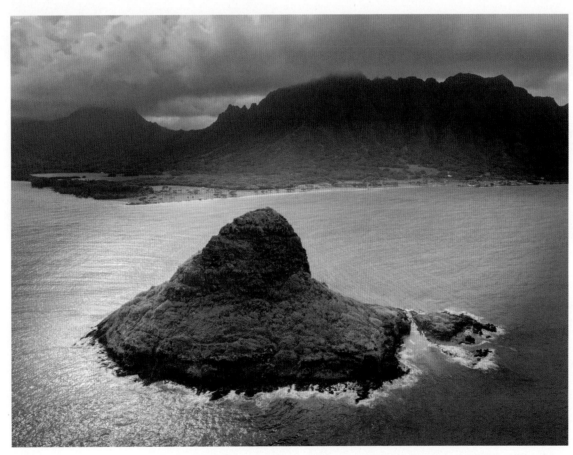

6.72

Vignette

One of the quickest ways to add a professional touch to a photo and draw the eye into the image is the use of a vignette. I'm sure you have seen them many times. What was once considered a flaw of the lens is now a popular effect. A rounded lens receives more light in the center than around the edges, which causes a darkening effect. There is a Vignette filter in Lightroom, but we aren't using it for this creative vignette. Instead, we are using the one in the Effects panel in the Develop module.

Whereas a regular vignette is applied to the original shape of a photo and can be cropped out, a post-crop vignette will fill the image, even after we crop it or change its shape.

6.73 An image without a vignette

6.74

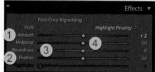

Let's take a look at the components of a vignette (**Figure 6.74**). The actual vignette you use will generally be much subtler, but in these examples, the settings are turned all the way up so you can clearly see what each setting does.

- **Amount:** To the left is darker; to the right is brighter. In this case, it's all the way to black.
- **Feather:** Softens and blends the edges. Here, it is all the way down and shows a hard edge.

- **Roundness:** From a rounded rectangle shape all the way to a circle.
- **Midpoint:** The size, from just in the corners to most of the image.

Here are some real-world settings and application of the vignette. You will notice I use these on a number of images in the book. After we apply the effect, notice how it draws you into the photo and adds an almost subliminal border to the image.

6.75 The different settings of a post-crop vignette

Creative Use of Dehaze

I mentioned the Dehaze adjustment already. Now I want to share a couple of useful creative applications of this effect. These aren't effects you will use often, but they are nice to have tucked away in case you need them. We can use them in conjunction with the Gradient tool to add or decrease atmosphere. An additional use for dehaze is bringing out details in clouds; it works really well

for this. You almost always have to move the blacks slide to the right a little bit to compensate for dehaze.

Add the Gradient tool and zero it out.

Add just a little bit of Dehaze and see how it gives the sky and clouds a boost.

6.76 Edited image
without Dehaze

6.77
Dehaze can add
punch to the
clouds and sky

We can also produce the opposite effect by reducing Dehaze, which will create some fog in the image.

In this example, we added a gradient and reduced the Dehaze slider. You can also use Lightroom masks to protect the subject. Here we subtracted from the gradient and chose select subject. This excludes the subject (boat) from the gradient.

6.78 The image before Dehaze is reduced

6.79 The image after Dehaze is reduced on the gradient. It looks like the fog has rolled in.

SHARPEN

LET'S WRAP UP THIS CHAPTER by talking about sharpening. All lenses create a slight amount of blur, so a little bit of sharpening is needed. Lightroom automatically applies a small amount of sharpening to every image as it's processed. Quite often, you might want to add more sharpening yourself.

The important thing is to leave sharpening until the very end. I often save unsharpened or minimally sharpened versions of an image so the last step (known as finishing sharpening) is dependent on how the photograph will be used. If you are going to print the image, it will require more sharpening than if you are going to post it on Facebook or Instagram.

The reason for this is resolution. The larger the image, the more sharpening you need. It also depends on how close the viewer will be to the image. If you are looking at the photo really close, you won't want too much sharpening, or people will see the halos around the details in your photo. However, if they are standing back a bit, looking at an image hanging on a wall, a bit more sharpening is desirable because it makes the photo look more crisp.

If you are going to print or output the image from Lightroom, then add some sharpening. However, if you are going to continue working on it in Photoshop, wait and add sharpening after the work is all done.

Sharpening Workflow

Whenever you're doing any sharpening, make sure you're viewing the photograph at 100% view so you can see the details.

The Amount slider determines how much sharpening is applied. Start with this slider; otherwise, nothing else will do anything (**Figure 6.81**).

Hold down Alt/Option to get a preview as you slide the Radius slider. Adjusting the radius will determine how bold the sharpening applied to the edges will be. Sharpening is achieved by adding contrast around the areas of detail. Too much and you will start to see halos around the edges. **Figure 6.82** shows a small radius.

With a larger radius, as in **Figure 6.83**, you can see what the Radius slider does to achieve sharpening.

Adjusting the Detail slider will bring out textures and lower contrast details. Holding down Alt/Option provides a preview of the detail areas that are being sharpened. Be careful—too much detail and a moiré pattern will start to appear on the image (**Figure 6.84**).

6.80 This image shows the photo zoomed in to 100%, with default sharpening applied

6.81 If you hold down the Alt/Option key while sliding the Amount slider, you will see a black and white overlay so that you can clearly see the results of the sharpening

6.82

6.83

6.84

6.85

Finally, the Masking slider will help you keep the sharpening effect while reducing noise or moiré that may have been introduced. Hold down Alt/Option as you move the slider to see where the sharpening will be applied (white areas) and where it will be masked or hidden (black areas). A zero amount will result in no masking and the preview will be solid white. An amount of 100 will result in no sharpening to the image at all and a solid black preview. To prevent the introduction of noise, find the amount where the edges and areas of important detail are being sharpened while larger areas without detail are being masked (**Figure 6.86**).

6.86

6.87 A closeup of an area with a lot of noise added in sharpening

6.88 Masking eliminates a lot of this noise

In **Figure 6.89** you can see an area of the photo at 100% with sharpening applied. Be sure to examine different parts of the photo to make sure the sharpening is pleasing throughout the image.

Figure 6.90 shows the full image with no sharpening applied.

Figure 6.91 shows the entire image after sharpening. It might be difficult to notice at full size. You want the sharpening to make the image crisp, but you don't want it to look like it was obviously manipulated.

6.89

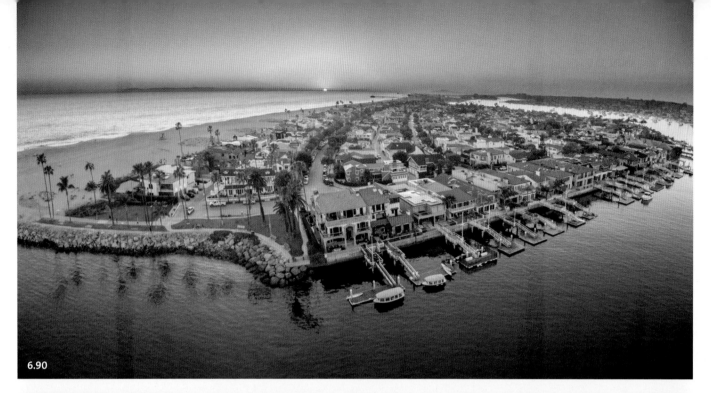

6.90

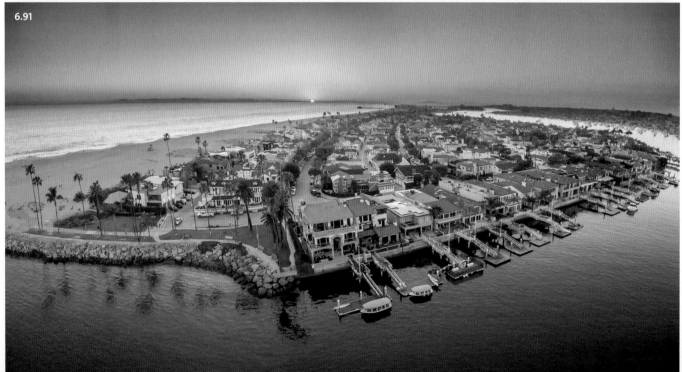

6.91

CONCLUSION

IN THIS CHAPTER, you learned a lot of basic image adjustments that will make up the bulk of your postproduction work in Lightroom or ACR. In the past, I would have suggested ways of doing a lot of these tasks using Photoshop's adjustments and filters. In today's world, all this basic processing is best handled in a modern tool such as Lightroom or ACR. It's much faster, it's completely nondestructive, and it produces better results than adjustments and filters. Remember that ACR and Lightroom aren't limited to RAW files; they are also your best bet for working with JPEG and TIFF files.

There are a number of tasks that only Photoshop can do or that Photoshop can do better than Lightroom. We are going to examine those in the next chapter. We aren't done with Lightroom yet, either. Advanced tasks, such as HDR and panoramas, will be covered in the next chapter.

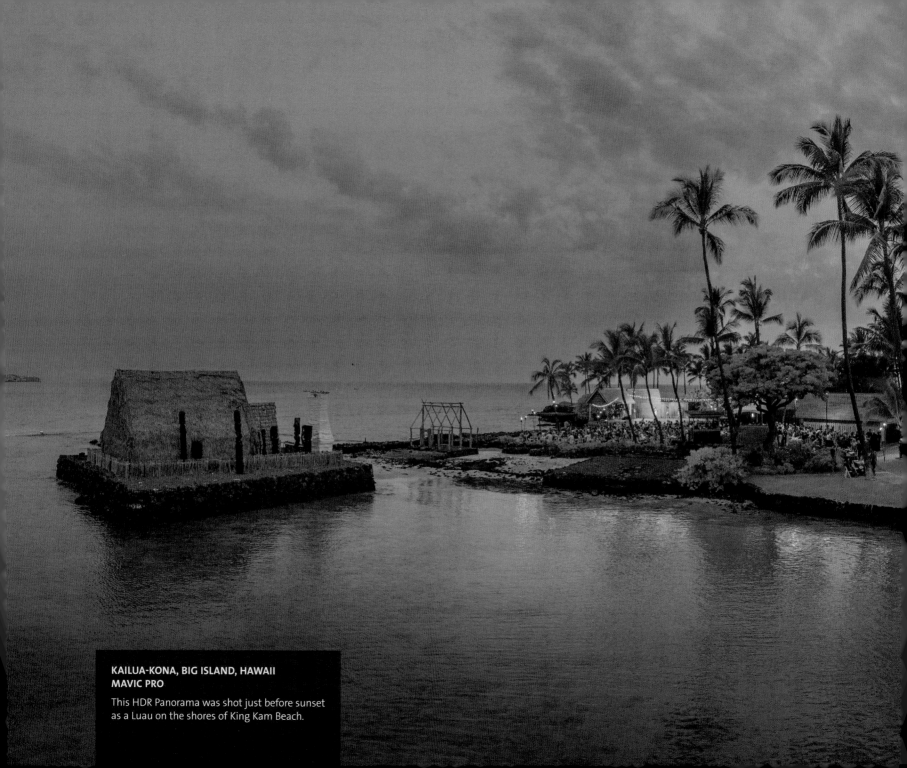

**KAILUA-KONA, BIG ISLAND, HAWAII
MAVIC PRO**

This HDR Panorama was shot just before sunset
as a Luau on the shores of King Kam Beach.

CHAPTER 7

ADVANCED PHOTO EDITING

IN THIS CHAPTER, we are going to apply a lot of the techniques used in the previous chapter. However, we are going to expand on these techniques and step it up a level. If you haven't read the previous chapter yet, I encourage you to do so before reading this one.

We're going to move into some more advanced techniques that involve working with multiple photographs and combining them. We will make panoramas and HDR images and even combine the two into HDR panoramas. We will also be covering multiple advanced techniques and lots of tips to help you get the very best results from your aerial photographs.

PANORAMAS

ONE OF THE MOST BREATHTAKING PHOTOS you can create with your drone is an aerial panorama. A panorama is when you capture multiple images while panning around a scene, then stitch them all together in software.

I have received more positive feedback on these types of images than any other. While they may appear difficult to make, it's actually quite easy to make an aerial panorama if you follow the upcoming steps carefully. Don't be discouraged if your first few panoramas don't look great. With practice, you will learn what works and what doesn't.

I'm going to show you how to create a panorama in both Lightroom and Photoshop. I prefer the Lightroom method because it's quicker. The Photoshop method works well for images that have a lot of distortion. The ultimate is to combine Lightroom and Photoshop in the workflow.

Panoramas in Lightroom

Adobe Lightroom Classic is a great choice for creating panoramas. Here is the Lightroom panorama workflow.

I discussed how to shoot panoramas in chapter 4, so I won't repeat that information. Let's begin with four images that we have captured for a panorama. Select all the images to be used in the panorama by Ctrl-/Command-clicking the thumbnails (**Figure 7.1**).

7.1

We need to prepare these images for stitching. We can perform some preliminary corrections by applying a lens profile. This step will dramatically increase the reliability of your merges.

Choose the Develop module and scroll down to the Lens Correction panel (**Figure 7.2A**). Apply a profile, as I described in the previous chapter:

1. Click Profile.
2. Select Enable Profile Corrections.
3. Choose the make (the manufacturer) of your camera.
4. Choose the model of your camera. Many of the newer DJI drones use a built-in profile. If this is the case, you will see Built-in as shown in (**Figure 7.2B**). This means the corrections are applied in-camera. In this case, skip the profile step as it isn't needed.

If you don't see your camera, choose something similar and experiment with the Distortion slider to remove the majority of the lens barreling.

Now that the majority of the lens distortion is removed from your photo, you want to pass these settings on to the rest of the images in the panorama (**Figure 7.3**):

1. Make sure the images are all selected in the filmstrip.
2. Either click the Sync button on the lower left of the right panel in the Develop module or choose Settings > Sync Settings from the top menus.
3. You will see the Synchronize Settings dialog. Click the Check None button to turn off all settings.
4. Select the Lens Corrections checkbox to only sync the lens profiles and nothing else. If you adjusted anything else in the single image, then make sure to sync those settings, too, or just click the Check All button in that case.
5. Click Synchronize, and all the selected photos will now have the same settings applied to them to match the profile.
6. It's time to make the panorama.

 Right-click and choose Photo Merge > Panorama. You will see three projection options. For most panoramas, Spherical will work best.

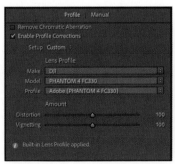

7.2A

7.2B

7.3

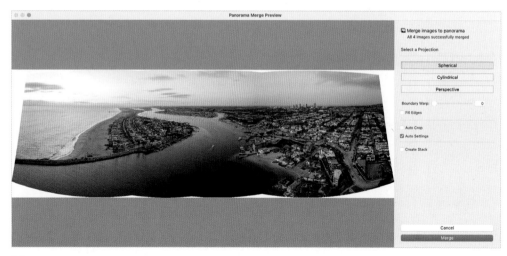

7.4

If you are shooting vertical panoramas or shooting directly down and flying in a grid to create a mapping style panorama, then use Perspective. These are the only times when Perspective might look good.

Note that if the camera was not level during shooting, you will see a wavy horizon or stair stepping no matter what you do. Either reshoot the panorama or use the Photoshop method in the next section.

PANORAMA PREVIEW

One of the things I love about Lightroom is the quick panorama preview. It hasn't stitched the images yet; it's just showing us what it will look like. This saves a lot of time because you can tell whether your pano is going to look good before stitching. This saves you the wasted time of trying to merge a pano that isn't going to look good or work well. While shooting panoramas, shoot the sequence several times, because sometimes they won't work, so it's good to have other options. When you are more experienced, you will have a much higher success rate.

Fixing the edges

You will notice a white boundary around the panorama. These are transparent areas. You will need to get your panorama into a rectangle, and there are two options for this: fill the white area, or crop it out. There are some useful tools for this.

AUTO CROP

You can choose to hide the transparent areas by automatically cropping the panorama. Turn on the Auto Crop option. The image will be cropped automatically to hide all the transparent pixels. The drawback of this method is you might lose a lot of your image. If nothing important is cropped out, it's a viable option.

This isn't a non-reversible decision because you can also turn off cropping in the Crop tool in Lightroom after merging and undo this.

BOUNDARY WARP

A fantastic feature is Boundary Warp. Once the white areas are cropped, you can lose some important information. The Boundary Warp will stretch the pixels to fill the rectangle, sort of like printing on silly putty and stretching it. Slide the Boundary Warp slider to the right and notice how Lightroom warps the image to recover the white space and unwrap the photo (**Figure 7.5**). You can push it all the way to the right and recover every pixel. However, at full strength, it could result in unnatural-looking warping in the image or a wavy horizon line. Find that balance of a straight horizon and recovered information.

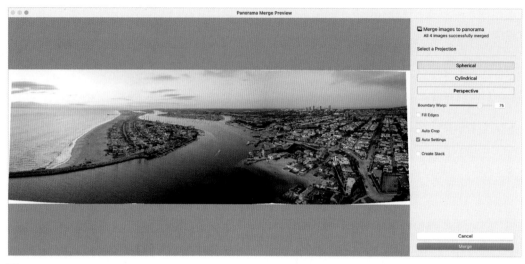

7.5

FILL EDGES

There is a third tool available, the Fill Edges (**Figure 7.6**) tool. Fill edges does content aware fill on the white edges. It automatically clones and stamps from the surrounding image to fill the hole. This tool works quite well in skies, foliage and areas lacking specific structures and other more random textures. Sometimes, you can see doubling of objects near the edges. Most of the time, it does a good-enough job that you can crop out the artifacts on the corners and get a good result without having to crop your images too tightly.

My favorite approach is a combination of all these three tools to get the best compromise. You can see that here in **Figure 7.7**.

You can choose to crop at any time; however, Boundary Warp and Fill Edges can only be applied in the initial merge preview window.

Click Merge and Lightroom will merge the photos together and create a merged panorama. The resulting image is a DNG file that still contains the full dynamic range of the image.

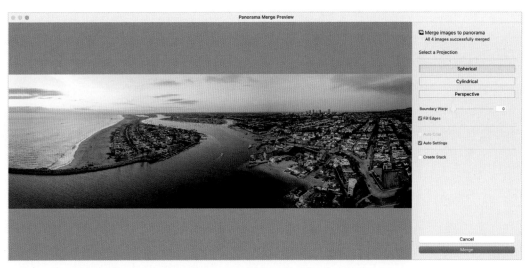

7.6

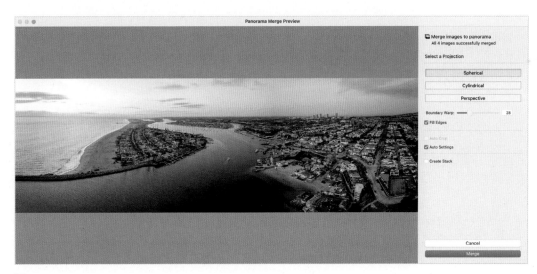

7.7

Note that if you shot your panorama as a grid and encompassed more than a single row, you don't do anything different. Simply select all the images that you want to use in the panorama and merge it just as we did here.

Here is the same panorama with the corrections from the previous chapter applied (**Figure 7.10**).

If you are curious, here are the settings I used in Figure 7.9. I also applied the Gradient filter to the sky and slightly turned down the exposure and the color balance. This is covered in the previous chapter.

7.8

7.9

7.10

Panoramas in Photoshop

There are a number of other applications that can merge panoramas, including PT GUI. I don't have space to cover them all here, so I'm sticking to Lightroom and Photoshop, which is what I use anyway. Photoshop is great if the image is too distorted in Lightroom, if you don't have Lightroom, or if you just prefer doing it in Photoshop. Here are instructions for making Panoramas in Adobe Photoshop.

Open the Images in Lightroom or Adobe Bridge (it comes free with Photoshop). If you are doing it in Bridge, here are a couple of steps to follow (**Figure 7.11**).

Select all the photos that you want to include in the panorama. Right-click a thumbnail and choose Open in Camera Raw.

In Camera Raw, we are going to apply the lens profile to reduce distortion (**Figure 7.12**).

1. In the Filmstrip, select all the images by pressing Ctrl/Command+A, or right-click a thumbnail and choose Select All. Whatever adjustments you make to an individual image are now going to affect them all.

2. Click the Optics panel.

3. Apply the lens profile.

7.11

4. Check that it's using the correct profile. If not, choose your camera from the options. If it says *built-in*, don't worry about this step, as the profile is applied in camera.

5. Click Done to apply the settings and return to Bridge.

Time to pass the images off to Photoshop. From Bridge, choose Tools > Photoshop > Photomerge (**Figure 7.13**).

7.12

7.13

A great way to work is to start in Lightroom and hand off the photos to Photoshop to do the merging. Apply the lens corrections first in Lightroom, like we did in the previous tutorial. Then right-click and choose Edit In > Merge to Panorama in Photoshop (**Figure 7.14**).

7.14

It doesn't matter if you start from either Lightroom or Bridge, the result is the same and they both open in the same tool in Photoshop.

You will now see the Photomerge dialog in Photoshop (**Figure 7.15**).

1. Source files show the images that will be included. Notice support for RAW files.

2. Choose a projection method (layout). Cylindrical works best for the majority of stitches, or try Auto.

3. You will see a few options. Blend Images Together is turned on; otherwise, the images will only be aligned and not masked together.

4. To save time, Vignette Removal and Geometric Distortion Correction are turned off, because they were already done when we applied the Camera Lens profile. It won't harm the image to turn these options on; it will just take longer to complete the stitch.

5. Content Aware Fill Transparent Areas is a nice option to save you time, and we used it in the Lightroom Panorama previously. However, we are going to be doing some manual corrections, so we will leave it off because it's pointless applying it at this stage of our workflow. Click OK to finish.

7.15

After a bit of a wait, Photoshop will complete the merging of all the different photos and you will see something that looks like a caveman rug with your panorama on it (**Figure 7.16**).

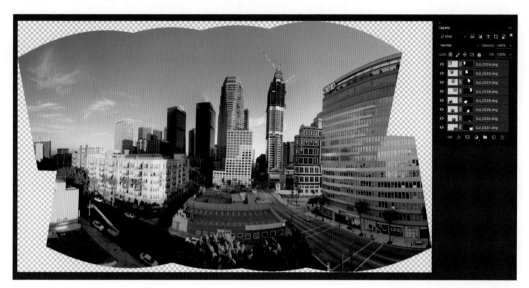

7.16

FIXING DISTORTION IN PHOTOSHOP

We are going to stretch our image around a bit and clean up the edges.

With all the layers selected, press Ctrl/Command+E to merge all the layers into a single layer (**Figure 7.17**).

Choose Filter > Adaptive Wide Angle to enter a tool that we can use to repair distortion and bending. It will automatically choose the Panorama option in the top right. (If you are bringing in a finished panorama from Lightroom for correction, try changing to the Fisheye option.)

7.17

To use this tool, drag the Constraint tool across bent areas to straighten them. It's a bit of a balancing act, like multiple people jumping on a trampoline at once. Sometimes an adjustment will look good, and other times it will ruin the rest of the image; be prepared to frequently press Ctrl/Command+Z to undo. Here is how I like to approach the Adaptive Wide Angle tool to straighten images.

The first thing we need to do is create a level horizon (often, this is the only correction I do to a panorama) (**Figure 7.18**). On the left side, drag the Constraint tool across what should be the horizon line. Hold down the Shift key and the line will turn yellow. This means

that it will force the pixels underneath to a perfectly horizontal line and the rest of the image will be rotated and warped to fit.

Repeat for the right side of the image. This will level the entire image. You can't do it all in a single line; you have to approach it from the left and the right separately.

Now we can straighten key elements in the photograph. Be careful that you don't overdo it, but take your time and have fun. Notice that the building at the bottom is bent. Drag the line out and you will see that it curves with the distortion (**Figure 7.19**).

7.18

7.19

I decided not to hold down Shift on this because I didn't want to rotate the slope of the hill, just remove the bending. See the result in **Figure 7.20**.

1. Notice that the horizontal lines display in yellow while the angled ones display in blue.
2. Vertical lines can be set to a perfect 90 degrees by holding down Shift. Notice I straightened some of the buildings on this.
3. I also straightened the top of the building on the right with another adjustment.

When you are satisfied with the result, click OK to apply. Try to get all your work done at once; going back into the Adaptive Wide Angle more than once doesn't produce the best results.

To finish up the panorama we need to crop the final image (**Figure 7.21**). Choose the Crop tool and decide on the size of the final image. It's OK to leave a few gaps on the sides and maybe the corners because we can fill these back up later. When you are happy with the crop, press the Enter key.

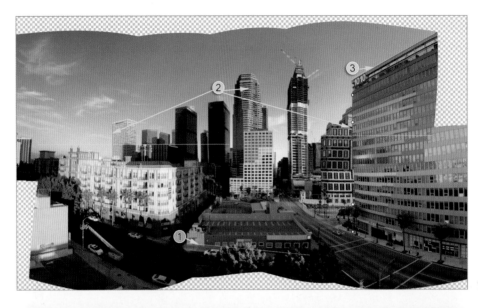

7.20

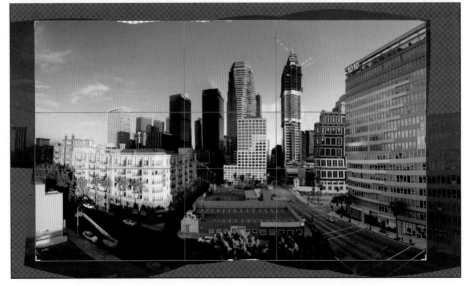

7.21

We need to fill up the gaps. Ctrl-/Command-click the thumbnail in the Layers panel to select all the transparent parts of the image (**Figure 7.22**).

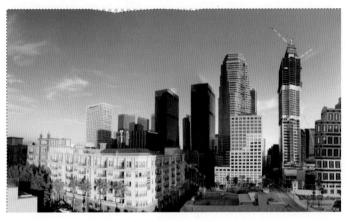

7.22

Press Ctrl+Alt+I (Command+Option+I on Mac) to invert the selection.

We also need to expand the selection so that there is some overlap. Choose Select > Modify > Expand. Choose about 10 pixels (**Figure 7.23**).

7.23

Now, fill with the Content-Aware Fill. Choose Edit > Fill, and choose Content-Aware from the option (**Figure 7.24**).

7.24

All the edges should now be filled with a similar pattern and texture. If not, select those areas and re-apply Content-Aware Fill (**Figure 7.25**).

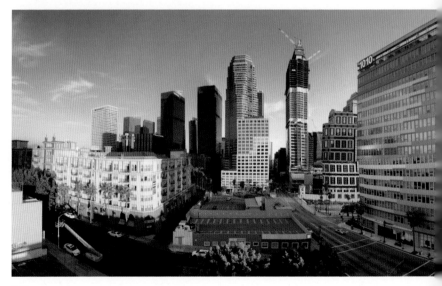

7.25

HIGH DYNAMIC RANGE (HDR) IMAGES

THERE IS A LIMITATION IN PHOTOGRAPHY—the dynamic range of the sensor. Dynamic range refers to how much of the visible spectrum can be captured on the sensor at once. Most of the time, this isn't a huge issue. However, when you are shooting a high-contrast scene, such as a sunset, this becomes a problem. Just think of images that you have seen that look great but have a white blob in the sky where the sun should be. **Figure 7.26** is one of my earlier images, and you can see that the sensor wasn't able to capture enough information in the sky for there to be any visible details in the reflections on the left. Although this might have been acceptable a few years ago when aerial photography was rarer, it's not as forgivable today.

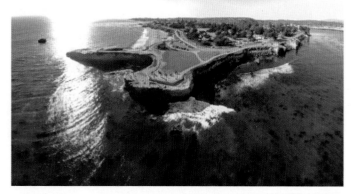

7.26

This is particularly challenging for aerial photography, because you are often capturing a bright sky against a darker foreground, clothed in shadow. Here is the solution: Capture more than one photo, with each one having a different exposure to capture the highlights and shadows separately. Then, blend them together into a single photo. This single photo is called HDR, or high dynamic range, because it has more dynamic range than can be captured in a single photograph. I talk about this more and provide instructions on how to capture these images in chapter 4.

Typically, we would choose a correct exposure for either the ground or the sky for these types of exposures and then compromise in the rest of the photo. (A graduated ND filter can help with this issue, too.)

Figure 7.27 shows a correct exposure for the sky. There are lots of details in the clouds. But if you look at the foreground, almost all the detail is lost in the dark.

We make another exposure to capture all the details in the foreground (**Figure 7.28**), but the sky is now completely blown out, because the sensor can't capture enough highlight detail at the same time.

The solution is to do AEB (auto exposure bracketing) and capture a series of images with different exposures. You can change the camera settings manually between shots to capture the full dynamic range of a scene on cameras that can't do it automatically. Typically on my terrestrial camera, I do three exposures for an HDR capture: normal exposure, an exposure over by two stops, and an exposure under by two stops. The DJI app is preset to .7 stop brackets, so I usually go for the highest spread and capture AEB in five images.

7.27

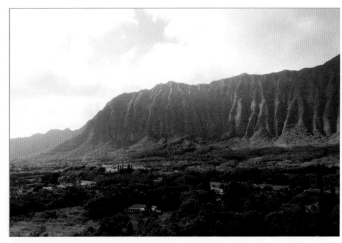

7.28

Here in Lightroom, I have selected all five images in the Library module; this is the first step to making an HDR image (**Figure 7.29**). We can do the same thing in ACR after opening all five images from Bridge.

Right-click and choose Photo Merge > HDR (**Figure 7.30**).

You will see a preview and some options. If you didn't achieve the expected result, turn on the Auto Tone option (**Figure 7.31**).

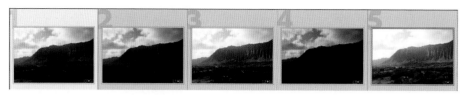

7.29

7.30

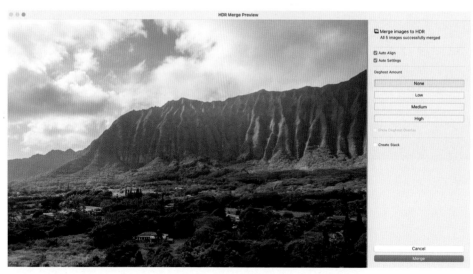

7.31

DEGHOSTING

Let's talk about deghosting. When you merge the different photos together, any movement between shots will appear different between frames—for example, a person walking through the frame, a car driving by, etc. The person or the car won't appear in all the frames, and if they do, it will be a different position for each frame. When the frames are merged together, these "sometimes present" objects will manifest as ghosting. If something is in one shot and not another, it could appear as a semitransparent overlay and look a bit weird. Hence the name ghosting.

Other movement, like leaves blowing or moving water, can also cause ghosting. You have to decide if the ghosting is a problem or not.

Choose Low, Medium, or High deghosting. Always use the lowest amount possible to preserve image quality.

In **Figure 7.32**, you can see that ghosting is a problem. Instead of being attacked by one seagull, it looks like I am being attacked by two.

Turn on deghosting and the ghosted seagull disappears (**Figure 7.33**).

7.32

7.33

This last step is completely optional: You can turn off Auto Tone before merging. Even though it doesn't do anything that isn't reversible (it moves the sliders to what Lightroom considers the best starting point for image adjustments), if you prefer to do all the adjustments yourself, then turn it off (**Figure 7.34**).

Click Merge, and Lightroom will merge the photographs together to make a single DNG file with the information for all the photos together. You will see a progress bar at the top left (**Figure 7.35**).

The next step is to make some more adjustments. To avoid having to hunt for your newly merged HDR images, change the sorting in Lightroom to Added Order (**Figure 7.36**). You can scroll to the bottom and they will be the last images there.

And here is the unedited merged image (**Figure 7.37**).

You will now edit this image just like you would any other photo. The difference is that you will have a lot more detail to play with in the exposure, highlights, and shadows.

Move the Highlights slider all the way to the left to see the impressive amount of highlight detail in the clouds (**Figure 7.38**).

Here are some basic adjustments made to the image in Lightroom. As usual, you can see the settings in the Adjustments panel (**Figure 7.39**).

7.34

7.35

7.36

7.37

7.38

7.39

It would look nice if we could lighten up the foreground a bit more without lightening the sky. Because we are using HDR, we have lots of detail in the highlights and shadows to play with.

Let's mask the foreground so we can adjust it separately.

Click the Mask button on the tool bar and choose Select Sky (**Figure 7.40**).

Notice the sky is selected (**Figure 7.41**) But we want the opposite.

See the three dots to the right of the sky mask? Click the dots and choose invert from the pop-up menu (**Figure 7.42**). You will see the foreground is now selected (**Figure 7.43**).

Make adjustments to make the cliffs pop more as shown in (**Figure 7.44**).

Just to show you can have even more control, such as lightening the foreground and not altering the cliffs anymore, click Create New mask and choose a gradient. Drag the gradient up to the edge of the cliffs (**Figure 7.45**).

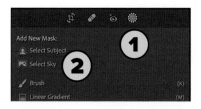

7.40

7.42

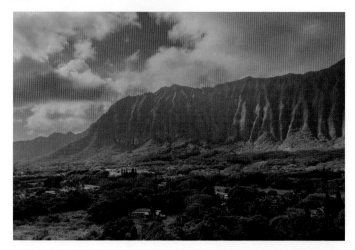

7.41

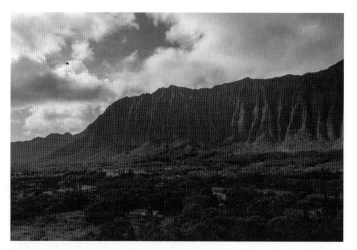

7.43

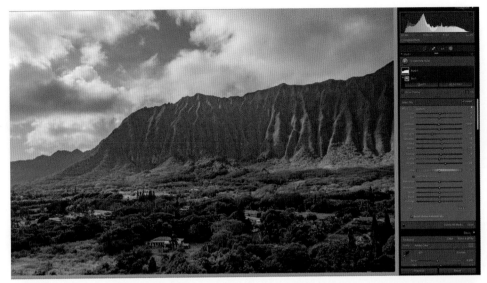

7.44

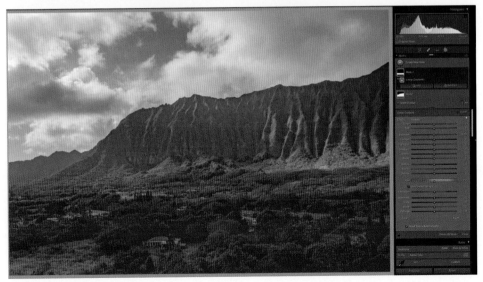

7.45

And a few more adjustments to brighten the foreground (**Figure 7.46**). The final image is **Figure 7.47**.

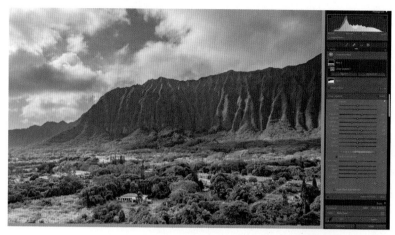

7.46

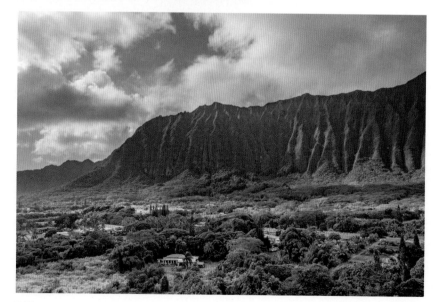

7.47

HDR PANORAMA

ONE THING I GET A TON OF QUESTIONS ABOUT is how I do my HDR panoramas, which are a combination of HDR and panorama in the same image. This gives you a nice wide Panorama, with the dynamic Range of an HDR. These images can be quite stunning. I'm going to walk you through the entire process of producing these images. In chapter 4, I discuss how to shoot these images, and now I'll show you how to put them together.

For this example, we will create a 24-Image HDR panorama (**Figure 7.48**). This is an 8-Panel Stacked Panorama. It consists of two rows of four panels each. The first four are covering the top half of the image and the additional are covering the bottom half of the image. Each Panel is a three-shot bracketed HDR capture. I have color coded each bracketed capture to make it easier to visualize. We are going to follow the process through and address potential issues along the way.

In Lightroom Classic (or Adobe Camera Raw) Select all 24 images. Right-click and choose Photo Merge>HDR Panorama.

7.48

Lightroom will open up the merge window and attempt to merge them together. This may take a little time, because it's a complex process.

After some time, you will see the preview if all went well (**Figure 7.49**).

If you look closely, you can see some strange marbling in the sky (**Figure 7.50**). Most of the time, this won't happen. Click Merge and Lightroom will create a new HDR Panorama.

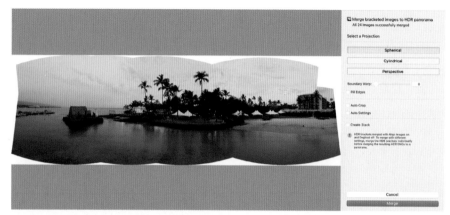

7.49

7.50

If we finish the process, you can see that the marbling in the sky isn't the only issue. Look closely at the middle palm tree. Can you see a bright halo around it? These artifacts are caused by ghosting (**Figure 7.51**).

Because the HDR is a bracket of multiple images (three in this case, but could be five, or even two) they are blended into one. If there is any movement between the shots—blowing branches, fast moving clouds, waves, vehicles, or people moving though the frame—they won't appear in the same position in all the frames. When they are merged, this position change may appear in only one frame. This creates a faint impression (like a double exposure) or some other artifact known as ghosting. Most of the time, you won't have too much trouble with ghosting, but in this case, it's causing an issue.

If you have an issue with ghosting, or the merge failed, it's OK. Take heart, here is how to do the process in a way where we have more control.

The process is actually quite simple. The first thing you need to do is merge all the HDR images together in Lightroom/ACR. Then when you have the new HDR images, you just treat them like regular photographs and stitch them into a panorama. The trick is to do HDR first, and then panorama. Lightroom/ACR will enable you to merge together HDR images. It won't work the other way around. This is a combination of the things we have already learned.

The first step is to merge each set of pictures into individual HDR images.

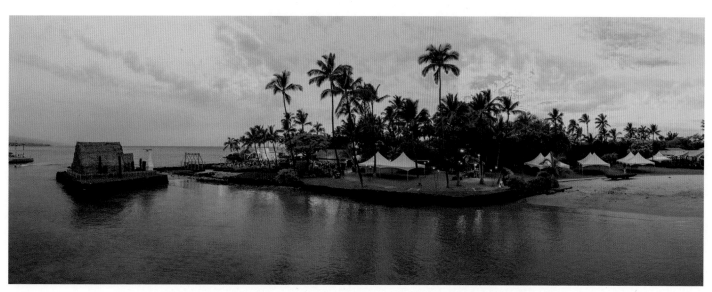

7.51

Select the first bracket of three images. Right-click and choose Photo Merge>HDR (**Figure 7.52**).

In the preview window, you can see the marbling problem (**Figure 7.53**).

Under Deghost Amount, change it from None to Low. Notice (**Figure 7.54**) that Lightroom fixes the ghosting and the image looks great now. Sometimes, you might need medium or even high, but always use the lowest amount you can.

7.52

7.53

7.54

Click Merge and the images will be merged and a new merged HDR image will be added to the group of images. Its name is appended with HDR and you can see a badge on the thumbnail indicating this image has been processed.

Now, we need to also merge each of the remaining brackets.

Here is a tip to speed things up when dealing with multiple HDR sets: Select the next three images to merge to HDR. Instead of going through all the steps we did in the previous HDR tutorial, use the keyboard shortcut Control+Shift+H (on Mac and Windows). This will put Lightroom into "headless" mode. It will merge the HDR images and skip the dialog. It will apply whatever settings were used the last time you used Merge to HDR. I suggest merging the first one the normal way (thus getting the settings that you want). In this case, we are using a low amount of Deghosting, Unfortunately, at the time of this writing you can't assign deghosting to the full auto HDR Panorama, which is why we are doing it this way now.

Without waiting for the merge to complete, immediately select the next five images and press Control+Shift+H. (For a bigger image, continue doing this for each set.)

You will notice that at the top left of Lightroom, there will be a progress bar that shows you the multiple processes going on at once (**Figure 7.55**).

7.55

When Lightroom is done, the merged HDR images will appear in the grids. Rather than trying to cherry pick the HDR images, change the sorting order to Added Order to push the newly merged files to the end of the grid.

7.56

7.57

Select all the HDR images that you wish to merge into a panorama. Do this the same way you would select normal images if you were doing a regular panorama. Select the images, right-click and choose Photo Merge>Panorama.

7.58

Notice that Lightroom/ACR merges these HDR images with no problem. Also note that there are no issues with ghosting anymore, just a nice clean merge.

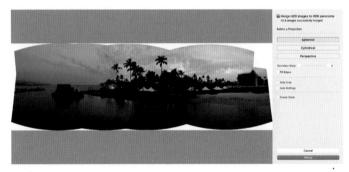

7.59

Crop, Fill Edges, or Boundary warp to remove the white edges (see the beginning of this chapter under Panoramas for an explanation of this). In this case, we chose to fill edges.

7.60

Merge and crop the ends for a nice composition.

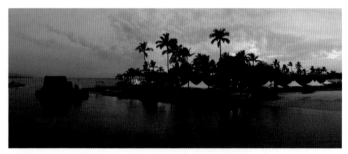

7.61

To finish off the image, apply some basic adjustments to make the details pop. **Figure 7.62** shows the settings and **Figure 7.63** shows our final HDR Panorama. These images can be very large and look fantastic when printed as large panoramas and hung on a wall.

7.62

7.63

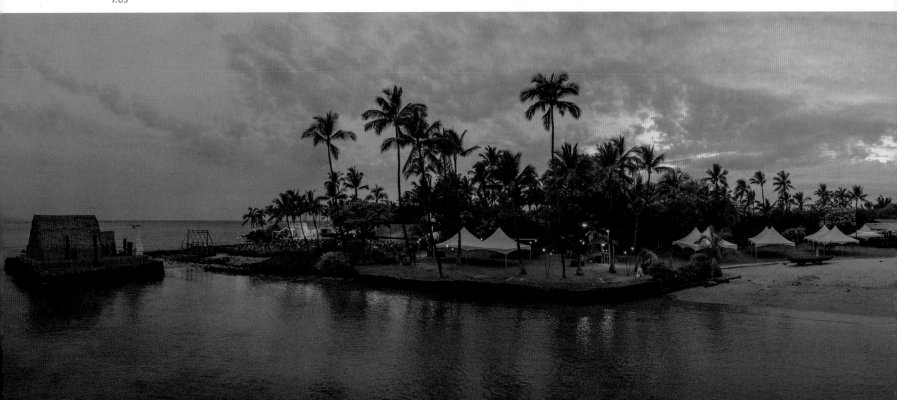

EXPOSURE BLENDING

ANOTHER WAY OF BRINGING BACK MORE DETAIL to your photos is to use Photoshop for layer masking. This method provides a lot of flexibility in editing.

Take two photos. The first one should be bright to show the shadow details; in this case, the rocks. Take a second photo to show all the details in the highlights, such as in the sky (**Figure 7.64**)

In Lightroom or Camera RAW, lighten up the bright image to see the details in the shadows. It doesn't matter if the sky is getting too bright (**Figure 7.65**)

Select both photos, right-click, and choose Edit In > Open as Layers in Photoshop. In Bridge, choose Tools > Photoshop > Load Files into Photoshop Layers (**Figure 7.66**).

7.64

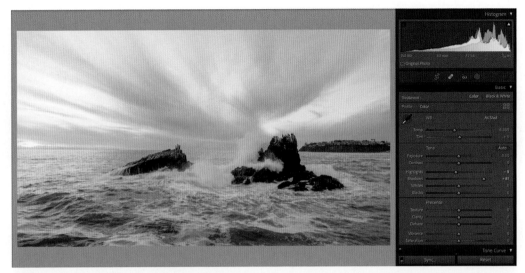

7.65

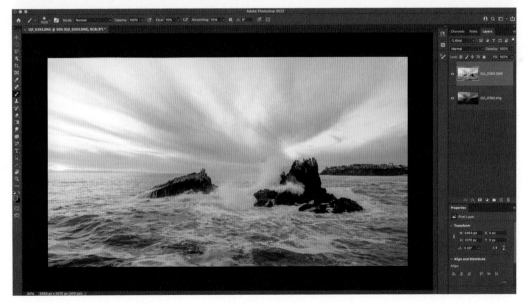

7.66

You will now see a new document in Photoshop with two layers. Make sure the brighter layer is on top. If there is a mis-alignment between the two layers, you can automatically have Photoshop Align them. Choose Edit>Auto Align and choose Auto (**Figure 7.67**).

Choose the top layer. Click the New Layer Mask icon in the Layers panel. This will create a layer mask (**Figure 7.68**). The goal is to paint into the layer mask with black. This will reveal the areas of the underlaying, darker layer that are currently hidden.

This allows us to paint back the brighter areas of the second photograph, thus blending the photos together (**Figure 7.69**).

Choose a soft-edged brush. Select black for the foreground color. Set your Opacity to about 50, Flow to 10.

If you are using a pressure-sensitive stylus such as a Wacom or Surface Pro, set pen pressure to opacity and flow.

Paint the sky and around the edges to darken the image and allow the cloud and water details to show through (**Figure 7.70**).

Figure 7.71 shows what the mask looks like after painting. Alt/Option and click on the mask to view it by itself.

7.67

7.68

7.69

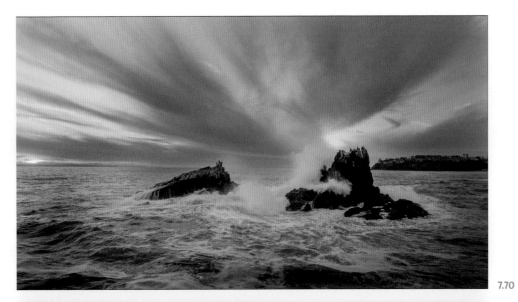

7.70

7.71

NOTE *You can use a paintbrush and paint in the area by hand for a softer, more painterly look. You can mask the edges to help achieve a tighter look. Here, I used the Object Selection tool to isolate the rocks.*

Make sure you select the actual Layer in the Layers panel and not the mask when making a selection. Don't forget to choose the mask again when painting.

7.72

7.73

When you are satisfied with the masking, here is a way to unify the layers even more.

Choose the two layers in the Layers panel and press Ctrl+Alt+Shift+E (Command+Option+Shift+E on Mac). This will preserve the layers and create a new merged layer on top of the Layers panel (**Figure 7.74**). This is called a composite layer, or sometimes a stamp visible layer.

7.74

Choose Filter>Camera Raw to open the layer into Camera Raw and make some adjustments. Because both layers are now being adjusted as a single layer, it tends to smooth out the differences between the layers and create a more balanced, natural-looking result.

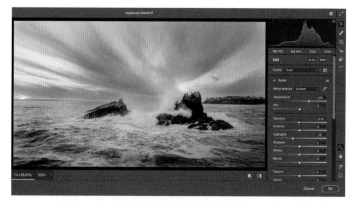

7.75

Dodge and Burn, Painting with Light and Shadow

One of the last things I like to do, right before sharpening, is dodge and burn. Dodging and burning come from the photographic darkroom, where light is selectively increased or blocked from the enlarger during the process of printing from a negative. Burning is when extra light is applied to certain areas of the image. This can be done by cupping the hand or cutting out a stencil. This will darken the area that receives the extra light (remember they are working from a negative).

Dodging is achieved by blocking light from part of the photograph with a card or shape on a wire. This area receives less light on the image and is therefore lightened or "dodged." Although we are employing this technique to a certain degree, I am also using shading techniques from traditional painting and digital art to create a hybrid technique that I call painting with light and shadow.

When you look at an image, the darker areas seem to go away from the viewer, while the lighter areas seem to come forward. This adds a lot of dept to an image and makes it appear almost 3D.

Let's begin with an HDR image from a Mavic 2 Pro that is processed and ready (**Figure 7.76**).

While Holding down the Alt/Option key, click the New Layer icon. The Alt/Option key will invoke the dialog box, rather than just create a new layer.

Change the blend mode to Overlay. You will see the Fill with 50% gray option is available. Click the box to fill with 50% gray, which will be invisible because of the overlay blending mode. I have named this layer "Big." We are going to do two passes. The "Big" is a traditional dodge and burn; the second pass will be to add dimension. You will see both approaches applied.

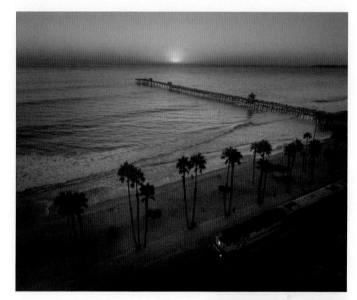

7.76

7.77

7.78

50% GRAY?

There has been a lot of discussion around the 50% gray, so I figured, why not address it here. In the early days before layers (when I was very young), people used the dodge and burn tools directly on the image in Photoshop. In Photoshop 3, when layers came along, the idea of working on layers non-destructively was born. The Dodge and Burn tools in Photoshop won't work on transparent layers, so a gray layer in Overlay mode provided a base for using these tools. Somewhere along the line, we started using the brush tools over the Dodge and Burn tools because of better control over opacity and flow. When using the brush tools, the gray base wasn't needed anymore. So, bottom line, if you are only using the Brush tools on that layer, it doesn't matter if you add the gray. I like to use it as a habit, and also it gives the flexibility to use filters or addition tools if I choose to. It doesn't hurt to add the gray.

The last step in the setup is to prepare the brushes. Choose the brush tool.

Press the D key to reset the foreground and background colors to black and white.

Make sure you are in Normal blending mode. Change the Flow to 10% so the effect happens more slowly, so we can build it up. Turn Brush smoothing to 0 or you will find your brushes lag when painting.

If you are using a Wacom, Surface, or other pressure sensitive pen tablet, choose the Window>Brush Settings. Turn on transfer and set Flow and Opacity jitter to Pen Pressure (**Figure 7.80**).

This will allow you to shade the effect by varying how hard you press, like you would with a pencil.

7.79

7.80

7.81

7.82

Set the foreground color to black and we will start by painting around the edges of the image to darken it (**Figure 7.81**).

Press the X key to choose white and paint gently over the subject area to lighten it slightly. We are directing the viewer's eye into the image with this hand-painted vignette effect (**Figure 7.82**).

OK, let's get into the good stuff. Create another layer in Overlay mode (as we did before) and name it small S for shadow (**Figure 7.83**).

This time paint with black to darken the areas surrounding the train.

7.83

Change to white and paint some light coming out of the headlight. I would normally use different layers for lightening and darkening, but I want the light to replace shadows, so it works on the same layer in this case (**Figure 7.84**).

If you look at the layer in normal blending mode, you can see where we have painted. The gray will be invisible; the darker and lighter areas affect the image (**Figure 7.85**).

Let's add some highlight area that will add the depth (painting with light). Create a new layer as before in Overlay mode and name it small h for highlights (**Figure 7.86**).

7.84

7.85

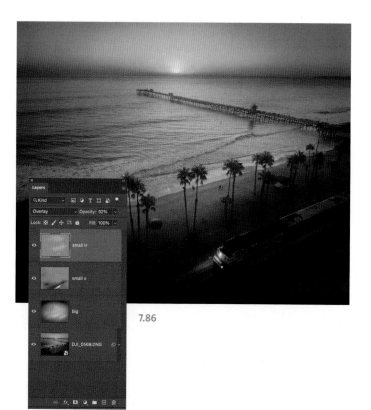

7.86

Set white as the foreground color and paint your highlights. See how it adds so much to the image? (**Figure 7.87**)

Just for reference **Figure 7.88** shows where we have painted with white. If you overlay it over the image in **Figure 7.89**, you can see where I painted.

7.87

7.88

7.89

Removing Distractions

Let's do some distraction removal. A number of tools are capable of performing this task, such as the Clone Stamp tool or the Content Aware Fill. In this case, we are going to use the Patch tool. The Content Aware Patch tool works like the Content Aware Fill tool, but it will work with a Smart Object, so you don't have to rasterize your layer to work on it. This makes it easier to make changes and also preserves the quality of the image.

Here is an image (**Figure 7.90**) that is being cropped. Notice the transparent areas in the corners, as well as the distractions such as the flare. All manner of objects can be removed and areas patched using the following tools.

7.90

You will notice that this image is a Smart Object. Look in the Layers panel and you will see a badge. Here is how to apply nondestructive Content Aware Fill to a Smart Object (**Figure 7.91**).

7.91

1. Create a new, blank layer above the Smart Object.
2. Choose the Patch tool.
3. Select Content Aware as the method.
4. Turn on the Sample All Layers option.
5. With the Patch tool, make a selection around the blemish or area to remove.
6. Drag the selection to a similar area that you would like to fill.

When you release your cursor, the area will be healed. The patch is on a separate layer, so you didn't have to rasterize your Smart Object.

Use the Patch tool to fill in the transparent areas left over when we cropped this image. Also use it to remove the lens flare in the bottom left of the image. Continue to use the same blank layer to patch the image. If you hide the bottom layer and look at the patch layer by itself, you will see that all the repairs are on a separate layer (**Figure 7.92**).

If you look at the image with both layers on, you will see how nicely the patch tool hid all the blemishes and areas of transparency (**Figure 7.93**).

One thing you have to be careful about is making adjustments to the Smart Object layer. If you make adjustments to that and not to the patches, they won't match anymore. What we need to do is combine them.

7.92

7.93

High Pass Sharpening

Let's sharpen this image, but only sharpen the areas closest to the viewer to really make it pop. High Pass Sharpening is powerful because it's on a separate layer, so it can be turned on or off, or masked. Also, the intensity of this effect can be adjusted with the layer opacity.

If the top layer is a composite layer, duplicate this layer. If not, create a composite layer on top (Ctrl+Alt+Shift+E on Windows or Cmd+Option+Shift+E on Mac).

Change the blend mode to Overlay (**Figure 7.94**). The image will look a bit strange for a moment, but it's just a transitional appearance.

Choose Filter > Other > High Pass (**Figure 7.95**). Notice the image looks normal again.

7.94

7.95

7.96

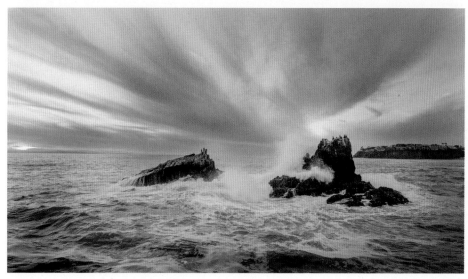

7.97

Adjust the Radius to create the sharpening effect—usually between 1 and 4 works best (**Figure 7.96**). Look at your image to see how much sharpening looks right. You want the details to pop, but you don't want halos or for the photo to look unnatural. The amount of sharpening will depend on the resolution of the image and the intended medium. For online, you will choose a little less sharpening than you would use for print work.

Here is the resulting image with sharpening on the top layer (**Figure 7.97**). One of the powerful things about High Pass Sharpening is the ability to sharpen selectively using layer masks. You can see the mask on the top layer in **Figure 7.98** that the areas painted black do not receive sharpening. This allows you to sharpen the foreground while keeping the background soft. This adds more depth to the image.

7.98

SPECIAL EFFECTS

SOMETIMES YOU WANT TO DO THINGS that are just fun and create something a bit different. These are special effects. Let's a have a look at some of my favorite effects.

Sky Replacement

Sometimes you get to the location at the right time: the light is doing exactly what you want and you capture what is almost the dream shot. Maybe everything is spot on except the sky. Either you have a gray marine layer, or perhaps there are no clouds at all and the sky is bland. When I'm local, I look up at the sky before heading to my location to see if it's going to be any good. When you are traveling or on a deadline, you can't always wait for the right conditions. Photoshop has a great tool to replace the sky in photos and it works quite well.

First let me show you how it works, then we will dig into the options a bit deeper.

Begin with your image (**Figure 7.99**). It's a good shot, the sun is even setting perfectly, but the sky is really boring.

7.99

Choose Edit > Sky Replacement (**Figure 7.100**). Choose a Sky from the thumbnails, or add your own (we will cover that in a moment). You will see a preview of the new sky. Click OK to apply and you have changed the sky, as easy as that.

Let's look at the options available to us.

You will see all the different layers in the layers panel. All of these settings can be adjusted in the Sky Replacement dialog box. Once the adjustments are applied then you can change any of the settings in the layers.

The settings are broken into three areas: the sky, the foreground, and the transition (**Figure 7.101**).

7.100

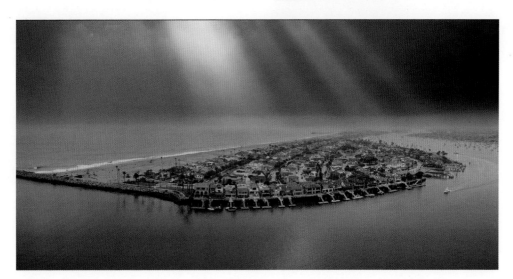

7.101

TRANSITION

Shift Edge: move the edge up or down so your horizon blends where it should.

Fade Edge: adjust the haze on the horizon.

SKY ADJUSTMENTS

Brightness and Temperature: make the color and lightness match the original image.

Scale and Flip: match the lighting direction and scale.

FOREGROUND ADJUSTMENTS

Color Adjustment: match the color with the color of the sky.

Lightness Adjustment: change the brightness of the foreground.

Lighting Mode: either lightens or darkens the transition.

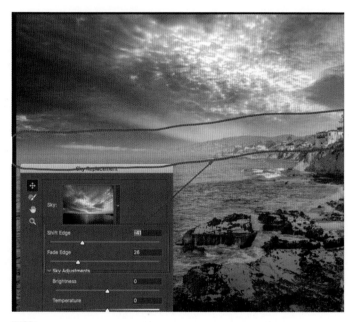

7.102

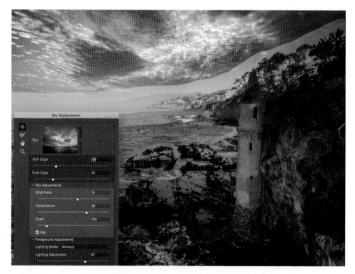

7.103

In this chart (**Figure 7.104**), I have mapped the settings in Sky Replacement to the results in the Layers panel, so you can see what each adjustment does. You won't be able to see the layers and the Sky Replacement at the same time while working in Photoshop. I broke it all out so you can see under the hood and understand exactly how it works. I hope this is useful for you.

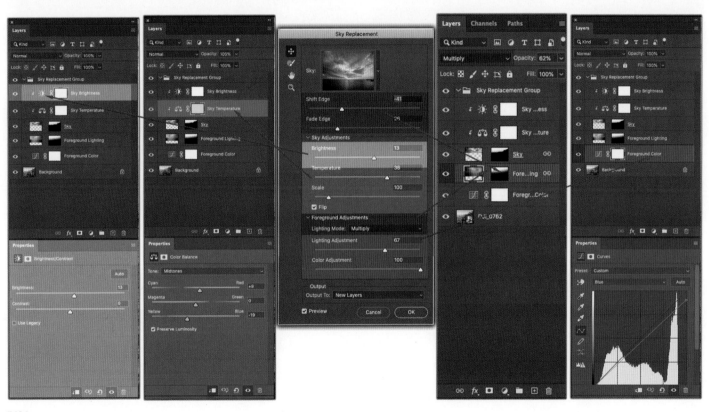

7.104

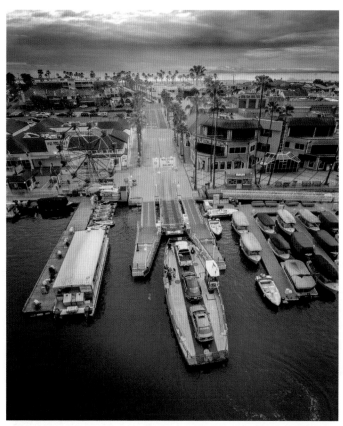

7.105

Tilt Shift

The tilt shift effect is a lot of fun. This can be used in a practical way to bring the viewer's eye into a portion of a photo and provide some of depth of field. Usually you end up with a very large depth of field with wide-angle lenses, and everything is in focus. It's useful to cut through the clutter with some simulated depth-of-field blur. Let's apply the effect to this image. This image is a vertical panorama at Balboa Peninsula at Newport Beach, California (**Figure 7.105**).

Right-click the image thumbnail and choose Convert to Smart Object. (The filter can be applied directly to a layer if you choose; we are using a Smart Object because that will make it re-editable.) (**Figure 7.106**)

7.106

Choose Filter > Blur Gallery > Tilt Shift, and you will see the blur gallery at its default state, as you see here (**Figure 7.107**).

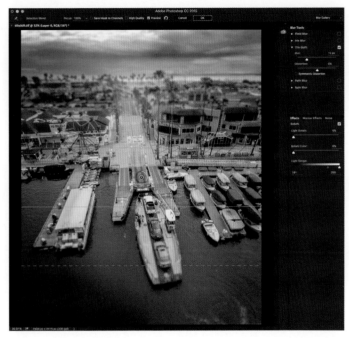

7.107

You can create a tilt shift lens effect by dragging the different lines. You will get a strip of focus with blur on the edges; this can also be used to make a photograph look like a miniature model.

1. The Blur slider controls the amount of blur outside the lines.
2. The focus area is between these two lines and can be dragged wherever you like. It can also be rotated.
3. Fall off. The blur will be blended between these dashed lines and the solid lines. Everything outside the dashed lines has a uniform blur of the amount that you set in step 1.

When you are happy with the result, click OK to apply to your Smart Object (**Figure 7.108**).

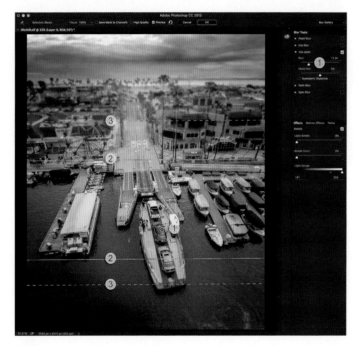

7.108

And the result looks like **Figure 7.109**.

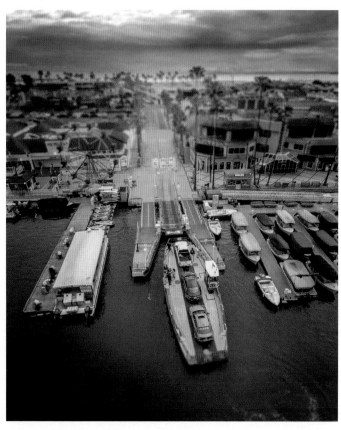

7.109

Because we are using a Smart Object, we can double-click the name of the filter in the Layers panel to open the settings. You can now change the settings.

In this next example, we are going to bring the lines closer together for more of a miniaturization effect (**Figure 7.110**).

7.110

If you look at the ferry, it now looks a little like a toy. This works because the blur looks like something you would see from a macro lens; it's much quicker than something you would see on a life-sized photo and thus fools the eye into thinking it's looking at a small-scale model (**Figure 7.111**).

7.111

Figure 7.112 is another example.

7.112

360-Degree Tiny Planet

Another one of my favorites is the tiny planet. I remember doing this effect before I was using drones. As soon as I started flying a drone, I knew this would work really well. I'm seeing quite a few people trying this effect now. Here is how to get it.

Start with a wide panorama. Technically, you should be shooting 360 degrees, all the way around. However, if there is ocean on one side, you can skip a few panels and no one will be the wiser; actually, it will be a more interesting planet. Make sure to fly lower so that some of the features stick up above the horizon, or your planet will look flat and boring (**Figure 7.113**).

Although we could eagerly jump in and make our tiny planet right now, there is a little trick we should do first; this will ensure we don't get an unsightly seam in our planet that will take a long time to fix.

Make a selection on the side that shows a horizon. Use the Rectangular Marquee tool for this (**Figure 7.114**).

Press Ctrl/Command+J to copy this selected area to a new layer. We will call this our "strip" for clarification.

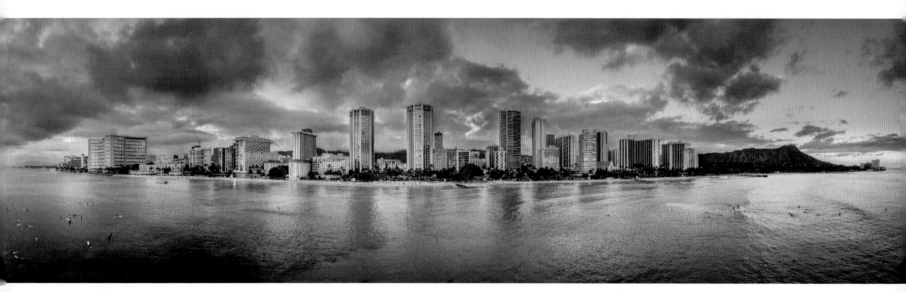

7.113

Holding down Shift (to keep it aligned), drag the copied strip all the way to the other side of the image. Zoom in nice and close, so that you can align it perfectly with the edge (**Figure 7.115**).

We now need to flip this layer horizontally, so that the edges will match later. Press Ctrl/Command+T for Free Transform. Right-click and choose Flip Horizontal (**Figure 7.116**).

Create a layer mask on the strip by clicking the Add a Layer Mask icon in the Layers panel (**Figure 7.117**).

Choose the Gradient tool and a black-to-white linear gradient. Make sure the blend mode is set to Normal and that Opacity is all the way up to 100. Drag the gradient in the strip from left to right; the copied strip should now seamlessly blend into the main image (**Figure 7.118**).

Now flatten the layers.

7.114 7.115 7.116 7.117 7.118

Now it's time to make the tiny planet! Choose Image > Image Size. The goal here is to transform the image into a square. Make sure that you are reducing size, and not increasing it, or the image will look soft and pixelated. I made this one 3000 x 3000 pixels (**Figure 7.119**).

Choose Filter > Distort > Polar Coordinates. Choose the Rectangular to Polar option (**Figure 7.121**).

Figure 7.122 shows your tiny planet effect. Pretty neat, huh?

7.121

7.119

Now you have a square image; it looks weird at this point, but that's OK. Make sure to rotate this 180 degrees so that it's upside down. Choose Image > Image Rotation > 180 (**Figure 7.120**).

7.120

7.122

7.123

Perform some cleanup work. In this case, I rotated the planet around. I also chose to crop out the extra stuff on the edges. Sometimes, you can use the Clone Stamp and Content Aware Fill tools to fill up the edges with more of the outside texture. It's entirely up to you.

Phew! That was a lot of information to get through in one chapter. This chapter and the preceding one provide a great jumping-off point for you to get started making amazing aerial images. There are a ton of techniques in these pages. This book isn't intended to be a guide to using Photoshop and Lightroom, and there are already plenty of good books and videos on basic Photoshop and Lightroom by Rocky Nook and at PhotoshopCAFE.com. This book is a survival guide for aerial photography, and I included the workflows and techniques that I use every single day on my aerial photographs.

Next up, we will take a brief look at working with aerial videos.

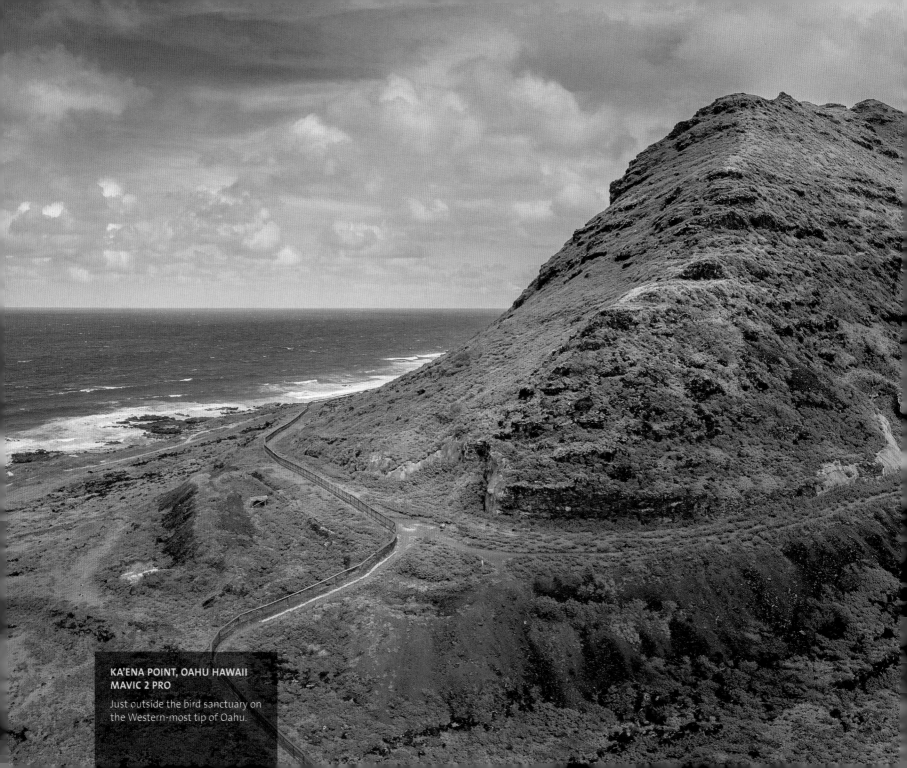

**KA'ENA POINT, OAHU HAWAII
MAVIC 2 PRO**

Just outside the bird sanctuary on
the Western-most tip of Oahu.

CHAPTER 8
EDITING AERIAL VIDEO

AERIAL VIDEO IS VERY EXCITING! It's the closest you can come to flying without actually flying. In this chapter we are going to look at some of the basics of editing aerial footage. This is not intended to be a "how to edit video" chapter, because there just isn't space for 400 pages on video editing. Many good resources already exist, and it would be impossible to cover all the possible video editing packages. You could be using iMovie, GoPro Studio, Vegas, Adobe Premiere Pro, Apple Final Cut Pro, Avid Media Composer, or even Photoshop.

Because it's my video editor of choice, I'm going to be using Adobe Premiere Pro. Remember that this isn't a Premiere Pro tutorial; it's a video editing tutorial, and I hope to share strategies and ideas that will work on any video editing application. But I will begin by discussing a few other video applications.

FREE (OR ALMOST FREE)

MANY VIDEO-EDITING PACKAGES ARE AVAILABLE TODAY. These range from software preinstalled on your computer to professional editing programs used in television and movies. Some examples of free or nearly free packages: Adobe Premiere Rush, GoPro Studio, iMovie, Lightworks, HitFilm Express 4, Windows Movie Maker, and DaVinci Resolve Lite. You can also edit video in Adobe Photoshop.

The professional packages cost money. The most popular are Adobe Premiere Pro, Apple Final Cut Pro, and Avid Media Composer.

8.1 Final Cut Pro

8.2 Premiere Rush

TRIMMING CLIPS

WHEN YOU HAVE FINISHED SHOOTING and transferring all your footage to your computer, you now have video clips. The next step is to find the "shots," those moments that you are going to use. Not the setups, the follow-through, or flying into position—the actual hero shots. These shots should be clean and smooth. You might have multiple takes of the same thing. You could find multiple candidates and then choose the winner later, or you could be looking for that winner right now.

The important thing is that we have to mine all this footage for the very best shots to use. This used to be tedious when we were all flying GoPros. Because there was no remote shutter, each clip would last an entire flight. We would press Record manually, take off, and fly, and then push Stop upon landing. All our clips would be 10 to 20 minutes long, just for a few seconds of action.

Now we have the option to start and stop video while in the air. This cuts down on a lot of the clutter. If you read chapter 5, you'll know it's good to always shoot a little pre and post roll. Start recording a few seconds before starting the shot and let the camera roll for a few seconds after the shot. Before we do anything else, we need to find these shots. Maybe you took notes while shooting? Not a bad idea to jot down a few things after you have landed, while everything is fresh in your mind—or have an assistant make the notes while you are shooting.

Mining the Shots in NLE

Here is the process for mining all the shots in an NLE (non-linear editor). I call it mining because you have to dig through a lot of footage to find the gold, but it's there. I'm using Premiere Pro for this task. This process is the same in Final Cut Pro and other NLEs.

Import the clips that you want to work with; they will appear in your Project panel in Premiere Pro or in the Library in Final Cut Pro (FCP). Double-click to open it in the Source Monitor. We haven't added this clip to a timeline; we are just examining it right now (**Figure 8.3**).

8.3

Examine the clip to find your first shot. There are a few ways of doing this.

- Simply press the Play button or the spacebar to play the video clip normally.
- Use the JKL Keys. This is the preferred method of professional editors. Tap the L key to play the video, the K key to stop it, and the J key to play backward. Each time you tap the L key, it will increase the speed; each time you tap the J key, it will decrease the speed. If you are playing backward, successive taps of the J key will increase backward speed and L will slow it down. Most editors keep fingers on these three keys and use them to quickly navigate and home in on the areas that interest them.
- Scrub the timeline. Drag the playhead to quickly move to a section that interests you (**Figure 8.4**).

8.4

When you have found your shot, move the playhead to where the action starts. Press the I key. This will set an "in point." You have marked the clip to begin paying from here (**Figure 8.5**).

8.5

Play until the end of the shot and press the O key to set an "out point." You will see your isolated shot marked. Note that this doesn't delete any of the video; we have just marked the clip to begin and end on our in and out points (**Figure 8.6**).

Eventually, all the clips that you will use will go on a timeline; this is where you construct your movie from all the shots. There may be other shots that you want to extract from the same clip, so here is how you can save the shot that you just marked.

8.6

8.7

To create a new timeline (called a sequence) (**Figure 8.7**):

1. Drag from the Source Monitor to the New Item icon.

2. A new sequence will be created with your trimmed clip on the timeline. The timeline will inherit all the settings (frame rate, size, codec settings) from the video clip that you dragged to the New Item icon. (To change any of these, go to Sequence > Sequence Settings.)

NOTE *You only need to create one sequence for each video you are making. After this, any additional clips will be added to the timeline of the same sequence (timelines and sequences are the same thing).*

If you prefer to prepare all your shots at once and add them to a sequence later, you can create subclips (called compound clip in FCP X). A subclip is a separate file that contains the video from in point to out point. This works just like any video clip, but it's all trimmed and ready for assembly later.

To create a subclip, right-click the clip in the Source Monitor and choose Make Subclip. You will see a dialog box (**Figure 8.8**). Make sure to deselect Restrict Trims to Subclip Boundaries. Name your subclip.

Make Subclip

Name: finishline

Restrict Trims To Subclip Boundaries

Cancel OK

8.8

You will see your named subclip in the Project panel (or bin). I suggest creating a bin by clicking the Folder icon and naming it. You can now drag all your subclips into this bin to keep them together (**Figure 8.9**).

8.9

Play the rest of the clip and look for additional shots. Here is one we would like to use (**Figure 8.10**).

8.10

Oh no! What do we do to get the next clip? We already have in and out points set. Simply press the I key to set a new in point at the playhead. If it's after the out point, the out point will be cleared. Find the end of this second clip and press the O key to set the new out point. Bingo—that's two clean shots from one clip.

Convert this clip into a new subclip or add it to the timeline if you are building as you go. To add it to the timeline, make sure the playhead in the sequence is at the end of the previous clip and press the Comma (,) key (**Figure 8.11**).

To make a timeline assembly, continue to do this for all your clips. Either make subclips and then assemble them, or add them to the timeline as you go.

8.11

Trimming in Photoshop

Did you know you can edit video in Photoshop? Photoshop CS6 Extended and CC are capable of working with video. You can get some pretty impressive results. It's a bit slower than Premiere Pro, but it can get the job done.

Choose File > Open and select your video clip. It will open in Photoshop. If you don't see the timeline, choose Window > Timeline (**Figure 8.12**).

To set the in point, place your cursor over the beginning of the clip in the timeline and drag to the right. You will notice a little window that allows you to preview your edit. Release to trim to the new start point (**Figure 8.13**).

8.12

8.13

To set the out point, drag from the right side of the clip. Drag to the left to set the new out point. You will see a little window that shows where you are trimming (**Figure 8.14**).

You can add more clips to the timeline by clicking the Filmstrip icon to the left of the timeline and choosing Add Media (**Figure 8.15**).

WHY TRIM?

The old-school way of filming forced people to watch the entire video from start to finish. Everything you recorded was played. Now, we have technology that allows us to edit our films to be short and tight, which keeps the audience wanting more. For sharing

aerial clips online, you don't want anything over three minutes long; often, 90 seconds is enough. Keep it short and sweet and people will enjoy watching your videos. Drag it on and on and people will get bored very quickly. Also, it's common to include an aerial shot as B-roll to be used as a part of a bigger video project. Incorporating drone shots with other video is a great way to add production value to your movie, ad, or vlog.

There is a saying: "If in doubt, leave it out." If you're unsure of the value of a shot, then don't include it. You want your video to be compelling and interesting.

8.14

8.15

PHOTOS FROM VIDEO

IT'S ALWAYS BETTER TO SHOOT PHOTOS SEPARATELY because you really want them in RAW format to get the best quality. Also, you should be setting a shutter speed for video, which isn't ideal for photos because of blur. There will always be those times when you capture a magical moment on video that just can't be repeated for a photograph.

A good example of this is my iconic "pelican from above" shot. This was the first image of its kind captured (before the eagle on Dronestagram) and was used by DJI, Adobe, and a number of drone dealers to showcase what was possible with this technology. It was also exhibited internationally as part of the Skypixel Perspectives gallery.

A little back-story on this shot: It was my first flight by the ocean, and I was using a Phantom 1 with a GoPro Hero 3 Black Edition and rolling video at 1080p. After filming some surfers, I brought the Phantom back to land. I saw the pelican heading in my direction and could see that it was on a direct path to fly under my camera. My heart was pounding with excitement. I made some quick adjustments to the angle of the camera and hovered perfectly still. The pelican wasn't even bothered by my drone and swooped very close under the camera. Even though I didn't have any FPV at the time, I knew I had the shot of a lifetime. The pelican appeared in exactly 25 frames, so the whole moment lasted only one second.

I found the frame that I liked the best, and slightly warmed up the color to match the colors present at the time. I also created a vignette on this version of the photo to show the pelican a bit better, since it's such a similar color to the environment. I didn't make any other alterations or manipulations (**Figure 8.16**).

To achieve this, a photograph has to be extracted from video. After examining and trying many different methods, I've found that the two best ways to extract an image from video without losing quality are available in Premiere Pro and in Lightroom. (I used the Lightroom method to make the pelican image.) Both methods produce the same quality and result.

8.16

Extracting a Still in Premiere Pro

This method is very quick and simple. It's the best option if you are editing a video and come across a frame that you would like to turn into a still image. Use the Left Arrow and Right Arrow keys to move forward and back, frame by frame, to find the exact frame you desire.

Click the Export Frame button or press Shift+E (**Figure 8.17**).

8.17

When the Export Frame dialog pops up, choose TIFF as the format, because this is a nondestructive format that will retain the most detail (**Figure 8.18**).

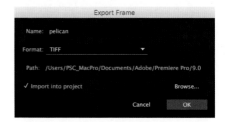

8.18

Select the Import Into Project box to add the image to the Project panel. This makes it easy to find—just right-click and choose Reveal in Finder.

Extracting a Still in Lightroom

Lightroom is a great program for extracting frames from video. The first thing you need to do is open the video in the Library module.

You will see a player at the bottom of the window (**Figure 8.19**).

1. Click the little gear icon to open up the options.
2. Scrub through the video.
3. Click the arrows to move frame by frame to find the exact frame you want.

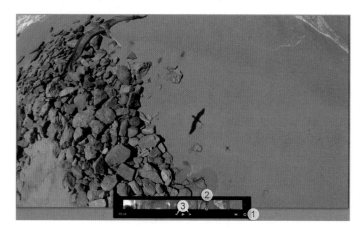

8.19

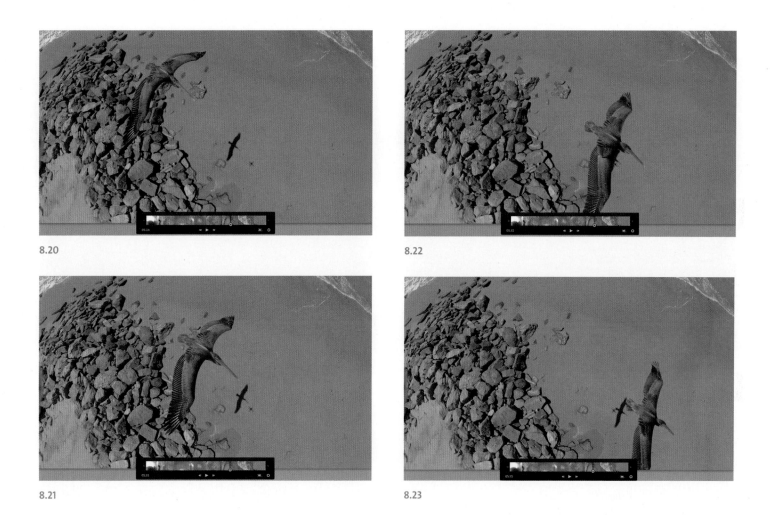

8.20

8.21

8.22

8.23

When you have the frame that you desire, click the box next to
the gear and choose Capture Frame (**Figure 8.24**). That's it!

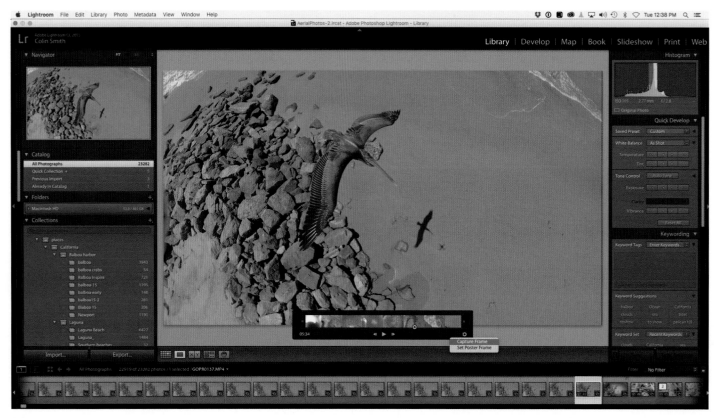

8.24

For a shot like this, it's more about capturing a unique moment than about artistic expression. Apply minimal adjustments and maintain journalistic integrity. Here, I barely moved any sliders at all to finish the image (**Figure 8.25**).

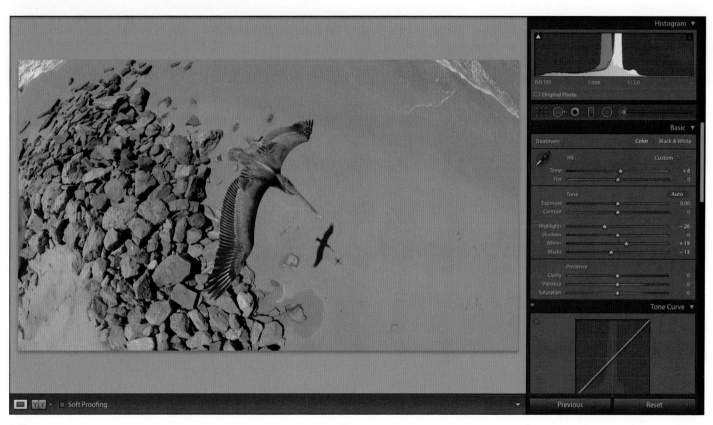

8.25

Doubling the Size of a Still Frame From Video

Often a challenge when pulling a still frame from a video is its small size. This won't matter as much with 8K video, but if your footage is HD (1920x1080) or 4K, you might need it larger for printing. Fortunately, Lightroom and Adobe Camera RAW have a feature called Super Resolution. This will create an image four times as large with very little loss of quality. The result is an image that is double the height and double the width of the original. Here's how it works.

If you are using Camera Raw, right-click on the photo in Bridge and choose Open in Camera Raw.

When the image opens in Camera Raw, right-click. Choose Enhance from the menu that pops up (**Figure 8.26A** and **8.26B**).

Camera Raw will make a copy of the image at the larger size and save it as a new DNG file next to the original (**Figure 8.27**) The quality is better than any other resizing tool in Photoshop because it uses AI to rebuild the image.

The process is identical in Lightroom, but easier because you don't have to bring anything in. Simply right-click on a thumbnail in the Library panel, choose Enhance > Super Resolution, and Done. This makes it really easy when you are using Lightroom to extract a video frame. Super Resolution can only be applied once to each image, you can't apply it multiple times.

8.26A

8.26B Click the option that says Super Resolution

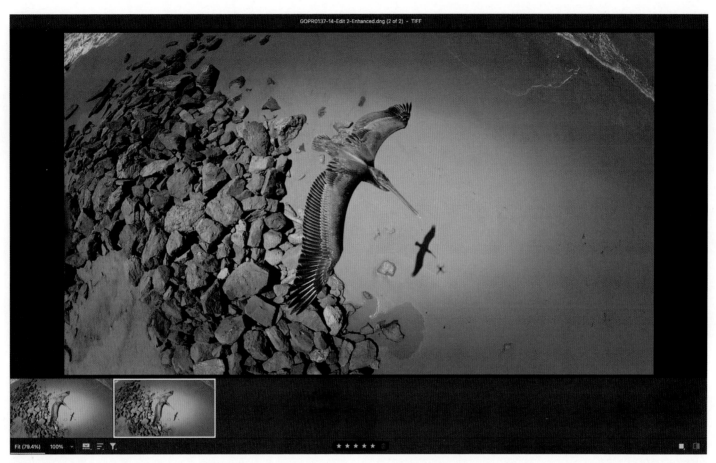

GOPR0137-14-Edit 2-Enhanced.dng (2 of 2) - TIFF

Fit (79.4%) 100%

★ ★ ★ ★ ★

8.27

COLOR GRADING

COLOR GRADING IS A FANCY TERM that really means making your video look awesome. Grading and color correction are used to fix video issues such as a color casts, and to enhance a video and give it a cinematic look. There are a lot of good dedicated applications for color grading. You can also do a lot inside your video editor.

Lumetri

The Lumetri panel for color and tone correction in Premiere Pro is my go-to place for color grading aerial video. This makes it as easy as using Lightroom to make adjustments to video. First we are going to look at basic adjustments and enhancements.

Here is a clip that was filmed on a gloomy morning with the marine layer present. To apply the adjustments, select the clip

in the timeline and then open the Lumetri panel by choosing Window > Lumetri Color (**Figure 8.28**).

In the past, it required quite a bit of skill to do a simple color correction to video. Now, we can just slide the Temperature slider like we do in Lightroom to warm up the shot (**Figure 8.29**).

8.28

8.29

In the Basic Correction panel there are sliders for tone. Here, I made adjustments to add a bit more contrast to the shot without getting too carried away. The names and functions of the sliders are similar to those in Lightroom. When editing video, you generally go for a little more contrast and less saturation than you would with a photograph. You will notice on films and television that colorists very often crush the blacks to achieve that cinematic look. Of course, this isn't a hard rule, and you can do whatever you want to make your shots look the way you want them to (**Figure 8.30**).

1. **Exposure:** Overall brightness.

2. **Contrast:** Changes overall bright and dark tones. High contrast means more punch. Lower contrast means more details in shadows and highlights.

3. **Highlights:** Recover details in highlights by sliding to the left.

4. **Shadows:** Recover details in shadows by sliding to the right.

5. **Whites:** Brighten and clean highlight areas by moving to the right.

6. **Blacks:** Add deep, rich blacks to shadows by moving to the left.

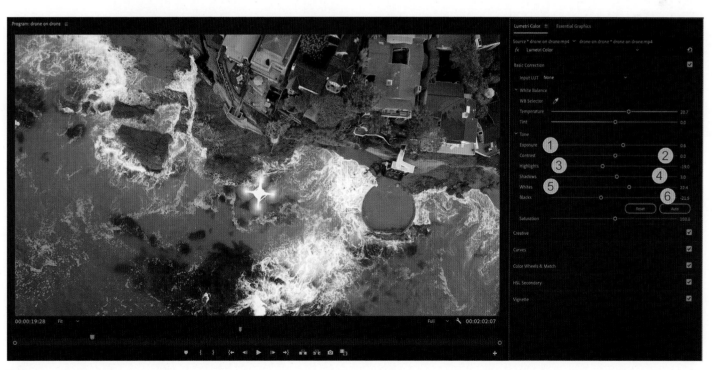

8.30

What About the Histogram?

Normally when you are adjusting photos, you will look at a histogram to see if your shadows and highlights are clipping. In video, these indicators are called scopes. In Premiere Pro, they are called Lumetri scopes and can be found under Window > Lumetri Scopes. When the panel opens, it may be blank. You will see a little wrench icon at the bottom; this is where you choose which scopes you want to use. There are a number of different scopes, and it's an education in itself to understand all of them.

In this image, I have opened the histogram and the RGB Parade. You can see that the histogram is very much like the one in Photoshop—with a difference: this one is rotated 270 degrees. The shadows are on the bottom and the highlights are on the top.

One of the most useful scopes for video is the RGB Parade. Here you can see all three color channels at once, and you can see shadows on the bottom. If the colors run past the bottom, those shadows are crushed and losing detail. If the colors run all the way to the top, it means the highlights are blown out (**Figure 8.31**).

8.31

Adding Color to the Shadows and Highlights

A very common practice in color grading is adding color to the shadows and highlights. Perhaps the most common are a blue/teal in the shadows and a yellow/orange in the highlights. This is nicknamed the "blockbuster look." You will see it a lot in Hollywood movies.

Of course, if you are going for beautiful nature shots, you might want to take a note from National Geographic and keep the colors as natural as possible by sticking mainly to the Basic Correction panel. However, if you are going for a dramatic cinematic look, then these tools are your friends.

Click the Color Wheels panel. You will see that it's broken up into three areas: Shadows, Midtones, and Highlights. Using the slider to the left of the wheels will either brighten or darken the tones in those regions. To adjust colors, drag the wheel toward the color that you want to add more of. If you hold down the Shift key, you can move them faster (**Figure 8.32**).

Here we have applied some subtle shadow and highlight adjustment to our shot. We added a little bit of green to the shadows to make the water look more natural and added a bit of red to the highlights (**Figure 8.33**).

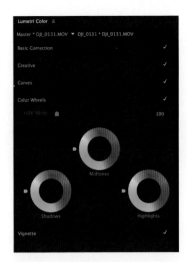

8.32

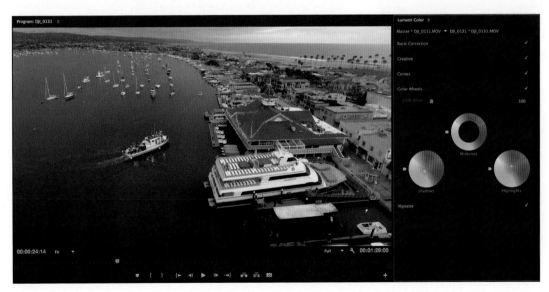

8.33

To further demonstrate the power of the Hollywood cinema look, let's take a shot right out of camera.

Let's add a subtle blockbuster look (**Figure 8.34A**).

1. Add some teal in the shadows.

2. Add orange in the highlights (**Figure 8.34B**).

3. Darken down the shadows.

4. And brighten up the highlights.

The result can be seen in **Figure 8.35**.

8.34A

8.34B

8.35

Storytelling with Color Grading

In this establishing shot, we are slowly moving up the harbor toward the pavilion. Our heroes are on a boat. As we approach, our boat comes into the scene and we follow it into the dock. This might be a perfect time to cut to some dialogue in the boat. As you can see in this sequence, the color grading adds to the story. What have they been up to? Where have our heroes been and what are they going to do next? (**Figures 8.36–8.38**)

The establishing shot gets the viewer's attention and sets them up for the next part of the story by giving a sense of location and mood. Let's examine how to create this look. If you aren't using Premiere Pro CC, you can apply these principles to the tools available in your editor.

First of all, we start with the Basic Correction panel and make adjustments like we did earlier. This time we are embracing the gloomy blue and even enhancing it (**Figure 8.39**).

8.36

8.38

8.37

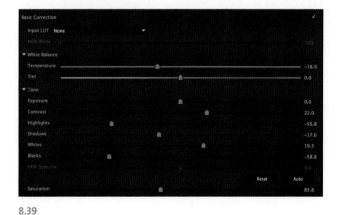

8.39

Next we go to the Creative panel (don't worry about the looks yet; we will get to that next). We are able to apply some of the blockbuster look in the Shadows and Highlights color wheels here. Reducing the saturation and boosting the vibrance is a great combination to reduce distracting color. I also added some faded film, which just reduces the contrast in the shadows a bit (**Figure 8.40**).

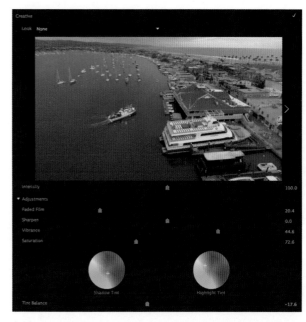

8.40

Under RGB Curves, we can make adjustments to the different tones. This works like curves in Photoshop or Lightroom. We increase the overall lightness in the midtones by pushing the mids up a bit. In curves, shadows are to the left and highlights are to the right. When you push the diagonal line upward, it brightens the tones in that region. When you pull down on the line, it darkens those regions (**Figure 8.41**).

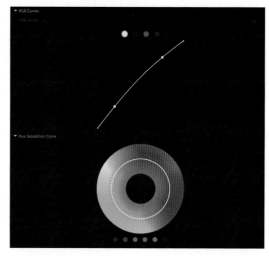

8.41

In the Color Wheels section, I added more blue to the shadows and a touch of magenta to the midtones so that the clip wouldn't feel too monotone (**Figure 8.42**).

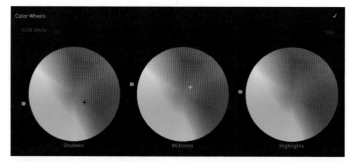

8.42

And finally, there is a Vignette portion of the panel. Used sparingly, this darkens the edges and creates focus on the center of the shot. I use vignettes very sparingly on video, but they have a lot of impact when used on the right shot. In this case, I wanted a sense of drama and mystery, and vignettes play right into that (**Figure 8.43**).

8.43

LUTS

ONE OF THE COOLEST THINGS to come along for stylizing video is LUTs (lookup tables, or, more accurately, color lookup tables). Without boring you with all the science, a LUT is basically a preset that you can apply to your footage to give it a certain "look" or style. LUTs are interesting because they work across a number of programs, including After Effects, Premiere pro, DaVinci Resolve, Final Cut Pro, and Photoshop.

We are going to examine some of the preset LUTs that come with Premiere Pro. Then we are going to make our own LUT in Photoshop and apply it in Premiere Pro. The same LUT will work on Final Cut Pro.

8.44

Using LUTs

When we looked at the Lumetri panel in Adobe Premiere Pro CC, I purposely left out the LUTs because I wanted to save them for their own section. In the Creative panel of the Lumetri panel, you will see the Look drop-down menu with all the installed looks (these are the LUTs). Using some footage I recently shot in Cape May, New Jersey, let's see what the looks do (**Figure 8.44**).

You will see a preview window that allows you to inspect the different looks. Click the arrow on the thumbnail to cycle through the LUTs and get a preview of how they will affect your footage (**Figure 8.45**).

8.45

When you have found the right LUT, click the preview window to apply it, or choose one from the drop-down list. You can adjust the strength of the look by moving the Intensity slider (**Figure 8.46**).

The look can be fine-tuned by adjusting the other settings in the Lumetri panel. Usually it's a good idea to apply the LUT first and then dial in the settings to match your footage. Here is the shot with some adjustments made (**Figure 8.47**).

8.46

8.47

Scrub through your shot to make sure that the look works on all the frames. Here we are at a different frame of the same shot, and you can see the settings that I applied to customize this look (**Figure 8.48**).

You will notice that there is an empty slot for an input LUT in the Basic Correction panel. This is separate from the Creative LUT that we applied. Often, you apply camera LUTs first. By applying a camera LUT in the Basic Correction panel, you get a great starting point that saves time when tweaking each clip. It also allows for the use of two LUTs: the first to get a good, clean clip, and the second to be applied for creative effect. Let's look at how to create a basic camera LUT.

8.48

Rolling Your Own LUTS

LUTs are awesome for working with presets and achieving cool and interesting looks in a single click. I'm going to show you how to make your own LUTs in Photoshop that you can use for basic, customized, or creative purposes.

MAKING A CAMERA PROFILE LUT

In this little tutorial, I'm going to show you how to make a LUT that is specific to your camera. If you have multiple drones, I suggest that you create one for each drone. This is going to save a lot of time in the future and give you a quick, accurate starting place every time. This is basic color management that will make your footage look exactly as it should.

SHOOTING A REFERENCE

The first thing you need to do is take a picture with the camera. You can't just take a picture of anything, though, you need to shoot a known, measurable thing. I use the X-Rite ColorChecker; experienced editors use this to match specific colors. You can also use a gray card, as long as it has 18% gray, black, and white. Wait, a picture? I thought we were working with video. We are, but the LUT we make with a photo will work on video.

Figure 8.49 is a nice shot of the ColorChecker.

Figure 8.50 is our shot from the Phantom 4.

8.49

8.50

This doesn't look good at all, but that's OK. That's the point—we are going to fix it and create a LUT from the corrections. The first thing you will probably notice is that your aerial camera might have issues focusing this close to something. That's OK; focus isn't important as long as you get the chips in the shot. Also notice that there is a reflective black, and I positioned it so at least some of it is in shadow. The shiny black is actually capable of showing darker blacks than the matte chips.

If you want super-accurate colors, pop the ColorChecker in front of the camera and shoot it before flying to capture the ambient color temperature of your environment. Take one shot with the light striking the checker and one in the shade so that you have both of those samples. In time, you will probably end up using the direct light samples more often.

SETTING IT UP IN SOFTWARE

Open your shot into Photoshop CC (LUTs are new to Photoshop, and only work in CC). You can crop in tighter to the ColorChecker if you like. If it's a raw file, open it in Photoshop without making any corrections. Make sure it's flattened as a background or the LUTs won't work.

Apply a Curves adjustment layer and go to the Properties panel. You will see eyedroppers to the left; we are going to use these (**Figure 8.51**).

1. **Set Black point.** This will define the darkest point of your image.

2. **Set Gray point.** This sets the white balance.

3. **Set White point.** This defines the brightest part of the image as white.

The first thing we will do is fine-tune the settings. This only has to be done once. If I were to click the brightest portion of the image, it would be set to pure white with no detail, and the black point would be pure black with no detail. This will add contrast, but we want to allow for a little more dynamic range, so we are going to redefine black and white to the eyedroppers. Don't understand yet? That's OK; keep following along and this will make sense soon.

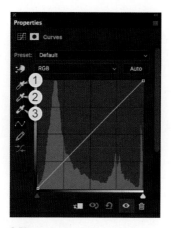
8.51

Double-click the white eyedropper (**Figure 8.52**). You will see a color picker. Change the value in B (Brightness) from 100 to 90. This will give us 10% overhead in the brights. (In print, we only add 5%, but I feel we need a little more in video. You can try 5% if you like the result better—experiment!) Click OK.

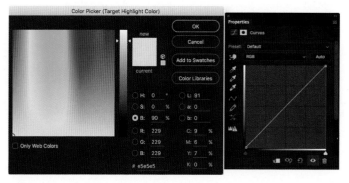
8.52

Double-click the black eyedropper and set B to 10. At some point, a dialog may pop up asking if you want to set these as the new defaults. Click Yes, and you won't have to perform this step in the future (**Figure 8.53**).

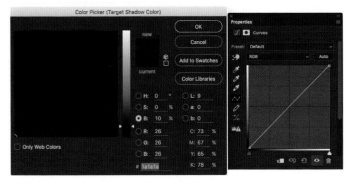

8.53

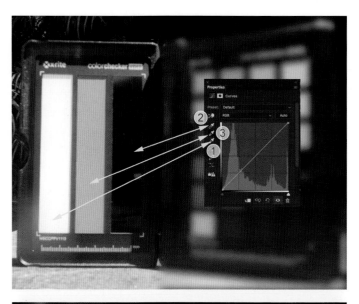

CREATING THE LUT

This is where we do the actual correction and save it as a LUT. Notice that one side of the ColorChecker is in exposed sunlight, while the other side is in shade. We are going to create two profiles: one for sunlight and one for shade. Then we'll have the ability to use whichever one is appropriate.

With the Curves adjustment layer still open (**Figure 8.54**):

1. Click the white eyedropper. Click into the white strip; this is pure white.

2. Choose the black eyedropper and click into the darkest part of the black strip.

3. Grab the gray eyedropper and click into the gray strip in the photo to define the gray point (color balance). If you are using the smaller chips, choose the 18% gray option.

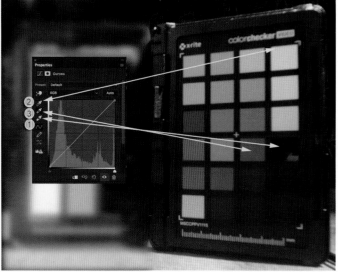

8.54

Figure 8.55 shows that the color chip is now properly balanced in the photo.

8.55

Notice the change in the curves. These are the exact corrections needed to color correct and balance the shots from the camera in the present lighting conditions. Now we need to transfer this information to the videos. The way to do this is to convert these adjustments into a LUT (**Figure 8.56**).

8.56

Choose Export > Color Lookup Tables. Choose the formats that you want the LUT to be in (**Figure 8.57**). Typically, 3DL and CUBE will cover you for video editing software. Click OK.

8.57

Now just name your LUT and save it to the location of your choosing. A LUT file will be created. In this case, I called it P4shade-color. lut. This is for Phantom 4 shade color correction. I also made one for direct sunlight and called it P4 Sunny Color. Name your LUTs however you like, as long as it makes sense for you later on. Make a set of color correction LUTs for each of your aerial cameras. A basic sun and a basic shadow LUT should be reusable for most of your shots. However, if you have a different lighting situation—such as artificial light, twilight, sunrise, or sunset—you will need to shoot the color target and create separate LUTs for those lighting conditions (**Figure 8.58**).

8.58

USING YOUR LUTS

All right, now that you have made some LUTs, let's use them in our video. Once again, I'll be using Premiere Pro, but you can use these LUTS in any video editor, provided it has LUT support. Most professional video editors support LUTs; if yours doesn't, there are third-party plugins and programs that support LUTs.

Figure 8.59 is a shot from out in the desert. It has a very warm look to it. Let's neutralize the color using our LUT.

8.59

Open up the Lumetri panel. Depending on how you want to use this, open to either the Basic Correction panel or the Creative panel.

NOTE *If you open it as an input LUT in the basic panel, it doesn't provide an option to fade, but it does allow you to apply another LUT in the Creative panel to "flavor" the footage.*

If you open it as a look in the Creative Panel, you have the option to fade the look, but you can't apply a second look.

Because this is a utility look (camera LUT)—meaning that it's fixing the footage and not applying any creative flavor—we are going to open it in the Basic Correction panel.

8.60

In the Basic Correction panel (**Figure 8.60**), click the field next to Input LUT. You will see a list of available LUTs. We are going to use our custom one. Click Browse.

Navigate to the LUT that you created earlier (in this case, P4 Sunny Color.3DL). We are using the one we created for sunlight and not shade, as the footage we are working on is in direct sunlight (**Figure 8.61**).

8.61

8.62

Figure 8.62 shows the color cast in the footage is neutralized in just a couple of clicks.

For some shots, this effect might appear a little sterile, as it basically removes all colored light and produces a perfectly white-balanced result. This is the intention, and it's a great starting point to add a little flavor. It's very difficult to apply a reproducible effect when you are trying to correct color at the same time as adding style; you might have to match multiple clips, and this camera LUT will enable you to do that.

In **Figure 8.63**, I added a little blue into the shadows and a touch of yellow into the highlights to warm it back up without producing an overall color shift. Using a custom camera LUT makes this possible and easy.

8.63

PLUGINS FOR STYLIZED LOOKS

I WOULD BE DOING YOU A DISSERVICE if I didn't mention some of the most popular plugins used to create different looks quickly and easily. These are the most popular video plugins used for color from Red Giant Magic Bullet Suite (now owned by Maxon) as well as Boris FX Sapphire (borisFX.com).

This collection of plugins is used in television and cinema all the time, and chances are, you've seen them on your favorite show. Let me show you a couple.

Magic Bullet

The first and probably most popular plugin is Magic Bullet Looks.

Figure 8.64 is a starting clip from Treasure Island, San Francisco. I shot this on a GoPro 3.

When you apply Magic Bullet Looks, not much shows in the Effect Controls panel. Click Edit, and it all happens in the plugin (**Figure 8.65**).

8.65

8.64

On the left, you will see all the looks. These are presets—tons of them! Most of the time, you can find exactly what you are looking for by selecting one of the many presets.

Click in the lower-right side and you will see the tools appear at the top right. These tools apply different effects to the presets (**Figure 8.66**).

8.66

You will see slots in the bottom. This is where all the tools and effects live. Click one of the tools and its controls will appear so that you can change just about any parameter (**Figure 8.67**).

As you can see in **Figure 8.68**, there are layers of effects in the presets; just click and adjust.

8.67

8.68

And we now have a cinematic version of the footage in a few clicks (**Figure 8.69**). You can apply the stock presets, or you can modify them. You can also build your own looks from scratch and save them as new presets.

Another really useful plugin is Magic Bullet Film, which emulates the look of different film stock and film processing (**Figures 8.70–8.72**).

8.69

8.71

8.70 Unedited footage

8.72 Edited footage

Magic Bullet Colorista III offers high-end color tools to get your footage looking great. Colorista III's tools also allow you to apply a key and isolate the adjustment to any part of the video. So, for example, you could adjust just the sky, and it will track the adjustment as the video moves (**Figure 8.73**).

8.73

8.74

Boris FX, Sapphire

Boris FX has an extensive suite of video plugins, as well as Optics for Photoshop. When it comes to effects and color grading, Sapphire stands alone. There is a large collection of filters with a dizzying number of presets, as well as the ability to customize almost any parameter.

Here is the original clip directly out of my camera (**Figure 8.75**)

Here you can see the many presets in the Film Effect filter (**Figure 8.76** and **8.77**)

8.75

8.76

8.77 The final image

In (**Figure 8.78**) you can see one of the other filters that instantly produces vintage colors.

8.78

FIXING COMMON AERIAL VIDEO PROBLEMS

IN THIS SECTION we are going to look at how to fix some of the common annoyances that take away from the quality of our footage. This isn't about how to apply sexy looks or a wow factor. This is the knowledge you need to create nice, clean footage.

Reducing Shake

There will be times that, despite your best efforts, there is a little shaking in your footage. Three-axis gimbals have certainly taken the brunt of camera shake out of our footage, but there are still those times when there is a mistimed gust of wind, or perhaps you made a couple of micro-adjustments during your flight path that you would really love to smooth out.

There are different stabilization features in different video editing packages, but I think that Warp Stabilizer in Adobe After Effects and Premiere Pro are the best available.

Select the clip that you want to stabilize. If you want to do a portion of a clip, cut it with the Razor tool, because you can't contain the filter with in and out points.

Choose Warp Stabilize from the effects. (Type "stab" into the filter search bar to save time hunting.) Drag the filter onto your clip and it will begin analysis. This could take quite a while for a longer clip, so you will see a blue bar that lets you know what is going on (**Figure 8.79**).

8.79

When Warp Stabilize has finished analyzing the footage, it will apply stabilization (you will see an orange bar) (**Figure 8.80**). Stabilization happens much more quickly than analysis.

8.80

After stabilization, you can play back your video and see how you like it. For the most part, the default settings work well. If not, there are ways to alter how this little gem works.

To make it easier to understand the settings, here is the skinny on how Warp Stabilize works. Warp Stabilize looks for the key action and tracks the objects in the footage; this is why analysis takes so long. When it has figured out the difference between desired movement and general shakiness, it locks those points down. For example, imagine a rock rolling around inside a can as someone is shaking it. The can is the frame and the rock is your footage (hopefully, it's a bit smoother than that). Imagine that instead of a rock, you have piece of chewing gum stuck to the inside of the can. This is what Warp Stabilize does—it finds the heart of the footage and locks it to the inside of the frame.

So now that your objects are locked to the frame, where does all the shaky stuff go? If you were to zoom out you would see that the footage has been enlarged so that it can be repositioned in frame by constantly moving it around and rotating it to compensate for the shakiness. The edges of the footage are outside the frame, but because it's zoomed in a bit, you can't see the edges moving around.

So, basically Warp Stabilize does the following:

- Analyzes and locates shaky footage.
- Turns the main action into a pivot point by locking it into position in the frame, like sticking a pin through it.
- Slides and rotates the footage around the pinned point.
- Enlarges the footage so that you can't see the rotating, moving edges.

Use Subspace Warp (**Figure 8.81**) to stretch the footage rather than having it rigid. This makes it more efficient and easier to stabilize. Although Subspace Warp works most of the time, sometimes you can get weird Jello effects. These can be reduced by choosing Position, Scale, Rotation.

8.81

A side effect of enlarging footage is a loss in resolution. Sometimes this can cause the footage to appear soft and fuzzy. The edges are hidden by using Stabilize, Crop, Auto Scale (under Framing). If this is causing the footage to look too soft, you could try Stabilize, Synthesize Edges instead. This does the equivalent of Content-Aware Fill on the edges, rather than scaling them (**Figure 8.82**).

8.82

You will also see the setting Crop Less <-> Smooth More. This is the balancing act. If it scales more, it gives Warp Stabilize more edges to play with and makes it possible for more smoothing, but it produces softer-looking footage because of the loss of resolution. If you want to keep the image quality high, don't let it scale so much; the side effect is that there is less for Warp Stabilize to work with, so it doesn't produce as much smoothing. Change these settings only if the footage is noticeably soft or you aren't getting as much stabilization as you need.

Removing Lens Distortion

Because the lenses we use on our aerial platforms are usually wide, they can cause a fisheye effect or barreling. The newer drones do a pretty good job of removing most of this distortion and some have built-in correction profiles, so you may not have to remove

it unless it's really obvious. However, some drone cameras have a ton of distortion (**Figure 8.83**).

8.83

This can quickly be fixed in Premiere Pro. The cost is that you will lose some of the image around the edges.

Under Filters, find Lens Distortion Removal. You will have to scroll there manually, because all the profiles will be hidden when you use the search bar. You will see common profiles, such as most of the DJI line and the GoPros. More profiles are being added all the time. Grab the profile that most closely matches your camera (if it's not on the list, grab something close) (**Figure 8.84**).

8.84

In **Figure 8.85**, you can see that the distortion is mostly removed by adding the profile.

8.85

You can customize the amount of correction, which is especially important if there isn't a profile for your exact camera. Change the Curvature setting in the Effect Controls panel (**Figure 8.86**).

8.86

Reducing Prop Shadows

Sometimes you will see dark, moving bands on the corners or sides of your video. Quite a few people are puzzled about these and wonder how they got there. This is what's happening: When you point the camera 30 to 45 degrees into the sun, the shadows from the propellers project onto the lens. This mainly happens when the sun is higher, during the middle of the day. You won't see it as much, if at all, early or late in the day, when the sun is lower.

To avoid this:

- Fly earlier or later in the day.
- Use a lens hood (a UV or ND filter won't help reduce this effect).
- Shoot with the sun behind or directly in front of you, but avoid 30- to 45-degree angles.

Sometimes it's unavoidable, and you have to reduce the propeller shadows so that a piece of footage is usable. I have found a great plugin that helps with this issue: Flicker Free, from Digital Anarchy (www.digitalanarchy.com). It works with Premiere Pro, After Effects, FCP, Resolve, and Avid. This is how it works.

Figure 8.87 is a shot with prop shadows. They are circled in red in **Figure 8.88**.

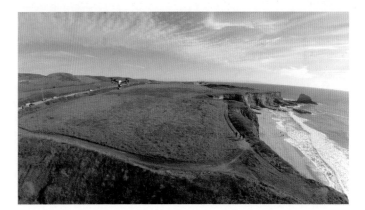

8.87

8.88

In the editor (I'm using Premiere Pro), find the section of footage with prop shadows. Using the Razor tool, cut before and after the problem to isolate the trouble area. We only want to use the filter where it's needed. Apply Flicker Free (**Figure 8.89**).

8.89

Change the Preset setting to Rolling Bands 4. Render and play back. In many cases, this is all you need for a good result. In **Figure 8.90**, there is a tiny bit of shadow left, but not enough for people to really notice.

8.90

If you find there are still problems, just nest the sequence by right-clicking the clip in the timeline and choosing Nest Sequence. Now you can apply Flicker Free to the nested sequence, but at a lower setting (**Figure 8.91**).

8.91

Reducing Noise

Although film grain may add a romantic feel to your videos, noise is just noise, and there is nothing good about it. Noise is those pesky dots on your footage. They can be colored, or they can just be grainy (**Figure 8.92**).

8.92

Noise is usually found in the shadow areas. If you are shooting at ISO 100, you probably won't have much of an issue. However, when the ISO gets turned up, the sensor has to work harder and noise is produced. To properly see noise, you need to view your footage at 100%. To avoid it, try to keep your ISO at 100. The larger sensors such as the 1" and micro 4/3 on the Mavic 3 handle low light quite well and you won't notice as much noise unless you are shooting at a very high ISO. It's a good idea to test out your camera and see where the noise threshold starts to become troublesome.

After Effects, Photoshop, and Resolve come with their own noise reduction tools, but Premiere Pro and Final Cut Pro don't.

In Photoshop, just convert the video to a Smart Object and then use noise reduction in Camera Raw. Yes, you can edit video in Camera Raw in Photoshop. Have a look at chapter 6, where we do noise reduction in Camera Raw. It's exactly the same process for video.

If you want to do noise reduction in Premiere Pro or After Effects, you will have to get a noise reduction plugin. The most popular is Red Giant's Denoiser 3 filter.

To use this filter, zoom in to 100% so you can see the noise.

Apply the filter and click Sample.

Adjust the Noise Reduction amount until the noise is gone.

You can play around with the settings in Fine Tuning if you are losing too much detail in the footage (**Figure 8.93**).

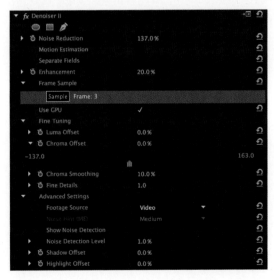

8.93

Figure 8.94 shows this shot with noise reduced.

8.94

ENCODING

ENCODING IS HOW YOU DELIVER THE FINAL VIDEO. The settings that you use depend on the purpose of your video. If you are saving high-quality video to be included with other footage to be further edited and produced, you'll need a non-destructive format. The most common are Apple's ProRes and QuickTime Animation codecs. These formats maintain all the quality and also produce very large files. These files are good for working on, but not the best for people to watch, as they require some pretty hefty resources to play back smoothly.

The second type of format is the delivery format. This is when you're ready for the video to be shared with the world. Maybe you are going to upload it to YouTube, put it on a mobile device, or put it on your website. In those cases, you are looking for the best quality at the smallest possible file size so that the video will play back smoothly on the viewer's device, whether it be a mobile phone or a 4K television. The most common standard for delivery is H.264, a type of mp4 video that is used on pretty much everything. The only thing that threatens to replace it is H.265, which will be the next standard, but it will take quite some time for it to be fully adopted. Many of the newer drones have the ability to shoot H.265.

The very last thing you do with your video is encode it. This is the video equivalent of printing.

Encoding from Adobe Premiere Pro

When you encode from Premiere Pro, you are actually using Adobe Media Encoder (AME), which allows you to encode more than one video at a time, as well as lots of other things. Don't worry; I'm not going to get technical on you now. We are going to look at basic encoding using presets. There is a preset for pretty much everything you need.

To encode, choose File > Export > Media or press Ctrl/Cmd+M.

Adobe Media Encoder will open. It's a four-step process to encode (**Figure 8.95**):

1. Make sure your timeline is not restricted to an in and out point.

2. Choose an output format (codec).

3. Note your video's name and destination when you export it.

4. Start encoding.

You can see that we have chosen H.264 as the output format. There are a ton of presets. If you choose Match Source, the video will be output at the same dimensions and frame rate as the edit on the timeline.

8.95

Click the Preset field to see all the presets that are available; there are presets for Apple TV, Facebook, iPhone, Android phones, Vimeo, YouTube, and more. Find the preset that matches your desired destination and you should be good to go (**Figure 8.96**).

8.96

Alternatively, if you want to maintain quality because you are going to edit this footage more or add it to another project, **Figure 8.97** shows the settings you need:

1. Change the Format setting to QuickTime.

2. Click the Video Codec menu (Click the Video tab if it's not highlighted).

Choose Animation from the list (**Figure 8.98**).

Finally, choose Export to export your video, and it will begin encoding.

8.97

8.98

If you want to continue working in Premiere Pro while it's encoding, or you want to encode more than one clip, choose Queue.

If you choose Queue, Adobe Media Encoder will open for batch processing. Click the green arrow at the top right to begin encoding.

Encoding from Photoshop

To encode video from Photoshop, choose File > Export > Render Video.

Photoshop also uses Adobe Media Encoder, albeit with fewer features.

Here in **Figure 8.99**, we are ready to encode at H.264. This is the default option. Choose a preset from the Presets menu. There are not as many options as in Premiere Pro, but it's still a pretty decent list.

If you require higher quality for further editing, change Format to QuickTime and change Preset to Animation High Quality (**Figure 8.100**).

Click Render to start encoding.

8.99

8.100

PARTING WORDS

THANKS SO MUCH FOR READING THIS BOOK. I hope it's been helpful to you. I hope that you found the answers to your most pressing questions and that you found the methods and workflows that you needed. But most importantly, I hope you found inspiration in these pages that will motivate you to take to the skies in search of beautiful photos and video.

If you need more information or resources, PhotoshopCAFE.com is rich with information, and you can't find better books than those by Rocky Nook.

INDEX